Understanding Digital Cameras

Understanding Digital Cameras

Getting the Best Image from Capture to Output

Jon Tarrant

AMSTERDAM • BOSTON • HEIDELBERG • LONDON • NEW YORK • OXFORD
PARIS • SAN DIEGO • SAN FRANCISCO • SINGAPORE • SYDNEY • TOKYO
Focal Press is an imprint of Elsevier

Focal Press is an imprint of Elsevier
Linacre House, Jordan Hill, Oxford OX2 8DP, UK
30 Corporate Drive, Suite 400, Burlington, MA 01803, USA

First edition 2007

British Library Cataloguing in Publication Data
A catalogue record for this book is available from the British Library

Library of Congress Cataloguing in Publication Data
A catalogue record for this book is available from the Library of Congress

ISBN–13: 978-0-240-52024-7
ISBN–10: 0-240-52024-6

For information on all Focal Press publications
visit our web site at http://books.elsevier.com

Printed and bound in Italy

07 08 09 10 11 10 9 8 7 6 5 4 3 2 1

Working together to grow
libraries in developing countries

www.elsevier.com | www.bookaid.org | www.sabre.org

ELSEVIER BOOK AID International Sabre Foundation

Contents

Preface

A lot has changed since I first entered the photographic industry as a professional photographer and technical journalist. Some of the companies, both digital and traditional, that I used to know well are no longer in existence: there are also other companies that previously confined themselves to household electronics but now have a strong presence in the digital camera market. This is the way of the world. So too is human mortality, but that does not make it any easier when news arrives unexpectedly. In the time between the publication of my previous book for Focal Press in 2003 and this one there have been four significant losses from my address book.

Barry Waterhouse was a keen digital amateur and a storehouse of knowledge about Lancia Fulvia cars. His website featured the products of his efforts and as such exemplified how digital images could communicate in a way that was simply not possible with the printed medium.

Pam Lee was a professional social photographer who shot weddings (including my own) and society events: she came to photography late in life and always wanted to learn more about it.

Bob Carlos Clarke was a giant of the photographic world whose efforts to promote the medium were tireless and whose talk was forthright. He was always keen to try new digital cameras but I suspect that he never fell out of love with the darkroom.

Douglas Arnold was one of my much-valued contributors while I was editor of the *British Journal of Photography* and touched me with his enthusiasm for astronomy. His influence has crossed with me from photography into teaching.

These are some of the people whom I will never forget. But life moves on and for that reason this book is not dedicated to the memory of the past but to a vision of the future. At their request, this book is dedicated to my Year 11 Physics class and to a new generation of photographers for whom the digital medium will be the norm.

Acknowledgements

No book is the product of just one person's efforts and I therefore wish to thank everybody who has made this particular volume possible. I am enormously indebted to John Clements for his continuing support and friendship and am also grateful to Andrew Stevens, Paul Stewart and Michael Ruskin, all of whom have contributed their pictures and experiences to this project. Thanks also go to the various students who offered pictures and are credited where their images appear, and to the many models who participated in my own pictures. Special thanks in this respect go to Anouska and Jack for being such co-operative, if sometimes unwitting, models.

Among the companies that have been particularly helpful are Sigma, Nikon, Kodak, Fujifilm, Lexar, Epson, Johnsons Photopia and Colour Confidence, if not directly then in helping with features that have appeared in the *British Journal of Photography* and *What Digital Camera?*, some of which have gone on to provide material for this book. In addition I have taken advantage of many free software projects and wish to acknowledge the efforts of, and express my admiration towards, all those who devote time and effort to the free software cause.

Finally, I want to thank my wife Lin for participating in numerous discussions about everything related to digital photography and well beyond, not to mention her unending patience and always being there to lend support whenever the going got tough.

Jon Tarrant

Understanding Digital Cameras

Digital photography is all about spontaneity. This coloured-glass window was snapped on a digital compact then enlarged using SizeFixer software. The picture was made possible by the fact that modern digital cameras are now so small and yet offer such high image quality that it is practical to carry them in a pocket or handbag just in case an opportunity such as this presents itself. The golden rule is always to have a digital camera on hand and to make sure that you know how to get the very best out of it – which is exactly what this book is all about.

CHAPTER 1

Introduction

Ten years ago there was a prediction that within 15 months we would have digital cameras that would compete with film on the basis of image quality. Writing in a small-circulation and short-lived publication called *PQ Magazine* I scoffed at the timing of that prediction and turned the claim on its head by observing that only when digital cameras can do everything that film can, to equal quality and at equal cost, will it be fair to talk about digital cameras being true competitors to silver halide photography. Well it took much longer than 15 months but that time has definitely now arrived. Digital SLRs have fallen from the same price as a small car through the 1990s to the cost of a decent television set today. Similarly, whereas the price of a digital compact camera was once on a par with a week's holiday abroad, costs are now so low that digital compacts have become common Christmas presents. Not only that but image quality has also improved, maybe not so that it equals film in every respect but certainly enough to better it in most areas. In short, digital photography has truly come of age.

Photography has always been about making pictures that can be viewed independently of the subject portrayed. Such pictures may be holiday snaps or images recording world events; they may be portraits of film stars or family relatives; they may record exotic animals in the wild or flowers and birds in your own back garden. These pictures might be intended for viewing by a public audience, on the pages of a magazine or in an exhibition, or just as personal memories. All this could also be said of the visual arts in general and in the days before photography other artists did indeed fulfil many of these roles. But the camera changed all of that. More recently, digital cameras have moved the goalposts once more, not least because of the electronic medium that has blossomed alongside their development. No longer are pictures confined to printed media as the Internet now carries sounds and images to homes across the world. Whereas once it was the norm to gather in a darkened room to watch a family slide show or huddle together to view a handful of prints, today it is a trivial matter to send an electronic image to relatives on the other side of the globe at the press of a button.

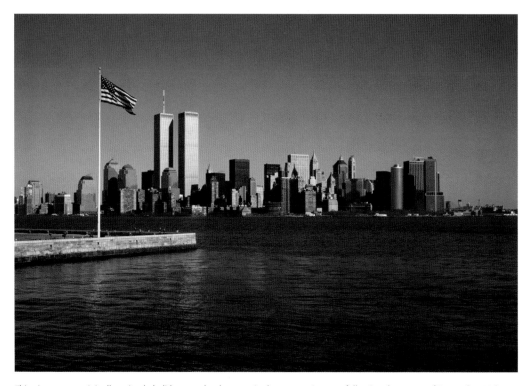

This picture was originally a simple holiday snap but has acquired greater poignancy following the events of September 11th 2001. It was taken on film, using a Mamiya 7, and was scanned so as to be incorporated into a library of digital images. The balance of quality between digital and film images is discussed later in this book.

In time to come people may not even talk about photography in the same way that they did in the past: inevitably there will be an element of de-skilling, as there always is when technology steps in to make our lives easier. Few people would be happy to double-declutch when driving a car today yet this was a routine technique 50 years ago. Likewise it seems probable that the Zone System and myriad effects that were applicable to film-based imaging will slip from photographic parlance. This is not necessarily a bad thing but it does mean that I have decided to write this book using slightly different language to that which I would have used five years ago. Indeed, this book can be considered to be an updated, expanded and reworked version of my earlier book *Digital Camera Techniques* (Focal Press, 2003). A few of the explanations and pictures have been reused here but the emphasis has been changed considerably to reflect the greater familiarity and normality that digital imaging enjoys today.

Whereas the previous book tried to treat digital photography in the same way that books of old presented film photography, it is now obvious that the two media are different and should be treated as such. This does

not mean that there will be no mention of film photography in this book because the fact is that my own experience is rooted in film work and it would be a lost opportunity not to include retrospective comments when they are appropriate. Equally, digital photography is not always a bed of roses and in those areas where digital capture still lags behind film this point is clearly made. But there is no escaping the fact that digital camera sales have overtaken those for film cameras in terms of both value and volume. The great thing about this is that digital photography brings with it new ways of enjoying the medium through image manipulation and printing.

In the previous book I stressed how much better it is to be a skilled camera user than to be forced to correct camera mistakes using image manipulation programs. That stance too has shifted slightly and this book now discusses some of the opportunities and techniques that exist for improving images using various types of software. Personally, I still believe that skilled camera work is more valuable than the ability to correct failings later on, but I accept that this is becoming an out-moded view.

New additions to this version of the book include a chapter devoted to lenses and optical quality as these things apply to digital cameras, a chapter on high-quality (fine-art) printing techniques and an expanded series of chapters looking at techniques that are appropriate for specific areas of digital photography. This book's coverage of digital imaging software has also been increased, to the extent that there is now one chapter on image manipulation techniques and another that looks at other types of software, including programs for enlarging, cataloguing and watermarking images.

I have tried to keep references to items of equipment as generic as possible while at the same time providing pointers to useful types of equipment and suggested suppliers when this is appropriate. That said, specific references are sometimes useful to help put markers in the sand (and it definitely is sand, not stone) to indicate the developing state of digital camera technology. To that end I have concluded this book with a brief and largely personal view of some of the landmarks that exist in what is still the very short history of digital cameras. I have also included discussion of some topics that may or may not remain important in the future but which are certainly of concern right now. One of these is the move to have a universal raw format for digital camera files instead of different formats from each camera manufacturer: another is the still-persistent debate about the relative quality of images captured on film then scanned versus those captured digitally at the outset.

Recognizing the fact that one book cannot possibly cover a field as vast as digital photography, with all of its technical, artistic and scientific nuances, I have also included some suggestions for further reading (both in print and on the Internet) at various points within the text. If any of the URLs go out of date then I apologise for this inevitable characteristic of the electronic medium and can only suggest that a search engine enquiry might establish a current alternative. In fact if you have time to

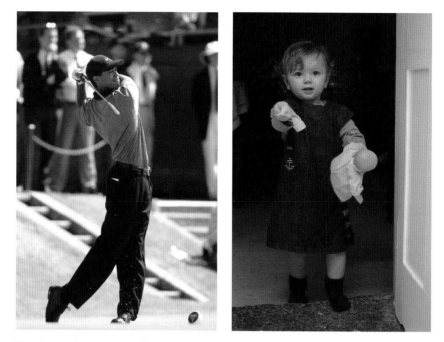

Most photographs are pictures of people in one way or another, whether they portray famous personalities (in this case the golfer Tiger Woods, left) or friends and family. Although the former pictures are more likely to have commercial value the latter have even greater sentimental value and need to be stored safely for future reference. Some of the software and hardware considerations that are at the heart of image filing and retrieval are discussed at various points in the following pages.

kill it can be illuminating to enter various photography-specific terms into search engines in order to discover what is new.

There can be no doubt that digital imaging is a fascinating and challenging field and I for one always look forward to learning new things about the medium. I hope that you do too and that this book will help to fulfil that need.

Pictures such as this should be within the capabilities of most digital cameras, including well-specified compacts. The most likely reasons for any unsatisfactory result will be poor focusing (because the composition contains so many different planes) or burned-out highlights.

CHAPTER 2

Basic Features

This initial chapter reviews the most important features of modern digital cameras. Its purpose is both to explain some of the options that are probably offered by your own digital camera and to highlight the sorts of features that you should think about when the time comes to upgrade to a new model. For the benefit of new buyers there is very brief advice regarding how to go about making that tricky first purchase and also a table, at the end of the chapter, summarizing the features and typical capabilities of different types of digital cameras. Current owners can probably skim the first section very quickly and more experienced photographers may want to skip this chapter completely, but please resist the temptation to leap ahead without at least a cursory glance as some of the information it contains is assumed in the later chapters.

Types of cameras

Digital cameras can be divided into four major categories according to the users at whom they are primarily aimed – professional, enthusiast, amateur and novelty (including camera-phones). There is also an alternative grouping that collates much the same cameras by the features that they offer:

- cameras with through-the-lens viewing, interchangeable lenses and sophisticated flash capabilities (professional cameras, also known as digital SLRs)

- cameras with through-the-lens viewing, a non-interchangeable zoom lens and modest flash capabilities (enthusiast cameras, often also known as hybrid cameras)

- cameras with separate viewing and picture-taking lenses, or screen-based viewing, a modest zoom lens and basic flash capabilities (amateur cameras, often in traditional 'compact' form)

- cameras or camera-enabled devices with a fixed-focus lens, sometimes without any flash support (novelty cameras and cameras in cellphones and laptop computers).

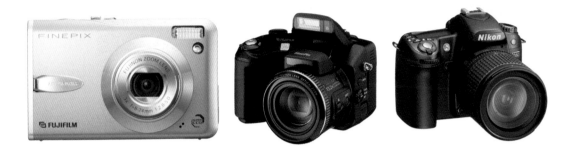

These three cameras are typical examples of the physical appearances of compact, hybrid and digital SLR designs.

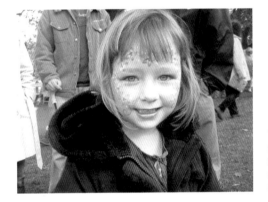

This compact-camera picture has relatively low resolution but creates a strong impact thanks to direct eye-contact and the girl's attention-grabbing red coat. Photograph © Tracey Burridge.

Inevitably there are some exceptions to this grouping, such as Epson's and Leica's rangefinder cameras that have separate viewing and picture-taking lenses but are far from amateur products, but on the whole this is a fair categorization. The meaning and importance of the various terms mentioned will be explained shortly but it is quite possible that you will realise that your requirements will be best suited to two different types of cameras, in which case the relatively low prices of some models may make ownership of two (or more) cameras a real possibility. This suggestion mirrors the reality of film photography where, not so many years ago, people would buy a well-specified but somewhat bulky camera for major picture-taking events but also had a pocket-sized compact camera for low-fuss use on other occasions.

Although there is a lot of technical information that ought to be taken into account, choosing a digital camera is ultimately a very personal thing. Some people will be swayed by looks with scant regard for specifications whereas others will want to know all the facts and figures of any given camera before deciding whether it is right for them. Then there is the matter of individual physical characteristics, such as the size of your hands and whether you prefer to look through a camera viewfinder using

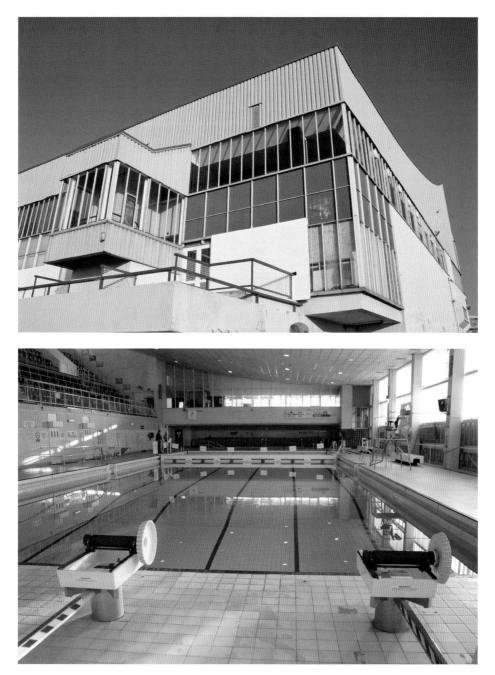

These two pictures of the former swimming pool at Fort Regent in Jersey were taken immediately before it was drained and decommissioned. They were taken using a Sigma SD10 digital SLR with interchangeable lenses: the same quality of images could almost certainly not have been obtained using a simpler camera.

your right eye or your left. In this context, brand-X could be the best-specified camera in the world but if it does not feel right then probably you will not want to buy it. The same will be true if, for example, you object specifically to excessive (or insufficient) weight in a camera. Despite potentially exhaustive analysis buying decisions always come down to personal preferences. The only thing to remember is that a digital camera is a tool, not an item of jewellery: it is meant to be used, not admired for its aesthetics. By all means buy what you like, but do not ignore the technical specifications entirely as these will limit what you can do with your chosen camera.

There are three rules that should always be kept in mind when choosing any digital camera:

1. You are far more likely to enjoy carrying a small, lightweight camera than you are a more potent but bulkier and heavier model. Therefore, when buying a camera do not ask which features you need but rather consider which ones you could live without in the interest of buying a more portable model.

2. The best camera for one person is not the best camera for another person. This means that although it is good market research to ask opinions from other digital camera owners, you may have different priorities and need to be clear about what these are before people start swaying you with praise for their own particular choices.

3. A better camera is always just around the corner and when it arrives an even better one will be waiting in the wings. In other words, you have to commit yourself to making a decision at some time and must accept the fact that if you wait for the elusive next-best-thing you will never make a decision at all.

With all of that in mind, it is time to look more closely at the most important features of modern digital cameras.

Camera features

Viewfinders

The viewfinder is one of the most important parts of any camera because it is the thing that is used to compose each and every picture taken. Many digital cameras have two viewfinders. One is the traditional optical viewfinder that is held to the eye just like when taking pictures with a film camera; the other is a screen on the back of the camera that can provide a live view of the scene in front of the lens. Interestingly, although almost all cameras have a screen on the back it is only very recently that high-end digital SLRs have started to offer live image preview even

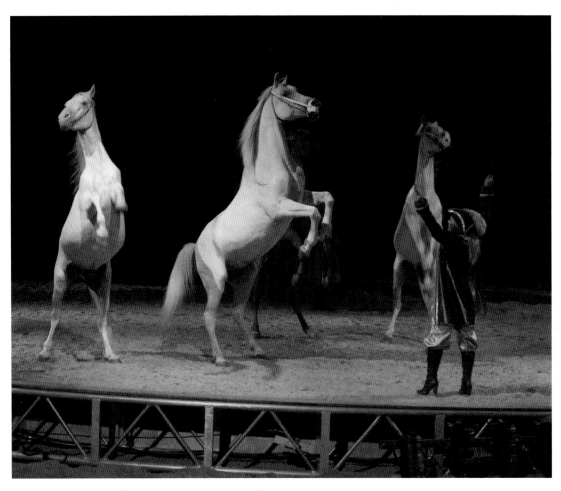

Flash photography was forbidden at this horse show but by holding the camera very steadily and trying to time the picture at a moment of stillness, between the horse rising and falling, it was possible to get a very acceptable result even without flash. This technique would be very difficult to use with any camera that has a 'jerky' electronic viewfinder (EVF).

though this has been a standard feature of compact and hybrid cameras for many years.

The straight-through 'glass window' type of viewfinder that was the *de facto* standard for film-based compact cameras has declined in popularity in digital models in favour of the on-screen live preview just mentioned. This is good in that it ensures that the picture taken matches the intended composition, and because it avoids the problem of an unremoved lens cap or stray finger unknowingly obstructing the picture-taking lens. It is bad, however, in the sense that it forces image composition to be done at arm's length, which in turn makes techniques such as panning (see Chapter 7 on action photography) more difficult. Also bear in mind

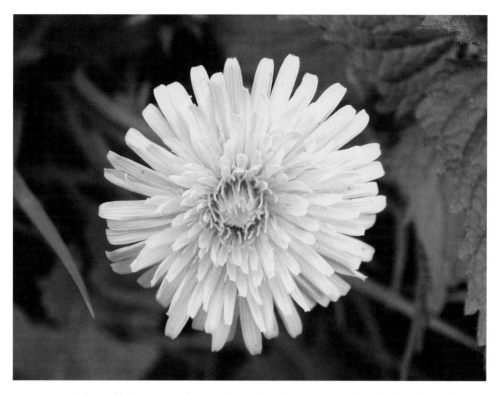

It is impossible to compose a close-up picture such as this using a separate viewfinder window but very easy to do using a compact camera's LCD preview screen. This is one of the most important technical advantages that digital compact cameras have over their film-based ancestors.

that although screens are much better than they once were they can become difficult to view in direct sunlight, making them almost useless outdoors on the very brightest of days.

The alternative form of 'glass window' is one where the view is deflected via the lens that will be used to take the picture. This deflection can either be optical, in the case of digital SLR cameras, or electronic for hybrid cameras. The latter technique involves mounting a miniature screen inside the camera for composition, thereby avoiding the poor-visibility-in-bright-light problem mentioned above for external viewing screens. There are two different drawbacks to the *electronic viewfinder (EVF)* design, the first of which is the fact that the screen often comprises a very visible array of dots, making it difficult to inspect the image critically. It is, for example, almost impossible to confirm that a picture is perfectly sharp and this fact must therefore be trusted to the camera. The second is a functional difficulty that arises from the same imaging chip being used to preview the scene, set focus and colour balance and also to capture the picture. As a result the viewfinder can be jerky or may even freeze momentarily when the picture is taken.

While it is certainly the case that these failings are being reduced as time passes, anybody who is considering buying a camera that has an electronic viewfinder is advised to test it most carefully before reaching a positive final decision. Observe how clear the viewfinder image is and what happens to it as the camera is moved around, perhaps to track a person who is walking past. Especially pay attention to what happens to the display as the shutter button is pressed. In the most extreme cases some electronic viewfinders can be so jerky as to make it almost impossible to photograph such things as aircraft displays and motorsport, not to mention children running around in the garden and even pets at play.

As mentioned above, it will often be very difficult or even impossible to confirm visually that the camera has achieved true sharp focus on a critical area of the picture. This is a limitation of all types of separate viewfinders and screen-based composition, whether this is done using an electronic viewfinder or the screen on the back of the camera. Therefore you must bear in mind that techniques that are based on careful control of the camera's focusing are less appropriate to compact and hybrid cameras than they are to SLRs.

Flash

Most digital cameras have an *in-built flashgun* that will be sufficient for everyday situations, but check the location of the flashgun to make sure that it will not easily be obstructed by your hands when the camera is held both normally and upright for portrait-style pictures. Look also to see which flash modes are provided. Compact and hybrid digital cameras often switch-on in automatic flash mode by default and will fire their flash units if the camera judges this to be necessary: you must be able to over-ride this because the camera cannot possibly know your desired intention for every single picture-taking situation. In some hybrids and mid-range digital SLRs the camera only warns you that it thinks flash will be required, often by means of an indicator lamp or flashing lightning symbol, and you can effectively switch off the flash by simply not pressing the pop-up button or by pressing the flash back down again if the camera releases it automatically. However it is done, a means of switching off the flash should be regarded as being absolutely essential as one of the most common comments you will read in this book, when lighting is mentioned, is to consider deactivating the camera's flash unit.

The other flash modes that you should look for are anti-redeye and slow-sync or night mode, which are different names for the same effect: this is discussed in detail in Chapter 5, which deals with photographing people. It is also useful to have a flash-on or full-power mode that enables you to force the flash to fire even if the camera thinks it is not needed. This can be useful when taking pictures in strong sunlight as a way of reducing the intensity of shadows on people's faces and is also discussed in Chapter 5 on photographing people.

GUEST PHOTOGRAPHER: JOHN CLEMENTS

John Clements is a professional photographer and much-respected lecturer and author with many years of experience in the photographic industry. Using the pictures on this page and overleaf he explains the operation and benefits delivered by the latest generation of digital SLRs' flash systems.

Portable and on-camera flash use has been a strength of film cameras for many years. In particular, the TTL (Through-The-Lens) method of measuring flash has proved to be extremely successful when a suitable camera and flash unit are paired. It is fast and adaptable and used by all of the major camera manufacturers. TTL-flash works by analysing the flash illumination after it passes through the lens, reflects from the film's surface and is picked up by a suitably placed measurement sensor. As soon as the correct amount of illumination has been detected the flash output is quenched. This all happens at high speed, in real time, while the picture is being taken.

With a digital sensor, however, the reflectance is not easy to judge and this means that real-time flash measurement is more difficult. So cameras now utilize a pre-exposure flash sequence that goes almost or totally unnoticed. It works in the same way, except that the pre-flash sequence is now measured either inside the camera's viewfinder, using a light-sensitive cell, or using a sensor that reads light reflected from the lens-facing side of the shutter (before it opens for the actual exposure). Once the camera has determined any adjustment that needs to be made for the exposure based on this pre-exposure test, the actual picture is taken. When this happens, the shutter opens and the flash fires at the determined level so that the light can record on the digital sensor. Although this process does not happen in truly real-time it is so fast that it makes no significant difference to the way in which TTL flash photography is used.

Portable and on-camera flash is most often used when the ambient light level is so low that picture-taking becomes difficult. Another, under-utilized, way of using flash is to photograph a subject or scene with a wide brightness range. In this situation the danger is that the sensor cannot record detail right across the subject brightness range but by adding fill-in flash it is possible to lighten the shadows, thereby reducing the subject brightness range and helping to ensure that more detail is recorded than would otherwise be possible.

The black-and-white picture here is a typical example of a wide subject brightness range: there are strong highlights and lots of mid-tones that taper-off into deep shadows. It was photographed using ambient light only. Getting the best result meant spending a considerable

Photograph © John Clements

Photograph © John Clements

amount of post-capture time adjusting the raw-data file, especially its tone compensation level, along with global levels correction and some noise reduction. That sort of effort is not problematic for the occasional shot but when there is no time for post-capture work, or you simply do not wish to have to adjust a large number of images, it is far better to use fill-in flash.

The colour image, shown opposite, is another example of a subject brightness range that is greater than any camera or film's ability to record. By adding some fill-in flash to the subject, the model was lifted to a lighter tonal value that is much nearer the brighter background. This image is an out-of-the-camera result with no post-capture correction. As such it was a much less labour-intensive picture that has benefited from the photographer knowing the right techniques to use in order to make life easier in the long run.

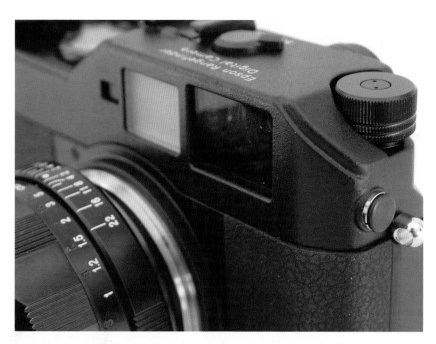

The presence of a hotshoe, into which an accessory flashgun can be slotted, is unmissable on the top of a camera but a Flash-PC socket may not always be obvious on the camera if, as here, it is tucked away on the side of the body and protected by a small, circular cover.

Even more important, at least to those who might want to explore more advanced lighting techniques, is the camera's compatibility with *external flash* systems. The necessary interface can take the form of either a slide-in hotshoe on the top of the camera or a small coaxial socket (the Flash-sync or PC-sync socket) that is typically found on the front or side

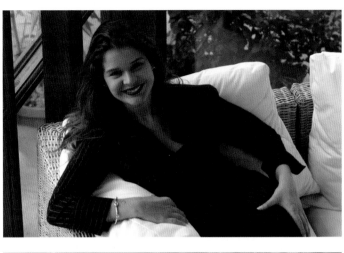

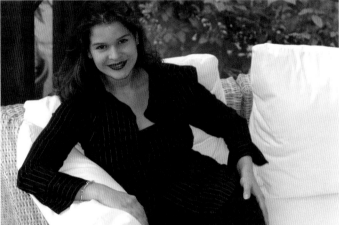

Taking portraits indoors can be very difficult using only natural lighting. In the top picture it is clear that the camera has been unable to reconcile the brightness of the exterior and the highlights on the cushions with the darkness of the model's face. The other pictures show automatic fill-in flash enhancement provided by a Nikon D1X (*middle*) and Kodak DCS 14n (*bottom*). There are clear differences in the ways that these two cameras have assessed the appropriate balance between the flash output and the ambient lighting level. All photographs © John Clements.

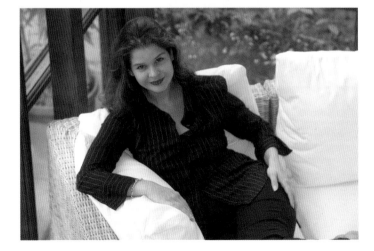

of the camera: it may alternatively be hidden behind a protective flap so do not automatically assume that it does not exist if you cannot spot it immediately. Any camera that has an interface for external flash units should also have, somewhere in its various menus, a setting that switches off the internal flash unit when external flash is being used.

Be warned, however, that the physical compatibility of old flash units with a digital camera cannot be taken as a guarantee that the two can safely be combined. Some old flash units that will slot happily into a hot-shoe or plug into the flash-PC socket use high triggering voltages that may damage modern cameras. The two most sensible tactics are therefore either to buy a flashgun that is specifically approved for your digital camera or to use a wireless triggering device that avoids having any direct contact between the camera and the flash unit. Wireless triggers are discussed in more detail in Chapter 8, which deals with studio photography.

Lenses

Compact and hybrid digital cameras have fixed lenses so it is important to know what to look for as the camera you buy will also determine the lens that you will have to use for all of your picture-taking. The only qualification to this comment comes in the form of lens adapters that extend the range of focal-lengths offered by the fixed lens, albeit at greater cost and the need to carry and fit additional items of equipment when the appropriate need arises.

In the days of film photography people routinely talked about the *focal-length* of different lenses and even now it is common to describe digital camera lenses in terms of their equivalents for 35 mm film-based photography. Therefore it is common to read specifications such as '24–140 mm equivalent', meaning that the digital camera will offer the same range of views as would be obtained when using lenses from 24 mm focal-length to 140 mm focal-length on a standard 35 mm film camera. This particular

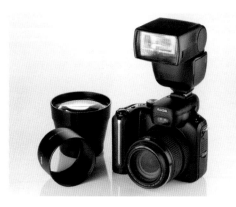

High-end digital cameras can often be extended by adding additional lenses, such as the tele-converter shown here for Kodak's EasyShare P880 (which additionally has its accessory flashgun mounted in the camera's hotshoe).

These two pictures illustrate the improvement obtained by fitting an optional tele-converter lens to the Nikon Coolpix 4500. The smaller picture (*top*) shows the best effort of the camera alone whereas it was possible to close in on just the bird's head when the lens adaptor was fitted.

range would be excellent for general use as the 24 mm end gives a very wide view that will suit open landscapes, interiors and group photographs in confined spaces whereas the 140 mm end will be great for individual portraits and action subjects at a medium distance from the camera.

A less dramatic but equally useful improvement can be obtained in the wide-angle capabilities of some digital cameras by fitting a suitable lens converter. Once again using the Nikon Coolpix 4500, the smaller picture shows the widest view offered by the camera whereas the larger picture shows the improvement obtained when a fish-eye adaptor was used.

Confusingly, some digital cameras only specify the true focal-length range of the lens fitted: this will always contain figures that are much smaller than those in an 'equivalent' specification and is likely to be something around 5–20 mm. The problem is that, because digital sensor sizes vary, different true focal-lengths are required on different digital

cameras to give the same equivalent field of view. Even worse, there is no easy way of converting from one set of numbers to another and therefore it is necessary to have a general feel for a useful minimum and maximum amount of scene area that ought to be covered by a digital camera's lens.

When the lens is set to maximum zoom it should be capable of framing a head-and-shoulders portrait at a distance of about 2 metres: when the lens is moved to its widest setting you should be able to get about four people across the frame at the same distance as previously provided a good head-and-shoulders portrait. As you might suspect, this would be a 4× lens, because its widest setting has four times the coverage of its most zoomed-in setting. This in turn means that the smallest figure in the zoom range should be one-quarter of the largest figure. The good thing about this rule is that it works the same regardless of whether the lens is specified in equivalent or true focal-lengths.

Linked to the range of focal-lengths offered is the *closest-focusing distance* that the lens features. Although these two characteristics are theoretically quite different they are linked in practice because the magnitude of the prevailing focal-length when the camera is set to close-up mode will determine how large an image can be captured of any given subject. Many digital cameras will focus down to about 30 cm, and some will go to within 10 cm, but the amount of magnification obtained depends not only on the distance but also on the focal-length of the lens. Generalizations are impossible to make other than to observe that a camera that can focus on the face of a watch, at a distance where the watch fills the screen, is doing very well in terms of close-up capabilities. It is more common for digital cameras to be limited to a close-up area that is the size of the front of a paperback book. Only you can judge how important it is for the camera that you use to be able to get as close as a watch-face.

Two further factors to look at when examining the lens of a digital camera are the ability to fit filters and other accessories on the front and the name of the manufacturer that created the lens. *Accessories* are important if you want to be able to extend the range of your camera but this is largely dependent on whether or not the camera manufacturer has seen fit to offer any such items. In other words, there may be little point in having a screw-thread on the front of the lens to accept accessories if there are none offered for your camera. It is not enough to know that a third-party makes compatible accessories because you must be confident that attaching another device will not hinder the operation of your camera in some way – or even damage it permanently. Weight is a particular issue and some camera manufacturers offer support tubes that attach to the camera body itself, not to the lens, to bear the load of any additional accessories. Therefore, look at the camera's lens as the basis for a system of accessories from the outset if this consideration is important to you: do not simply assume that the existence of a filter thread guarantees the existence of accessories for your own particular camera.

The *manufacturer's name* on the lens is a minor consideration in many cases but it ought to give you confidence in the quality that you can expect from the optics. In particular, some electronics manufacturers have teamed-up with photographic manufacturers to offer cameras that combine the expertise of both companies. Hewlett–Packard, Panasonic and Samsung, for example, have collaborated with Pentax, Leica and Schneider respectively.

The final lens consideration that needs attention is the range of *aperture numbers* provided. It is fairly common for these to run from about f/2.8 or f/4 to f/8 or f/11. The biggest aperture numbers (8 and 11) are not very high compared with the settings available on interchangeable lenses but, as was pointed out at the beginning of this section, all of this discussion refers specifically to cameras that have fixed optics. The issues for interchangeable lenses are more complicated and are discussed in a later chapter together with focusing accuracy.

Photographic controls

There are two basic aspects to photographic controls: exposure and focusing. *Exposure* can be set automatically by the camera or can be influenced either partly or completely by the user. In the last case, the camera is said to offer full manual control but this is quite rare on compact cameras although it is a standard feature on well-specified hybrid cameras and digital SLRs. Even without full manual control it may be possible to set either the lens aperture or the exposure time (shutter speed) manually: this is sometimes done directly by selecting specific numbers and sometimes done via icons that indicate particular types of photographic subjects. For instance, a running man icon would indicate action subjects and would encourage the camera to set the shortest possible exposure time (fastest shutter speed) in order to record a sharp image of a moving object.

Other icon-based settings are a person's head to select the settings that best suit tightly framed portraits (a long focal-length and a low aperture number to minimize background distractions), a mountain to select the optimum settings for long-distance landscapes (infinity focusing), a flower for close-up photography, as already discussed, and a crescent moon or person with stars behind to set the camera for night-time photography. This last mode is particularly interesting because the automatic exposure system built into all cameras, not just digital cameras, is based largely on the assumption that pictures should look as if they were taken under good daylight conditions if this is possible. Only when the camera lacks the settings necessary to achieve this result does the exposure system record darker-than-ideal pictures. The net result of this is that automatic exposure systems sometimes result in important parts of a picture being recorded far too light simply because they are trying to make a black night sky in the background look lighter than it should be. Photographing fireworks is particularly difficult for exactly this reason.

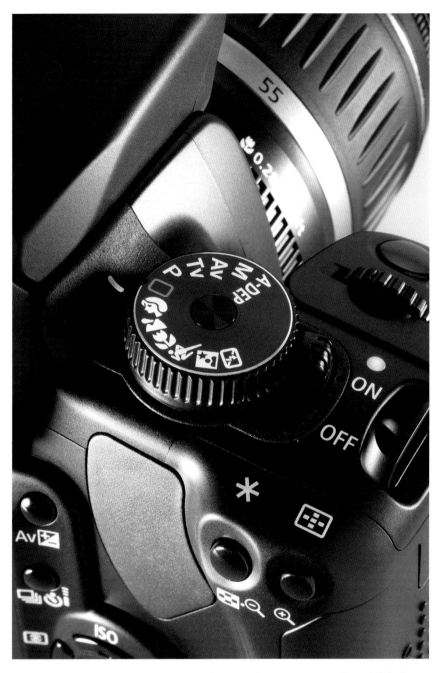

Digital SLRs normally feature a mode dial, such as this one on the Canon EOS 400D, that include both letter-based and icon-based settings. Appropriate use of these settings can make picture-taking much easier in specific situations.

Being able to control the area of the picture that is used for automatic focusing can be an advantage when photographing difficult subjects. The focusing area used here was to the right of the centre of the image, coinciding with the pilot's cockpit.

Focusing controls tend to be even more limited than the other settings provided and this will doubtless disappoint some people who have previously used film-based cameras. Most digital compact and hybrid cameras can only perform efficiently in auto-focus mode and the landscape icon is an acknowledgment that even this can fail when trying to photograph a distant scene through a coach window, for example. Manual focusing is sometimes provided but is rarely easy to use. In any case, as mentioned earlier, it can be very difficult indeed to judge whether or not the camera has achieved true sharp focus.

Luckily, most cameras perform well most of the time in automatic focusing mode but, once again, a personal test should be performed inside the shop before any particular model is purchased. The image must, however, be evaluated on a computer screen rather than on the camera's in-built display, which will almost certainly not be good enough for critical evaluation. Most shops that sell digital cameras have a PC on hand: failing this, buy a small storage card (you will need it for the camera anyway) and take some pictures back home, or to a friend who has a computer loaded with digital imaging software, for examination.

Much more information about exposure and focusing is given in Chapter 4, which is devoted to these topics.

Sensitivity range

Cameras that take pictures on film are limited in their usefulness by the film that is loaded: digital cameras have no such limitations because they incorporate a range of sensitivity settings that effectively makes it possible to 'change film' from one picture to the next. In fact many cameras have a setting in which the required sensitivity is automatically selected by the camera to obtain the best possible results. At least, that is what the marketing material for digital cameras would often have you believe. In practice, automatic sensitivity control can be a liability as well as a benefit and it is therefore important that this feature can be disabled if so required.

It is useful to choose a camera that has a wide range of *sensitivity (ISO) settings*. Even fairly modest digital cameras usually have settings from ISO100, or slightly less, to ISO400. More ambitious cameras could extend right up to ISO1600 or even higher. It seems logical to suggest that the wider the sensitivity range, the more versatile the camera will be but the highest ISO settings may well produce poor quality images and you might find that these settings are for emergency use only.

In general it is best to set the lowest sensitivity level (ISO100 or thereabout) and only to increase the setting slightly, if at all, when there is a pressing need. The balance between sensor sensitivity and final image quality is discussed later on in this book.

As well as brightness sensitivity there is also the matter of *colour sensitivity*. This comes in two forms: an option to create b&w or sepia images and the ability to fine-tune the colour balance of an image. It is tempting to query the use of a b&w mode during image capture, given that this effect can easily be obtained on the computer afterwards, but one reason is that if images are sent from the camera direct to a printing service, and a b&w result is required, then it is essential to be able to convert to b&w immediately. In addition there are creative techniques, such as coloured filtration, that are especially well suited to b&w and would be impossible to preview in-camera without a monochrome mode. Some cameras even include electronic simulations of filtered effects in their b&w mode sub-menu.

Two further aspects of colour control are white balance adjustment and the colour space in which the image is captured. These topics are discussed in Chapter 16, which is devoted to colour quality, so at this point it is sufficient just to cover the essential basics of this topic. Specifically, colour pictures can have a colour cast if photographed under lighting that is itself coloured (even though it may not seem coloured to the human eye): digital cameras correct this problem using a *white balance adjustment* that works well in automatic mode (AWB) most of the time and can be set manually to one of several different types of lighting under trickier conditions.

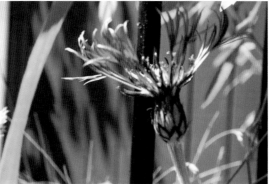

These two pictures illustrate the sort of difference in colour rendering that can be seen when the same subject is photographed using two different cameras. The larger picture was taken using a Canon EOS 300D: the colours are natural and the image has been sharply focused. The smaller picture was taken using a Panasonic Lumix DMC-LX1: its colours are much brighter and there is a general lack of sharpness caused by poor focusing owing to the demanding nature of the subject. Photographs © Annie Mitchell.

Once the colours of a scene have been recorded they are coded against a set of standard values to ensure that what one camera calls 'bright red' (in numerical terms) will be translated exactly the same way as another camera's recording of the same 'bright red'. A lack of consistency existed

Table 2.1 Summary of the typical features and uses of different types of digital cameras

Camera type	Typical features	Advantages	Limitations	Typical applications
Compacts	Sleek designs with optical viewfinder, zoom lens, removable memory card, dedicated battery and modest flash capability. Video capture.	Easy to use, often with one-touch program function for low-fuss photography. Good image quality.	Limited image quality options and flash power (usually only sufficient for close-range pictures).	Suitable for the vast majority of amateur needs. Different models have different advantages (longer zoom range, wider angle, raw format, etc.).
Rugged compacts	Bulkier than an ordinary digital compact but also more weatherproof.	Resistant against water, snow, dust, sand and mild knocks.	Limited zoom range and bigger overall dimensions.	Uses in demanding environments where a normal digital compact would not survive.
Hybrids	Bulkier version of a compact camera with more versatile zoom lens, larger battery, electronic viewfinder and a more powerful flash system.	Can cope with a wide range of picture-taking situations with a minimum of equipment and at relatively low cost.	Not as portable as a compact camera and not as versatile as an interchangeable-lens model. EVF may be slow to use at times.	Successful enthusiast digital photography under a wide range of conditions (perhaps with the exception of action subjects). Lens accessories add extra versatility.
Budget SLRs	Separate camera body and lenses. Sophisticated flash metering and menu options. Ability to capture extended sequences of pictures. Larger sensor with better image quality. TTL optical viewfinder.	Can cope with almost every picture-taking situation except extreme weather conditions and constant professional use (but including professional back-up roles).	Not as durable as a professional SLR and may lack the exotic features such as full-frame sensors, external power supplies and extreme low-light capabilities.	Advanced enthusiast use and as a back-up in professional work. Extensive lens range provides excellent flexibility. Reliable flash metering allows successful use under difficult conditions.
Professional SLRs	Similar to budget SLRs but with better build quality, faster operation and advanced menu options.	The most durable and reliable digital camera option possible with current technology.	Expensive and heavy (but prices have fallen considerably in recent years).	Constant professional use and amateur applications that demand maximum reliability under a wide range of conditions.
Digital backs	Bolt-on systems that add digital capture to compatible (mostly medium-format) camera bodies. Most features are provided by the host camera body.	The highest image quality possible with the prevailing technology. Fully compatible with the latest professional medium-format cameras.	Very expensive. Needs skilled operation to produce the best results. File format may be unique to the camera system and dedicated software.	Top quality professional photography where cost is not the primary concern and an assistant is usually on hand to carry heavy equipment.

(Continued)

Table 2.1 (Continued)

Camera type	Typical features	Advantages	Limitations	Typical applications
Rangefinders	Specialist manual-focus design that looks, and is used, like a film camera.	Ultra-quiet, fully controllable photography. Simple, rugged design.	Not suitable for general-purpose use on account of manual operation.	The ideal digital choice for traditionally-inclined photographers (including professional users).
Novelty designs	Often miniaturized designs, built into a pen for example, with crude optical viewfinder, fixed lens/focussing and internal memory.	Tiny size and unobtrusive operation. Low cost promotes widespread use.	Low resolution and little control over focusing and composition risks poor image quality.	Go-anywhere use including situations where photography is difficult or forbidden.
Cellphone cameras	Dictated by the style of the cellphone. Only basic controls for image capture.	The easiest way to carry a camera (assuming you routinely carry a cellphone).	Low-to-medium resolution and limited control restricts image quality.	Ideal for spur-of-the-moment use, whether it is to record still images or short video clips.

in the days of film photography, when it was commonly observed that pictures taken on Fujifilm products tended to have better greens than pictures taken on Kodak film. From this observation it was apparent that the two manufacturers' films did not record the same colours exactly the same way. Although such differences still exist, in digital photography it is possible to 'tag' pictures to say which standard definition of colour has been used, normally either sRGB or Adobe 98 RGB, in order to produce better consistency. It is useful to have a choice of colour mode but it is not true to say that either choice is automatically better than the other.

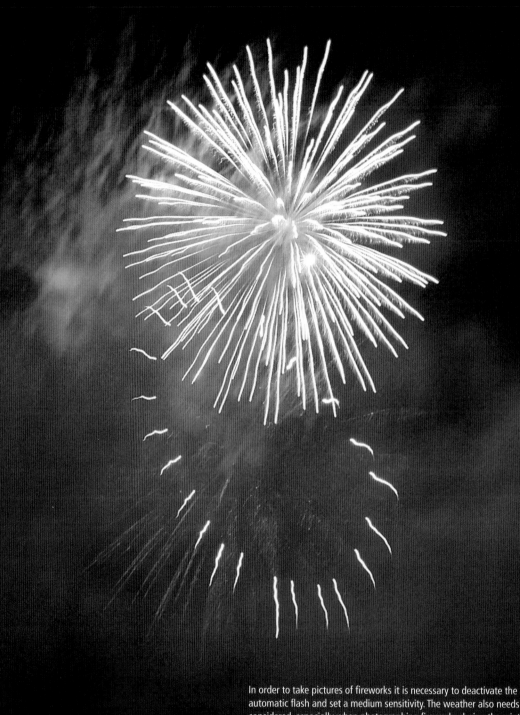

In order to take pictures of fireworks it is necessary to deactivate the automatic flash and set a medium sensitivity. The weather also needs to be considered, especially when photographing fireworks during the winter when rain is a distinct possibility. This picture was taken using a Ricoh Caplio 400G Wide, which has a weather-proof body.

Camera Menus

Although digital camera menus vary slightly from one type of camera to another, and even between similar cameras made by different manufacturers, there are some core options that are common to most cameras and which need to be considered in order to obtain the best pictures. As was the case for the previous chapter, the most detailed discussions of particular points (in this case image quality) are left to another chapter. The purpose of this chapter is to provide more of an overview and its contents are meant to complement the information given in your camera's user guide. Once again, this information could also provide some useful pointers to things to look for if you are about to buy a new digital camera.

This chapter is especially important because menus are unique to digital cameras: they have no direct equivalent in film-based photography (the closest parallel being the custom function options provided within professional SLRs) and they reflect the comparative complexity and greater control offered by the digital medium. Often they are divided into separate sections that cover general settings, image capture and image review. In the case of professional SLRs there are still custom functions that can be adjusted as well but these are not covered here as they are model-specific and mostly do not affect the digital side of the camera.

General settings

Some of the options in this section are fairly trivial, such as the format in which the *date* is recorded, but setting the date itself is genuinely useful because this can be used to find and help identify images in the future. The date setting should be retained even if your camera battery runs down but it may be lost if the battery remains drained for a prolonged period of time or if the battery is removed. So useful is the correct date that many cameras will issue a warning if the date has not been changed from the camera's default setting. There is no need to imprint the date visibly on each picture because this information, along with other details, is embedded invisibly within the image file as part of its metadata. You can view this information in the camera using review mode or on a computer by right-clicking on a

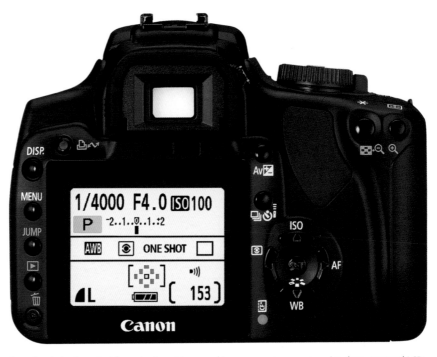

As well as being important for reviewing pictures, and in some cases even composing them, cameras' LCD screens are the primary user interface for conveying information and setting the camera to work in a specific way. Over the years screen quality has improved enormously, making cameras much easier to use. This example is the screen on the Canon EOS 400D.

picture file, selecting Properties from the menu that appears then clicking on the Summary tab. The date on which each picture was taken is also listed in the computer's browser when the Details view is selected. Clearly, given the usefulness of this information, it is good practice to set the date on your camera straight away if you have not done so already.

Other settings that probably only need to be made once are the menu language and the *video output* mode that is used when you connect the camera to a television set to review images taken (choose NTSC for the USA or Pal for the UK and mainland Europe). Similarly, you will probably have a personal preference about whether or not the camera should 'beep' or 'click' electronically in response to button presses and the shutter being fired, and a preference about how loud these sounds should be: both of these things can normally be set within the camera's menus. There may also be an option, probably called *Quick View*, that determines whether a picture is displayed on the review screen immediately after capture and, if so, for how long the picture is displayed. This is complemented by a setting that will switch-off the screen, or maybe even the entire camera, in order to save battery power if no buttons are pressed for a certain length of time. There will be occasions when you might want to over-ride this setting, such as when using the camera remotely, so check to see if

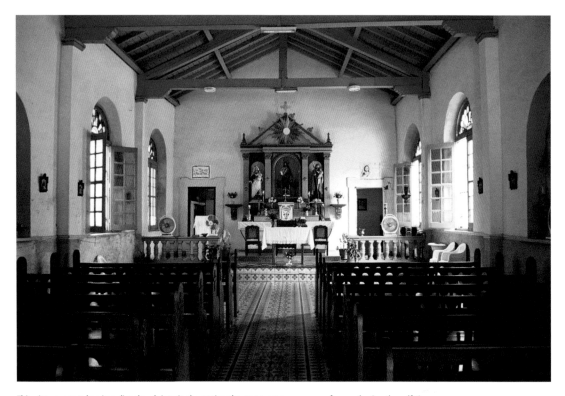

This picture was taken in a dim church interior by resting the camera on a secure surface and using the self-timer to trip the shutter automatically so as to reduce the likelihood of camera shake. A film-camera was used in this instance and the negative was then scanned to digitize it: more is said about this in the last chapter.

the menu has an 'always on' setting: if there is no such option then check to see what the longest period is before the camera shuts down.

A related option, but one that will be used occasionally rather than being set just once, is the camera's *self-timer*, which will probably offer both short and long time delays (typically 2 and 10 seconds respectively). This is useful either as a way of putting yourself in the picture, assuming that the camera can be supported without you holding it, or of capturing extended exposures without the danger of your hand knocking the camera when you press the shutter button. Linked to the latter application is the ability to capture a sequence of pictures with a specific time interval between each one. This setting might be identified as *intervalometer* mode and will enable you to record anything from a melting snowman to a flower opening in response to sunlight.

Image capture

By far the majority of a digital camera's menu settings refer to controls that are used at the moment of image capture. Foremost among these are

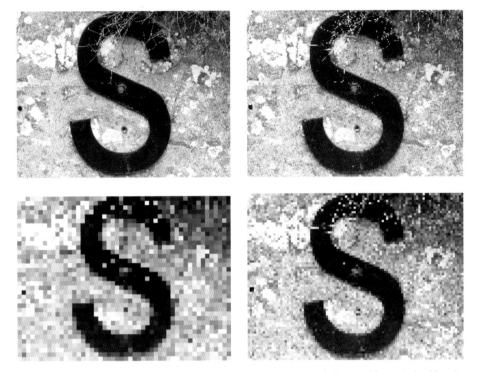

Going clockwise from top left, these four pictures simulate the effect of taking pictures with progressively fewer and fewer pixels. Although this 'pixelation' effect is rarely seen so obviously with modern digital cameras it is always lurking beneath the surface and is responsible for corrupting fine details in all digital images to one degree or another.

the number of pixels used, their sensitivity level and the format in which their data are stored.

Early digital cameras had so few pixels that pictures always needed to be taken using every one in order to ensure good image quality, but nowadays there can be times when the full pixel count is too much. This especially applies if pictures are to be e-mailed or if a rapid sequence of pictures will be captured. The former requires a smaller image file to make the pictures quicker to send whereas the latter needs a smaller image file to make the pictures quicker to store on the memory card so that the camera can then capture the next picture in the sequence. It is impossible to generalize about the number of pixels needed to get a good quality picture but this question is explored in some depth in Chapter 14, which is devoted to digital quality. If in doubt, the best advice must be to use as many pixels as possible.

The camera's *pixel sensitivity* is indicated by the prevailing ISO setting, where a higher ISO number indicates greater sensitivity to light and therefore

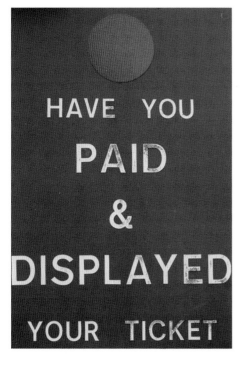

Looking closely at these two images reveals that their colour renderings are not exactly the same despite both having been taken at the same time using the same camera (Canon EOS 300D). The reason is that the slightly smoother-toned picture was captured at ISO100 whereas the picture with rather muddy colours was captured at ISO1600. This difference is due to the effect of noise on the image. More will be said about sensitivity, noise and exposure in the next chapter. Photographs © Annie Mitchell.

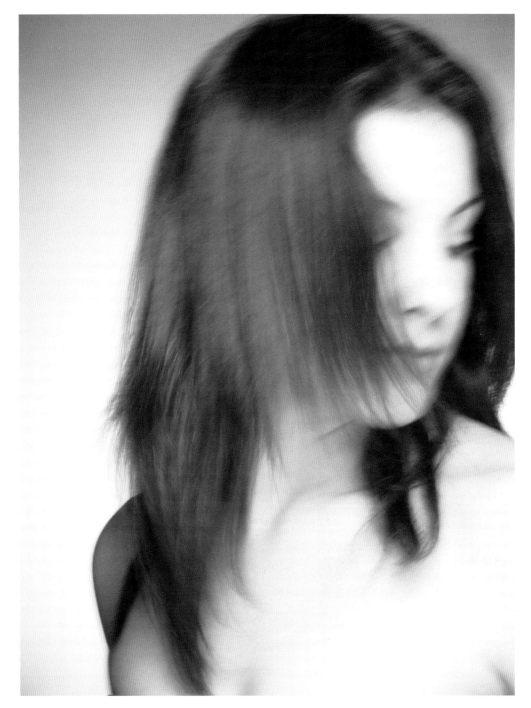

It is very important to remember that camera settings are not always made to obtain the most technically perfect result. This picture was taken using a slightly longer-than-normal exposure time and the model was asked to move her head to give this deliberately blurred effect.

a better ability to take pictures under low levels of lighting. Unfortunately, high sensitivity settings risk having noise in the picture, which usually takes the form of chroma noise that is evident as random coloured specks across the image, especially in uniform mid-toned areas. Some cameras have a noise-reduction mode that minimizes this problem but it may also increase the time between successive pictures so cannot always be used if a rapid sequence is being captured. Noise-reduction may also cause a slight loss of sharpness in the image. Either way, it is better to select a lower ISO value if possible as this limits the effects that both noise and noise-reduction can have on the camera's handling and image quality.

File format

The file format used for storing pictures will normally be one of the following three: compressed (JPEG – an acronym formed from Joint Photographic Experts Group), uncompressed (TIFF – Tagged Image File Format) or raw-format (more will said about this option shortly and again later in this book).

It is possible that there may be multiple options for the *JPEG* setting according to the amount of compression used. Greater compression gives smaller files that are quicker to store and results in a greater number of

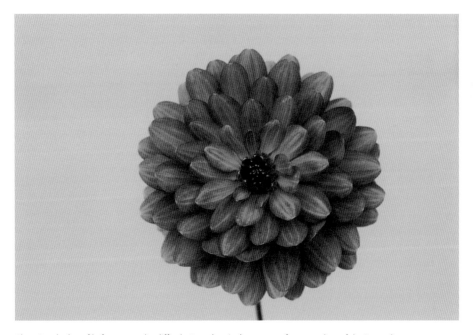

Choosing the best file format can be difficult. Raw data is the most perfect recording of the image but can slow the picture-taking process and makes post-capture conversion to a more universal format compulsory, but it is the common choice when image quality is paramount, exemplified here by the still life of a dahlia. Using JPEG compression means losing some of the image data and also limits the amount of post-capture work that can be done without degrading the image but is certainly the most convenient option and was used for the spontaneous picture taken of a demanding squirrel in a London park (overleaf).

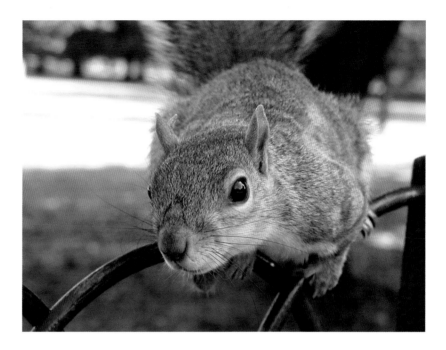

pictures being put on one memory card. Less compression loses these advantages but improves image quality because the compression method used is 'lossy', which means that as more compression is used so more and more image information is discarded.

Like JPEG, *TIFF* is a format that can be read by any image manipulation program, but in this case with superior image quality because such files are not compressed by digital cameras. Unfortunately, TIFFs are also larger files that take longer to store and also fill up memory cards more quickly. An additional complication arises through the existence of multiple implementations that are not all completely compatible with each other: for example, some implementations allow the use of compression, which is a feature that is not normally associated with TIFF data. Different TIFF versions caused real problems in the past, especially when the standard was revised to allow thumbnails to be embedded in the full-size image file, but this is not normally an issue nowadays. A more likely problem is the fact that some image editing programs are fussy about whether the file extension is given as TIFF or TIF, just as some are fussy about JPEG and JPG. The correct format is the three-letter version but most programs today recognize both. You will almost certainly find that your camera uses the three-letter ending in its file names whereas Macintosh computers and Mac-oriented software (even if it is running on a Windows PC) often favour the four-letter format. The problem that this difference can cause, and a way around it, are explained in more detail in Chapter 13 on supporting software.

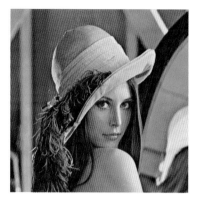

This picture is commonly used by imaging scientists to investigate the effect of different compression methods on image tones. It is part of a *Playboy* centrefold picture of Swedish model Lena Soderberg, photographed by Dwight Hooker. After initial objections to its use, *Playboy* has now consented to it being accepted as a standard test image and has reaped the benefit of continuous publicity ever since. The November 1972 edition of the magazine, from which the picture comes, was *Playboy*'s best-selling issue of all time, with more than seven million copies sold.

File naming

The main part of the file name is likely to be a sequence of numbers, perhaps with the letters IMG (for 'image') at the start. Each file name is one number greater than the name of the picture taken previously but if you delete a picture in the camera you will see gaps in the number sequences where the deleted files previously were. Many cameras offer the option to restart the number sequence or to keep on increasing the numbers in one long run: the former is neater if you are going on holiday, for example, and you want to be able to identify the pictures taken in order without worrying whether there were some earlier pictures that you have missed. In other words, if you have a continuous sequence of file names that starts, for example, at IMG02316.jpg and runs on to IMG02479.jpg then in years to come you may not remember what was the number of the first and last pictures, so may find it more difficult to locate all of the images. If, however, you reset the file names to start at IMG00001.jpg and continue up to IMG00164.jpg then at least the first picture is easy to identify. You can then find all the pictures that were taken at the same time by doing a search on your computer for pictures that were taken within two weeks of the first one (assuming that it was a fortnight's holiday). As a matter of policy I never delete the first picture in a sequence, even if it is not very good, because it serves the marker role just discussed.

Image adjustments

If you choose to save your images using the raw-data format then you will need appropriate software to both open and manipulate the pictures. Suitable software will have been supplied with your camera, at least in a basic form, and other image editing programs sometimes have plug-in options that allow them to read these files. There are also stand-alone programs that can do the same job: more is be said about these in Chapter 13 on software. That said, there is no avoiding the fact that raw-data files are less accessible than those that are stored using the JPEG or TIFF standards. The advantage

Photographs that are taken in raw mode have to be converted post-capture using either the camera manufacturer's software (as here) or a third-party program with the appropriate plug-in.

of raw-data files is the fact that they can be tweaked at a later date whereas other files are defined more specifically at the moment of capture. In particular, the exact exposure, sharpness and contrast levels, white balance and colour space are all set when a picture is recorded using the JPEG or TIFF standards whereas these things can all be adjusted post-capture if raw format is used. Kodak has a clever system for supplementing the information that is contained in a standard file, called *Extended Range Image (ERI)*, but this system is not generally implemented. Therefore it is necessary to think carefully about the aforementioned qualities before any pictures are taken if the pictures will be saved using the easily-read JPEG or TIFF standards.

Exposure

Exposure will normally be handled by the camera but it is often possible to choose from different exposure systems and to check the success of the selected system using the histogram function if one is provided. More will be said about this in the next chapter. In brief, if the picture on the review screen appears to be too light then you should reduce the exposure by setting a negative value in the exposure compensation menu option to avoid having parts of the picture burned-out (recorded as pure white). Similarly, if the picture is too dark then you should increase the exposure by using a positive amount of exposure compensation. Be warned, however, that these adjustments will probably be specific to a particular picture-taking situation but exposure compensation values are often remembered by the camera when it is switched off, so be sure to re-zero the settings afterwards.

Sharpness

Except when producing prints straight from a camera there is no reason to apply deliberate sharpening to your photographs, so keep the sharpness setting on either Normal or Off, depending on which option is offered by the

The larger picture here shows a scene captured with the camera's sharpening set to Normal. The two smaller pictures are sections that show the relative effects of using either High sharpening or None. It is clear that in-camera sharpening has given the picture a less natural appearance: sharpening should only be applied immediately before an image is printed and at a level suitable for the image size and type.

menu in your own camera. Similarly, be wary of increasing the contrast level as this can lead to a loss of detail in the brightest and darkest parts of the picture: it is more likely that you might want to decrease the contrast if you are taking pictures under very bright, direct sunlight but even here you will probably not improve the image quality in technical terms, although the picture may look better, because ultimate quality is determined by the tonal range of the sensor itself.

White balance

The white balance setting can be difficult to adjust successfully by hand but is one area where digital cameras perform very well in automatic mode, which is normally identified either as Auto or AWB (Automatic White Balance). The purpose of the white balance function is to remove any colour casts that may mar the picture owing to dominant colours in the prevailing lighting. This is very useful except for the fact that most pictures are taken under daylight conditions and any slight changes in the colour of the light, such as the warm glow that may be seen at sunset, could

GUEST PHOTOGRAPHER: PAUL STEWART

Paul Stewart is a news photographer and picture-desk editor who has used digital technology for many years. He runs a fully digital studio in London and his pictures have appeared in books, newspapers and magazines all over the world. A selection of his photographs can also be viewed online at www.potp.co.uk. Here he explains the difference that digital cameras have made to his professional work.

When the question was first put to me 'How has digital photography changed your life?' my immediate answer was 'utterly'. If you assume that most people see the news twice a day, early morning and perhaps in the evening, then the speed at which digital photography has enabled photographers to get material back to papers means that, as an industry, we have become competitive with television once again. When I am in my Picture Editor's role, I know that I can expect to receive late-breaking stories right up to deadline and still get them in the paper for the next morning. As a photographer, I know that pictures I shoot anywhere in the world, can, with the right equipment, be at the picture desk within minutes.

When digital photography first came to Fleet Street I helped to set a world speed-record of seven and a half minutes from the picture being taken to the time that it arrived at the paper. This was done using a file that would be considered impossibly small by current standards and sent down an unbearably slow phone line. Today, with 3G cellphones, broadband and satellite ISDNs it is routine to take a picture for a breaking news story and have sent it to the paper within five minutes.

In all environments the convenience of digital comes to the fore. The confidence that I get from being able to look at the picture on the screen of a camera and review it before finishing a shoot is worth its weight in gold. Then there is the ability to change the white-balance setting to cope with changing light conditions, which is immensely useful. Not only that but I, like many others, was worried for a long time about the impact that professional photography was having on the environment. Now, of course, the no-chemicals digital process means that the environmental impact is close to zero.

The question that has to be asked, however, is whether or not digital is actually 'better' than film. Despite being a Luddite when it comes to things like music reproduction, far preferring vinyl LPs to any digital medium, I have to say that in photography the advent of sensors with more than ten million pixels, and improved dynamic range and colour handling, has provided a situation where the quality of digital pictures, up to A2 size at least, in my opinion now exceeds that of film. On the rare occasions when I have to use film nowadays I find it a terrific inconvenience and long to get back to my digital equipment because of its ease of use and higher quality. The end of having to process film

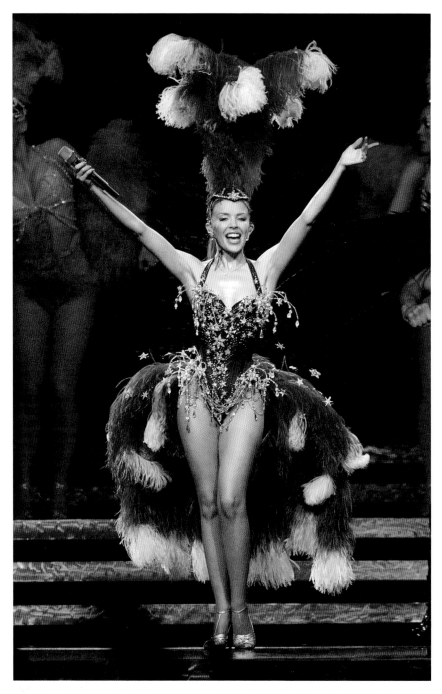

Kylie Minogue in concert. Photograph © Paul Stewart, who explains (opposite and overleaf) the benefits that digital photography has brought to his press work.

in an endless series of hotel bathrooms or even, in some cases, in the back of a car can only be an advantage.

The downside is that most photographers now rarely see the office of the newspaper for which they work and rarely meet their picture editors as even calling-in for fresh stocks of film has gone by the way. This has led to the isolation of photographers to some extent in the news media. But the huge advantage that has been brought about, not just by digital photography but also by digital communications media, to my mind outweighs this.

be part of a picture's appeal, in which case they should not be removed. Therefore, although it is tempting to set the camera's white balance control to automatic it may be better to use the daylight setting except when you know this to be wrong. Alternative settings normally include one for domestic interior lighting (tungsten) and another for office interior lighting (fluorescent) as well as fine-tuning for cloudy and bright sunny days and a further setting for flash pictures. If you are using external flash lighting it may be better to use the daylight setting than the flash setting: you can always do a test picture at each setting and view the resulting images to see which one you prefer. Note that colour has both subjective and technical aspects to its appeal and the setting that is technically most correct may not always give the result that is most pleasing subjectively.

Colour space

The colour space setting, which will often be a choice of either sRGB or Adobe RGB but may also include other options in the case of high-specification professional SLRs and digital camera backs, defines how the colours recorded by the sensor are described. This is done using standard references so as to ensure that two different cameras record the same scene in as similar a way as is possible within the limitations imposed by the different sensor chips that may be used. Most compact cameras use the sRGB standard because this is the standard to which most computer screens and printers adhere so it ensures that images viewed on a computer and output on paper are likely to be a good match for the original scene. The Adobe 98 RGB standard allows a wider range of colours to be defined and is better suited to pictures that will be published in books and magazines owing to the way in which colours are created using inks on paper. You might think that surely the same comment ought to suggest that inkjet prints made at home should be of better quality if taken from Adobe 98 RGB files, because these too are composed of minute ink dots on paper, but the software used to translate an electronic image into a physical print is differently optimized in these two cases so the optimum colour space choices are different.

In a picture that combines both artificial and natural lighting it is worth experimenting with different colour settings to see which one gives the most pleasing effect, regardless of whether or not it is the most technically correct.

If you use a professional image editing program, such as Adobe Photoshop, then the software will make any necessary colour adjustments but if your program cannot identify different colour standards then you will find that anything other than an sRGB image is likely to lack depth and brightness. Therefore, even though the advice for professional users would be different, the wisest move is to set your camera to sRGB colour unless you are absolutely certain that a different option will give you better results.

One of the factors that complicates colour assessment is the adjustable brightness of the camera's review screen. Bright ambient lighting tends to force you to set a higher screen brightness but this loses the subtlety that the screen can display and makes visual colour assessments very difficult. It is a shame that no tool exists at present, similar to the exposure histogram and over-exposure flashing highlights warning, to indicate the technical quality of the recorded colour but at present this does not exist. This is why, when working under difficult lighting conditions, it is better to record raw-data files as these can be converted into whatever colour

space is subsequently desired after making careful colour adjustments on a computer screen away from the hustle and bustle of picture-taking.

Image review

As well as the Quick View setting that displays an image on the camera's screen for a short time immediately after capture there is also normally an entire sub-menu of options that controls how pictures are displayed post-capture. The simplest choice is normally between one picture at a time, full screen, or thumbnails of multiple pictures. When one picture has been selected it is often possible to inspect it more closely by entering Magnify mode in order to get a better idea about image sharpness. This is normally a two-stage process where one button or dial increases the magnification while another moves the image around so that different magnified sections can be viewed. Normally it is not possible to move to the next image until the current image has been returned to a normal, whole-frame view as the scrolling action (moving around a magnified image) is done with the same thumb-pad that is used to swap from one image to the next.

Single pictures can often be displayed as either image-only or accompanied by picture-taking information or an exposure histogram. The latter is useful because it shows whether or not the sensor was able to accommodate the full range of subject brightnesses. Often the most severe exposure problem in digital photography is over-exposure, which is more obvious than a loss of shadow detail caused by under-exposure. For this reason the advice is often to err on the side of under-exposure so as to avoid losing highlight details. A quick guide to the overall exposure is offered by an exposure-warning mode that often takes the form of flashing highlights if the picture is over-exposed. This is a very useful feature to look out for, especially if it can be activated in Quick View mode so that any exposure problem is identified immediately.

If the camera has an orientation sensor then pictures should always be displayed the right way up but if it does not there may be an option in the playback menu to rotate specific pictures. This is a handy option but it is a little time-consuming if there are lots of pictures to rotate so, if possible, it is better to buy a camera that has an orientation sensor and to activate this if necessary. The reason why you might want to have it switched off is that camera screens are landscape format so any image that is displayed upright will inevitably be smaller and therefore harder to view and assess.

As part of their image review menus some cameras allow direct printing of specific images or labelling of pictures with DPOF (Digital Print Order Format) information so that prints can be output later with a minimum of fuss. Direct printing is most likely to be provided via the PictBridge standard and it is worth checking whether a camera that you are thinking of buying supports this option: if it does then you might consider buying a PictBridge printer as well for maximum compatibility. Similarly, if your

It is a sensible precaution to review pictures immediately after they have been taken in case the camera's settings need to be changed to achieve a better result. The best review screens include, along with the image itself, a histogram that indicates how well the image has been exposed. More is said about interpreting histograms in the chapter dealing with basic image editing.

camera uses the ExifPrint standard, which was pioneered by Epson, then it makes sense to buy a desktop inkjet printer that can recognize this data as its purpose is specifically to improve image quality, which is always a good thing.

Other settings

Two settings that may be changed from time to time are the digital zoom setting and the interface mode.

Digital zoom

Digital zoom is a way of extending the lens's ability to close in on distant details by cropping the picture more tightly at the moment of capture. This is done either by simply discarding the outermost pixels of a picture or by doing this then interpolating the remaining pixels to keep the same overall pixel count. There is no advantage to either of these options, not only over each other but also over capturing a picture that has no digital zoom applied. The only exception to this comment is if you wish to print or e-mail the picture immediately without doing any further image editing on a computer. If, on the other hand, you do have the time and inclination

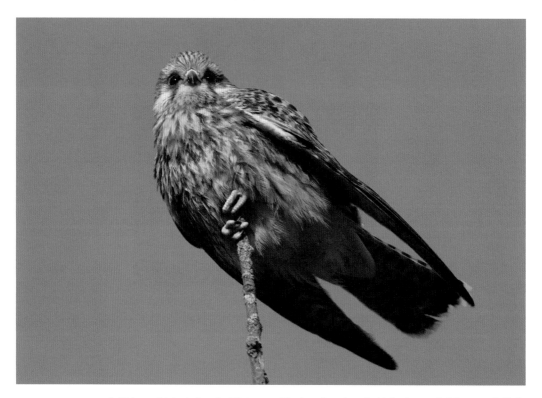

So high was this kestrel perched that even with a long-focus lens the bird only occupied the centre half of the picture. Thanks to a high pixel count it was possible to crop the image to remove the surplus sky and produce a result that is tighter-cropped than the original. It is always best to do this cropping post-capture rather than using the camera's digital zoom function (if one is provided).

to edit the image later then you will almost certainly be able to get a better result than the camera was able to provide. This is hardly surprising given the difference in processing power between a small digital camera and a stand-alone personal computer but it is still tempting to imagine that the digital zoom function offers a genuine advantage, which with the exception of greater convenience it does not.

Interface modes

A choice of interface modes will only be provided in the menus if your camera has multiple ways of connecting to other devices. In the early days of digital cameras there was only the old-fashioned RS-232 serial interface but later there appeared a choice between two faster serial standards: USB and FireWire (IEEE 1394). More recently, the advent of the even faster USB2 standard has made such choices largely academic and FireWire has become much less popular except with Macintosh computer users, for whom it lives on as iLink. Nevertheless, even Mac computers now support USB2 so there is little point in current cameras having two physical interfaces when all this does is to increase the cost of the camera.

There is, however, a growing move towards wireless connections. Kodak offered wireless cards for its professional digital SLRs many years ago and Canon unveiled a prototype digital compact with a bolt-on wireless (Bluetooth) unit back in 2000, but the trend nowadays is for Wi-Fi modules to be incorporated within the camera housing so as to avoid any additional bulk. In theory a Wi-Fi capability allows both file transfer and printing to be accomplished over short distances without the need for any cables but this does assume the existence of compatible hardware to receive the pictures. There is also currently an issue with battery drain and interference from other wireless devices but doubtless these things will improve as wireless technology becomes more common in general.

Approaches to wireless camera connectivity have advanced enormously in since Canon unveiled its first prototype Bluetooth camera in 2000. In September 2000 Kodak launched the World's first Wi-Fi consumer camera based on a SecureDigital (SD) Input–Output card and others have followed since.

Movies/motion pictures

Many digital cameras, especially compacts, are capable of recording motion picture images as well as stills. Typically the settings that relate to this mode allow vision-only or an accompanying soundtrack to be recorded: the settings may also allow a choice of pixel counts and frame rates. Higher pixel counts and frame rates result in better quality images but also produce bigger files that can fill a memory card very quickly indeed. In fact the memory card's specification, in terms of the rate at which it can store each of the images that comprises a moving-picture sequence, is another factor that limits the camera's video recording performance.

Reset

Perhaps the most important setting in every camera's menu is the master reset. This is used to restore the camera to its default settings and is invaluable if something seems to have gone wrong but you cannot work out which of the settings that you have changed is causing the problem. Obviously, however, activating the reset means having to go back through the menus and setting all the various options to your preferred modes. Some cameras also have a one-step-down reset function that controls which mode settings are remembered whenever the camera is switched off. This can be extremely useful if you like to have the flash unit turned off by default but the camera likes to switch it on. Inevitably, after you have done a master reset you will also have to reset the modes that are remembered by the camera when it is switched-off.

Memory cards

In *Digital Camera Techniques* (2003) I wrote at length about the factors that caused one type of memory card to be preferred over another and also warned about the likely demise of SmartMedia cards in favour of

In order to avoid possible problems it is best to format memory cards in the camera instead of doing this using a computer.

xD-PictureCards. This change has now come about but in fact the biggest battle now is between CompactFlash (CF) cards, which continue to be the medium of choice in most professional digital SLRs, and SecureDigital (SD) cards that are the common choice in digital compacts. The type of storage used in hybrid cameras varies. All types of cards now offer generous storage capacities and prices are fairly similar so there is no reason to favour one over another except for the fact that CompactFlash cards, being larger, are easier to handle – especially when wearing gloves.

All digital cameras have a menu setting that will format the installed memory card. In some cases it can be essential to format the card inside the camera, rather than formatting it on a computer, in order for it to work properly. This should not be the case if the hardware is fully compliant with universal standards but experience shows that universality is not always truly universal! In all cases, make sure there was no required data on the card that had not been copied off first as once the card has been formatted its data is lost – or rather becomes very difficult to retrieve. The best menus not only issue warnings that data will be lost before initiating the format routine but also provide information about the type of data on the card, such as the amount of space taken up by pictures and non-picture data.

This pseudo-candid picture was taken by available light so as to give the photograph an intimate feel: using flash would have produced a completely different effect (see smaller picture opposite).

Exposure and Focusing

The most important thing that digital photography has in common with film-based photography is a need to record pictures that are both correctly exposed and accurately focused. This chapter reviews these requirements in more detail than previously and also recaps some of the general principles that apply as there appears to be declining knowledge in this area. Nevertheless, this chapter is still not the whole story as far as focusing is concerned and readers should consult the technical chapter on optical quality (Chapter 15) to appreciate the finer details of some of the technical limitations that apply to digital photography.

In film photography there were two schools of thought regarding exposure. One proposed that the amount of light hitting the film, determined by the prevailing combination of exposure time (shutter speed) and lens aperture, should be such as to provide a fully toned negative. This meant

that if you held the negative up to the light there would be detail visible in every part of the image. The second approach was based on the idea that the exposure needed only to ensure proper shadow (minimum density) detail and that the film development process could be adjusted to provide the appropriate highlight (maximum density) detail. The second philosophy was made famous by Ansel Adams though it was actually co-devised by Fred Archer and Minor White, who penned the first book on the Zone System approach. Although these two approaches both have equivalents in digital photography it is generally more common, as it was in film photography, to aim for a good overall exposure at the moment of image capture rather than to rely on manual intervention at the processing stage.

Understanding exposure

The digital equivalent of a fully toned negative is an image that has data spread across the entire available range. The distribution of digital tone data is often represented on a histogram that plots the number (or percentage) of image points of a particular brightness against the intensity of that brightness. The scale goes from maximum black (0 on the digital scale) to maximum white (usually 255 on the digital scale). As with film, it is best not to rely on data at the very extreme ends of the scale, leaving a range of about 2–253 for data that can be recorded and recovered again later in the form of digital prints. Within this range, the data should be spread as widely as possible. The evenness of the distribution will depend on the nature of the scene being photographed and can vary enormously, and perfectly normally, within the desired range. The crucial point is that the data must naturally span the available tonal range and not be chopped off because it exceeds it, which is certainly possible under very bright lighting conditions.

The best digital cameras feature a histogram display function in their menu settings that lets you see how the picture data has been recorded straight after the moment of exposure. Remember that this fact cannot be assessed simply by looking at the image as a whole because camera screens are relatively crude devices that cannot render image data with the kind of accuracy demanded by discerning users. The screen's picture will be especially unhelpful if the scene is either high-key or low-key, meaning that it is composed mainly of either light or dark tones respectively.

The amount of light reaching a digital camera's sensor is determined by the amount of time for which the light is allowed to fall (the exposure time) and the brightness of the light. The former should correctly be referred to as the *exposure time*, or *time value*, but is often wrongly described as the shutter speed. This misnomer comes from the early days of film cameras, when the shutter was tensioned by different amounts depending on the exposure time required: this resulted in a change in the speed at which the shutter moved. Nowadays the shutter's speed is constant but the time interval between it opening and closing is varied. In the case of digital imaging the shutter needs to be closed before and after the picture is taken so that the

The perfect time to take pictures of floodlit buildings is when the overall exposure is between one and eight seconds for ISO100 with the lens set to f/8. Waiting until night has fallen results in a stark black sky and risks losing detail in the brightest parts of the building. The smaller picture here has also suffered from barrel distortion that is evident in the way the compact camera's lens has curved the building's turrets.

sensor can be emptied of any accumulated signal before the next image to be captured is projected onto its surface.

The brightness of the image will depend both on the amount of light falling on the original scene from the prevailing illumination and on the

size of the hole through which the light travels inside the lens to reach the sensor. Therefore it should be obvious that there are three factors (the scene illumination, the exposure time and the exposure aperture) that determine the brightness of the image that is recorded by the sensor. Assuming that the sensor has a fixed requirement for the amount of light it needs to achieve its maximum data level (which can generally be assumed to be 255) then it stands to reason that as the prevailing brightness of the scene varies according to the incident light intensity so too must the camera's exposure time and exposure aperture in order to provide exactly the correct amount of illumination that the sensor needs. It should also be obvious that there is not just one unique setting but rather a whole variety of possible combinations of exposure times and exposure apertures that will all be the perfect match for any given scene brightness. Finding the correct balance is a matter of exposure assessment, but choosing the optimum combination is a matter of interpretation on the part of the photographer – or the camera if it is used in automatic mode.

Hand-held exposure meters measure the amount of light reflected from a scene without reference to specific exposure time and aperture values but instead use a scale of exposure value (EV) numbers. Automatic cameras use these same EV numbers and convert them into specific exposure times and apertures using rules that are programmed into them: for this reason fully automatic exposure is often referred to as Program mode.

Pictures like this can be taken using a wide range of different aperture and exposure time combinations as they rely for their effect on the lens and composition rather than either movement or depth-of-field. Photograph © Maria Burridge.

Exposure balance

The exposure times used by stills cameras are based on a series of numbers where each one is half the previous one going in one direction and double the previous one going in the other. Starting at one second, the decreasing series runs 1/2s, 1/4s, 1/8s, 1/15s, 1/30s, 1/60s, 1/125s, 1/250s, 1/500s, 1/1000s, 1/2000s and so on. From the same starting point but going in the opposite direction, the increasing series gives exposure times of 2s, 4s, 8s, 15s, 30s, 60s, etc. There is one discontinuity in the halving and doubling pattern in each case but this is only to make the numbers more rounded and easier to handle.

Similarly, the exposure apertures also follow a sequence that halves and doubles but because the aperture is circular, and the area of a circle varies with the square of its diameter, the numbers used do not obviously show the expected pattern. In addition, for reasons that are explained in Box 4.1, the way in which apertures are quoted is related to the focal-length of the lens. The format used is f/x where f is the focal-length of the lens and x is the aperture number. The aperture numbers on digital cameras are normally within the range of the following values; 2, 2.8, 4, 5.6, 8, 11 and 16. The step by which these values increase is the square-root of two so it is not adjacent but alternate values that are either double or half of the preceding alternate value. For example, 4 is double 2 and half of 8: similarly, 5.6 is double 2.8 and (roughly) half of 11.

Nevertheless, because of the (squared) area effect each aperture setting passes twice or half as much light as the immediately adjacent settings: alternate settings, which are double each other, actually pass four times as much light (because double squared makes a quadrupling). Therefore it is possible to say that if the exposure time changes by one step in a certain direction, giving a halving or doubling of the time, then the aperture must be varied by one step in the opposite direction, giving a doubling or a halving of the amount of light that is let through, thereby giving the same accumulated brightness on the sensor.

Note, however, that in digital cameras it is common for the exposure time to be quoted in full, such as 1/250s, but for the aperture to be given as the aperture number alone, such as 11. Remember, however, that aperture values are related to the focal-length of the lens and the reciprocal of the aperture number so an aperture number of 11 passes less light (not more) than an aperture number of 4, for example. The following combinations of exposure times and lens apertures, which list settings where the amount of light passed by the aperture gets less as the exposure time is increased, will therefore all give the same image brightness on the sensor; 1/500s at f/4, 1/250s at f/5.6, 1/125s at f/8 and 1/60s at f/11. It is very easy to get confused by this, which is another reason why shutter or aperture priority modes are often a wiser selection than fully manual operation unless you are very familiar with photographic controls.

This rather flat picture was taken at dusk when the light level was very low indeed, as can be deduced from the lights in the distance. As the light level falls, so does the contrast in the scene. A tripod was used and two versions were photographed using sensitivities of ISO100 and ISO1600. The composite image compares small sections from these two pictures, revealing that the camera's noise reduction system has resulted in an overall loss of sharpness in the ISO1600 image (*right*) compared with the ISO100 image. This is an important side-effect of using noise reduction to compensate for a high sensitivity setting and proves why it is best, if possible, always to set a low ISO value.

This test examined the effect of deliberately under-exposing an image then lightening it afterwards using an image editing program. The three sections show: an under-exposed image that has been lightened (*left*), a correctly exposed image captured at a higher ISO setting (*middle*) and a correctly exposed image (*right*) taken at the lower ISO setting when the stage lighting was brighter. Close-up inspection shows that the higher ISO image contains more noise but there is little to choose between the other two versions. This means that slight under-exposure (equal to one F-stop) and subsequent lightening of an image can be a useful technique.

Choosing which combination of exposure time and aperture setting to use is a compromise between preventing image blur, controlled by the exposure time, and ensuring that everything important in the picture is recorded in-focus, which is determined by the lens aperture. A brief exposure time minimizes blurring but a high aperture number gives the greatest range of focus – and these two factors are in opposition as the sequence of equivalent exposure values given previously clearly shows. It is obvious that the sequence combines a short exposure time (such as 1/500s) with a low aperture number (4 in this case) – not a high number (such as 11) which would be preferred for maximum range of focus. Therefore the choice boils down to prioritizing blur over focusing, or vice versa.

Almost all digital cameras offer at least one way of prioritizing either the exposure time or the range of focus, which is correctly known as the *depth-of-field*. On the most basic level this is done via the subject or scene selection

Box 4.1 **Aperture and focal-length**

If you look at interchangeable lenses for digital SLRs you will notice that as the focal-length increases so too does the diameter of the front of the lens, even though the range of aperture numbers stays remarkably constant or may even get less for longer lenses. This seems contradictory with the idea that the diameter of the aperture through which the light passes inside the lens determines the aperture number, because if the diameter of lenses of different focal-lengths varies noticeably then surely their apertures should also vary. The solution is to be found in the fact that the aperture values are related to the focal-length of the lens in the form f/x. The result of the calculation performed by dividing the lens focal-length (f) by the aperture number (x) gives the size of the actual diameter of the aperture. Therefore, a lens that has an aperture of f/4 and a focal-length of 100 mm must have a physical diameter of 25 mm (100/4) whereas another lens that has the same aperture (f/4) but a focal-length of 200 mm will have a diameter that is twice as large at 50 mm (200/4). It therefore ought to be obvious that the longer the focal-length of a lens the larger the front of the lens has to be in order to capture the same amount of light as is captured by a shorter focal-length lens with the same aperture value. This in turn means that long focal-length lenses either tend to be much bulkier or they capture less light than other lenses with a shorter focal-length.

Canon EF 85 mm F/1.2L II USM lens, which has an exceptionally large front element and as such is capable of taking pictures under very low levels of light.

The simple way of rationalizing this is to observe that because long focal-length lenses are usually physically longer the light has to pass further through the tube and therefore the diameter of the tube must be increased so as to let the same amount of light reach the camera's sensor. This is a similar effect to that seen when driving through a tunnel: when inside the tunnel the far end is just a small circle of light but as you get closer the exit appears to increase in size and the lighting inside the tunnel gets brighter. A short lens is like a short tunnel in which the exit is always quite close to the entry point so seems bigger and brighter than the same size exit at the end of a long tunnel. The only way to make the exit of a long tunnel seem as large and bright as a shorter tunnel's is to make the exit much larger, which is exactly the pattern that is followed by the diameters of lenses.

This is the complete picture, taken of The Merge during a twilight concert, lightened after deliberate under-exposure by one F-stop. The image was adjusted using Paint Shop Pro with +30 units of brightness and +24 units of contrast.

options; sport/action mode prioritizes a short exposure time whereas landscape mode gives the greatest depth-of-field. More sophisticated cameras feature *shutter-priority* and *aperture-priority* modes, often identified as S (or Tv, for time value) and A (or Av, for aperture value) modes respectively.

When one of these modes is selected you have manual control over the exposure time or aperture and the camera then automatically sets the other one to give the optimum exposure conditions. As mentioned earlier, it is also possible for you to take full control over the shutter and the aperture by setting manual mode but digital cameras, excluding digital SLRs that are based on the traditional film-camera layout, are not as easy to use in this way as cameras were in the past owing to the greater prominence given to metering information in the older design. This is yet another reason why it is better to select either S or A mode depending on whether it is more important to control the exposure time or the depth-of-field respectively.

Acceptable blur

Exposure time is directly related to the amount of blur recorded in the picture because any moving object will change its position during the short interval while an exposure is being made. Even a stationary object can be blurred if the camera itself is moved: this applies both to random-direction camera shake and also to a progressive camera movement such as is used when panning (see Chapter 7 on action photography for more details about this technique). The easiest way to calculate the amount of blur that will be recorded is to find the time it takes for a moving object to cross the field of view then to divide this into the exposure time to get the fraction of the field of view that the object will cover while the exposure is being made. If, for example, a cyclist took 2 seconds to cross the field of view and a picture were taken at 1/1000s then it follows that the cyclist would move across 1/2000 of the field of view while the picture is being taken. This is a very small amount and might be so little as to go unnoticed, in which case we could say that the exposure time used was brief enough to arrest the cyclist's movement.

In the days of film photography it was usual to make some assumptions about the ways in which images would be viewed, then to combine these assumptions with known characteristics of the human eye in order to calculate the maximum permissible amount of movement that could occur during an exposure before the image appeared blurred. The same principles also apply to digital photography but with certain conditions.

The starting point for these calculations is always the resolution of the human eye: this is important because if the blur is so slight that it cannot be seen then to all intents and purposes it does not matter whether it is there or not. Analysis undertaken in Chapter 15 on optical quality leads to the conclusion that on an A4 print that is viewed at a comfortable distance of about 50 cm any feature that is smaller than one-fifth of a millimetre will probably go unnoticed. This provides a convenient way to work out the amount of blur that is permitted in an image before it becomes obvious.

If an image is printed so as to cover the full area of an A4 sheet of paper then the picture will be 297 mm long and the one-fifth of a millimetre area of unobtrusiveness will represent about 1/1500 of the width

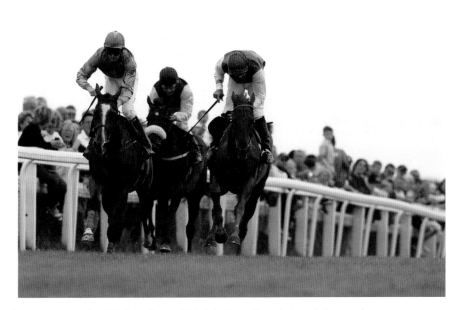

An object that moves across the field of view is more likely to be blurred in a photograph than one that moves directly towards the lens. On the other hand, one that moves across the field of view changes its distance very little and so is easier to focus on whereas one that moves towards the camera needs either carefully anticipated manual focusing or efficient automatic predictive focusing.

of the print. This means that the movement of the cyclist calculated previously (1/2000 of the field of view) is less than the critical amount and the cyclist will probably appear to be completely stationary in the picture even though it must inevitably have moved very slightly during the exposure.

Any parts of the cyclist that were moving quicker than the cyclist's forward speed, such as the tyres on the outside of the wheels and maybe the cyclist's legs, could still be blurred even though there is no overall movement. Not only is this a common sight but also it sometimes works in reverse to freeze motion that really should not be arrested. Propeller-driven aircraft are a good example in that a very brief exposure time will arrest the movement of the propeller blades as well the movement of the aircraft as a whole. This looks very odd indeed and careful thought must be given to the optimum exposure time that will suit pictures of old aircraft in flight. If such pictures are taken on bright days using Program mode then it is very likely that the camera will set an exposure time that is so brief as to freeze the propeller blades: it is therefore better to use shutter-priority mode and set a time that is no faster than 1/125s so as to retain some blur in the propellers. As the cyclist example illustrated, 1/125s is a very modest exposure time so you will almost certainly have to pan the camera to capture a sharp image of the aircraft itself at this setting.

Depth-of-field

As well as arresting movement, where appropriate, the exposure settings also control how much of the photographed scene is in focus. In theory it is only possible for a lens to be sharply focused at one specific distance away from the camera: this means that if you take a picture of somebody standing in front of a famous landmark then either the person or the background can be accurately in focus, but not both. An out-of-focus area can be detected by a lack of fine detail caused by a type of blurring that is symmetrical in all directions, whereas movement-related blur is most acute in a specific direction. In many cases it is desirable to be able to record high sharpness in both the foreground and the background, and despite the theoretical impossibility of this aim it is in fact possible to achieve this appearance in practice. This is possible because the different parts of a picture only have to be acceptably unsharp in order to appear to be sharp.

In exactly the same way that an estimate was previously made of the amount of movement blur that cannot be seen in a print, so the same principle also applies for focus blur, except that different amounts of softness (general blur) are acceptable or even desirable in different types of pictures. Portraits can withstand a small amount of visible softness in the form of lower resolution introduced by fitting a softening filter in front of the lens but hard-edged subjects such as modern architecture demand every trace of sharpness that the camera and lens can muster.

The basic technique for controlling the amount of unsharpness evident in areas that are closer to the camera or more distant than the object

The amount of depth-of-field required in an image depends on the range of object distances that exists within the picture and the extent to which different objects need to be recorded sharply in the final photograph. An essentially flat subject, such as the peeling paint shown here, needs only enough depth-of-field to accommodate the camera's focusing accuracy (this is discussed at length later in the book) whereas the garden hut and gate need a broad depth-of-field to maintain details in both parts of the picture.

on which the lens is focused is to adjust the lens aperture. A lower aperture number, such as 2.8 or 4, means that the region in which sharpness is maintained will be narrow whereas a higher aperture number, such as 8 or 11, will give a much wider region of acceptable sharpness. So when photographing landscapes that include foreground objects it is common to set a large aperture number. This in turn will mean using a longer exposure time but that does not matter in landscape photography because there is very little subject movement: what it does mean, however, is that you should use a tripod to avoid introducing camera shake (more details about this are given in Chapter 6 devoted to nature photography).

Similarly, if you want to photograph a subject that is in front of an untidy background then it makes sense to set a low aperture number, such as 2.8 or 4, so that the background becomes less distinct. This technique is harder to implement in digital photography than it was in the days of film partly because the smaller size of imaging sensors reduces the obviousness of focusing blur and partly because of the image structure of a sensor, which is regular whereas film has a random structure. Nevertheless, low aperture numbers do restrict the depth of sharpness in any picture. Conversely, if you want to have lots of sharpness in your pictures you should select aperture-priority (A) mode and adjust the aperture value to

By changing the composition of a picture it is often possible to create a much more striking result but in so doing the picture's depth-of-field requirement may also change so it is important always to consider these two aspects in tandem. Photographs © Victoria Byers-Jones.

a high number, such as 11. In theory there is a maximum amount of sharpness that can be obtained before diffraction effects start to mar the image but we do not need to worry about that complication here.

Focusing modes

One of the tools that many cameras provide to improve focus control is a choice of multiple focusing modes. Commonly these comprise a small-area option, a wide-area option and some combination of the two. The first is sometimes called *spot-focus* and may itself offer a choice of multiple small areas. Canon has for some time used a very sophisticated multi-point focusing system in its SLRs, both film and digital, wherein the camera illuminates a series of boxes to indicate exactly which part of the image has been used for focusing. Other manufacturers also offer multi-point focusing but not with as many different points as Canon uses: this is not necessarily a problem as it is not the number of points but the sophistication and controllability of the focusing system that matters most.

This picture is sharp in places but not overall and not in the most important areas! Ideally the snowman or the girls in Santa Claus costumes would be sharpest but in this picture the sharpest plane coincides with the boy sitting behind the girls. It is possible that the low-contrast snowman confused the camera's focusing system.

GUEST PHOTOGRAPHER: MICHAEL RUSKIN

Michael Ruskin is a keen amateur photographer who has been enjoying the delights of digital for almost a decade. He explains what it is that excites him so much about the medium.

After more than 50 years I can still recall my father's eager anticipation as he gathered together the bits of equipment and bottles of chemicals in preparation for developing and printing his rolls of black and white film. Equally I remember the inconvenience when the bathroom (the only suitable site for conversion into his darkroom) was out of commission for lengthy periods. I am sure that what appealed was the total involvement from the time of taking the photograph right through to producing the finished article.

In time he moved on to colour slides but, while there was still anticipation looking forward to the arrival of the little yellow packet from Kodak, the previous intimacy was missing, often replaced with disappointment when the outcome was not quite as expected. And oh the palaver finding the viewing box or, even worse, struggling with the projector and screen!

I personally would not swap either for the endless pleasures and variety provided by today's digital experience where, once again, one

Photograph © Michael Ruskin.

70

can feel 'in control' from the beginning of the process to the end. The digital world is one where disappointments can be forgotten as the immediacy of playback means that poor shots can be retaken and, with the aid of the computer, almost all faults can be corrected and where viewing can take place, again instantly, from the comfort of the armchair.

But, much more than that, there is also the satisfaction of being able to put one's photographs to some use, rather than just sticking them in albums to gather dust. With the variety of excellent programs available, birthday cards, thank-you notes and other creations can be produced using pictures that have meaning for both the sender and recipient, thereby putting an end to the frustration of finding cards with either suitable words or pictures, but rarely both.

And as for my other frustration (which proves just how amateur a photographer I really am) the reluctance to carry about what, to me, seems far too much equipment is forgotten when I can slip my Pentax Option into my top pocket knowing that I am set up for the day, able to switch, if needed, to a very acceptable telephoto or even video mode at the press of a button.

My father would be astounded at today's marvels but I am certain that his excitement would have been even greater – as is mine!

When *single-point focusing* is selected it is sometimes possible to adjust the active area manually, which is very useful when framing pictures with off-centre composition. This adjustment is often done using a thumb-pad on the back of the camera and can frequently be locked so that the pad is not knocked accidentally and the focusing area changed unexpectedly. Even compact and hybrid digital cameras frequently offer multi-point focusing, but with fewer points than are employed in digital SLRs, or have just one central small-area focusing region. In all cases it is normally possible to place the active area over the most important part of the scene and lock the focusing on that point by half-pressing and holding down the shutter release: the scene can then be recomposed and the picture taken by pushing the shutter release fully home. This half-pressure trick is also important because it speeds-up the camera's response when the time comes to trip the shutter, which can be a big help when photographing action subjects.

Linked to the area on which the camera focuses its attention is the priority given to achieving sharp focus. Early auto-focus lenses were awfully slow and even though speeds have increased enormously there can still be times when a lens is simply not quick enough to focus on a moving object, especially if the object has low surface contrast. There is a danger, when this happens, that the camera will not take a picture and the moment will be lost. In some situations you will not want the camera to prevent you from taking a picture and for this reason sophisticated cameras offer a choice between *shutter-release* and *focus priority*. The former

instructs the camera to take a picture the instant that the shutter is pressed, regardless of whether or not the camera thinks the scene is sharply focused, whereas the latter tells the camera to try to achieve sharp focus before allowing the shutter to fire.

A second refinement is the ability to switch between *single-frame* and *continuous focusing*. When single-frame is selected the camera checks its focusing for each individual picture but in continuous mode it assesses the object's movement and predicts how much the focus should be adjusted so that a second picture can be taken without the lens having to refocus afresh. Clearly this refinement is only important when pictures are being taken in quick succession, as individual pictures should always be focused separately.

Given that continuous focusing and shutter-release priority give the quickest response it is tempting to assume that these settings should be selected when working in a quickly changing situation but in fact they date back to an era of slower cameras and risk sub-standard image quality so should really be avoided. In general the best settings to choose are focus-priority with combined wide-and-spot evaluative focusing. This is the system that Canon's digital SLRs use by default with great success.

Exposure solutions

Many cameras offer a range of options for assessing the correct exposure to be used for any given scene, including spot-exposure and evaluative exposure modes that are analogous to the focusing modes explained above. As before, the evaluative option is often the best one but it can also be very useful to be able to measure the exposure recommended for an individual element in the scene if it is important and has a significantly different tonal value to those of its surroundings. This is where spot-mode metering becomes useful. In many cases the same areas will be used for focusing as for exposure but you should find, if you have a well-specified digital SLR, that there is a custom function setting that enables you to separate these two operations. This can be useful in some situations but in general it is often best, especially when using evaluative metering and focusing, to link these two measurements.

Image processing

At the beginning of this chapter, while discussing the two different approaches to exposure, it was said that despite all the sophistication provided byin-camera metering it is sometimes useful to be able to process the image after capture. In the days of film this was done by varying the development but in digital photography it is made possible by capturing images in raw-format mode. Although image processing is a software technique, and could be confined to those chapters in this book, it makes

Church interiors are traditionally difficult subjects and this one is no exception. On-camera flash tends to do more harm than good because of the large number of polished metal surfaces that often exist. Similarly, when the sky is very light outside the windows are often too bright for any sensor to record detail in them. In the days of film this was overcome by using adjusted development; in technical digital imaging it is handled with multiple exposures of different durations but in everyday photography the only answer is to compromise so as to retain as much detail as possible at opposite ends of the tonal scale. The smaller pictures are bracketed exposures with one F-stop more and one F-stop less exposure.

One of the worst offenders for ruining low-light pictures is a camera's automatic flashgun. This is an extreme example but it makes the point: there is no use in heeding a camera when it flashes a warning light to say that the dim ambient lighting requires additional flash illumination when to use flash would mean losing the picture completely. The only real answer is to mount the camera on a tripod and ignore the camera's 'low light' indicator.

sense to start to talk about it here. Sadly, if your own camera lacks a raw-format option then this technique will not be available to you.

Digital processing is made possible by the fact that sensors often capture more information than is stored by default in common image-file formats. As a result, the camera does the best job that it can of selecting the most important information from all the available data and then stores this in

one of the standard file formats (JPEG or TIFF). Kodak's ERI (Extended Range Image) technique, which was mentioned in Chapter 3 on menu options, appends the additional information to a standard JPEG file so that compatible software can recover data that would otherwise be lost. Kodak, like many other digital camera manufacturers, also offers its own unique raw-format option in which the data captured by the sensor is stored without any significant amount of interpretation. This means that all of the captured information can be inspected later and optimized with the benefit of the photographer's input and the greater processing power of a desktop, or laptop, computer. It is still often necessary to define the image using only 256 levels of information (digital values from 0 to 255) but now you are able to decide whether it is better to compress a wider range of data or simply to chop off some of this data. You can also adjust the overall exposure so as to lighten or darken the image overall and can tune its colour balance, then apply your preferred settings to a whole collection of pictures at once if so desired.

Effectively, recording images in raw format gives you the power to control the exposure to a limited extent after the picture has been taken. So very useful is this ability that any camera offering a raw-format option should be given serious consideration over other cameras that lack this feature. Never forget, however, that using raw mode is a more time-consuming process in terms of the post-capture efforts that you will have to apply to get the best out of the image. With that in mind it is possible to state that there will be some pictures that do not justify using raw mode, so choose the capture mode wisely in order to avoid being forced to undertake extra work that you may come to resent.

This picture of a girl taking part in a historic re-enactment is a fine example of a spontaneous portrait. The warm glow was added after the picture was taken with the intention of suggesting a sunset when in fact the photograph was taken mid-morning.

People

By far the most popular subject for photographs worldwide is people. It is therefore fitting that the subject-specific section of this book starts with pictures of people and that this topic provides most of the content for Chapter 8 on studio photography as well. These two chapters are distinguished by the types of photography involved. In this chapter the techniques discussed are lightweight and should not intrude too much into whatever it is that is being photographed: in Chapter 8 photographic techniques dominate. To a degree, therefore, the types of situations covered in this chapter are easier to get to grips with, especially since a large part of the studio chapter concerns not only camera work but also lighting techniques as well. In addition, the situations covered here ought to be within the capabilities of even the most basic digital compact camera whereas a more sophisticated and controllable camera, almost certainly a digital SLR, would be advisable for tackling the later techniques.

Babies and children

Spontaneity is the key when photographing babies and young children. The ideal camera is one that is always ready and easy to use. This is likely to mean a small-size (convenient to carry) point-and-shoot compact that can be relied upon to take good pictures with a minimum of fuss. At home, the first hurdle to taking pictures is often being able to lay hands on the camera quickly and it is sensible to have a place where the camera is always kept. The second hurdle is likely to be battery power, which can be guaranteed by keeping the camera in a docking station that also acts as a charger for the camera's internal battery. This is a solution that several digital camera manufacturers have adopted and even extended, in Kodak's case, by the inclusion of a small-format printer in the cradle housing.

Once the camera is in your hand the golden rule is to take a picture straight away: only after an initial picture has been taken should you start to think about ways to improve the picture, such as by changing the lighting, your position or the environment. That said, it is important that you do think about these things because the factor that turns a lucky snap into

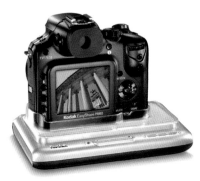

Cameras that have matching docking stations, such as this Kodak EasyShare model, have the dual advantages of being easy to find and always ready to use.

a good photograph is the ability of the photographer to accentuate the important parts of a picture and to minimize the effects of any distractions within it.

Therefore your motto when photographing babies and young children, and other subjects over which you have little or no control, should always be: 'snap first, improve afterwards'.

Box 5.1 Posing children

Children are often photographed most successfully when they are otherwise occupied. A child who is simply standing still or looking at the camera could seem happy or sad, pensive or in distress, but give a child a toy and not only will its facial expressions become more animated but also the toy itself will add a sense of context to the picture. Be warned, however, that when a child has a toy in its hands it will often look downwards towards the item, making full-face photography very difficult. The trick used in photographic studios is to have the toy held by an assistant, who stands close to the photographer but out the camera's line of sight so as to attract the child's attention.

If picture-taking is to be undertaken in a casual environment then thought must be given to the surroundings before the child becomes distracted. For example, there is little point hoping to get a nice photograph of a child opening a birthday present if he or she is standing directly in front of a television set that will create a nasty reflection in all pictures taken using flash. Similarly, if a child has a favourite place to sit then it may be possible to do a little 'gardening' around that area to make it a more suitable photographic background. And if you do resort to physically posing a child, perhaps by sitting him or her on Grandma's lap, bear in mind that many children do not like sitting still nor being held in position for long, so you really must take your pictures very quickly indeed.

When you are unsure whether a particular picture would be best done with or without flash, take both versions and choose between them later. Events such as cutting a celebration cake can often be held-up for just a moment to allow a second picture to be taken.

Making improvements

The first area for improvement is likely to be the *lighting* used. Most digital compacts switch on their integral flash units by default when powered-up so it is probable that your snapped picture, especially if it is taken indoors, will be taken using flash. This has three unfortunate side-effects; it can create unflattering and over-white skin tones, it can make backgrounds rather dark, and it can create unsightly highlights on highly reflective surfaces. The last of these three things can be improved by retouching later, as can the other two to a lesser extent, but it would be better not to have to contend with these difficulties.

If any of these problems arises the immediate answer is to switch off the camera's internal flash unit. Often this can be done via a dedicated button that offers a choice of different flash modes, including automatic, full power, anti-redeye, night scene and off. These various settings were discussed at length in Chapter 2, which deals with camera features, so at this stage it is sufficient to recap the most important aspects as they apply to photographing babies and small children.

Assuming that the camera's default setting gives automatic flash operation, the other settings that can be useful when photographing babies and young children are anti-redeye and off. The former is useful not just as a way of reducing redeye, which is a very unflattering effect, but also because it emits a series of low-power flashes before the picture is taken and this can serve to attract or hold the attention of an otherwise easily distracted child. Unfortunately, this trick is only likely to work a couple of times so choose your moments wisely!

Switching off the flash unit means that pictures will be taken using the prevailing lighting, which is the same illumination as that with which your eyes view the scene. The good thing about this is it means that pictures taken in this way tend to look more natural: the bad thing is that the pictures may

Photographing a baby from its own eye-level or slightly above (*top and middle*) creates a very different effect from looking down from an adult viewpoint (*bottom*).

be blurred. Very slight blurring, which tends to make pictures look a little bit soft – as if they are slightly out of focus – is not necessarily a problem but severe blurring can ruin a picture completely. Happily, digital cameras score highly here thanks to the fact that pictures can be inspected immediately after they are taken and the extent of any blurring can be assessed at once. If severe blurring cannot be avoided then the answer may be to switch the flash unit back on: the alternative option of increasing the camera's ISO setting is trickier to assess and ought to be a decision that is made in isolation rather than in the midst of picture-taking. For that very reason this topic is covered separately in Chapter 4, which deals with exposure.

When taking pictures indoors with the camera's flashgun switched off you must hold the camera as still as possible in order to minimize blurring due to movement of the camera. Blurring due to movement of the sitter is harder to control when photographing babies and young children (which is why Victorian studio photographers were forced to use braces that held sitters firmly in position while a picture was being taken).

Making improvements – outdoor lighting

Lighting is just as important when taking photographs outdoors. Soft non-directional lighting, such as is seen on an overcast day, is very flattering but bright sunlight is not. This may seem contrary to expectations: certainly many a wedding photographer curses the same bright sunny weather that causes guests to comment on what a beautiful day it is. The reason for this is the darkness of the shadows cast by direct sunlight and the effects of these shadows in making people squint or accentuating wrinkles and skin blemishes.

Ironically, it can be useful to switch a compact camera's flash unit to full power in situations where the child being photographed is wearing a sun-hat that casts a strong shadow or is facing into the sunlight and suffering from shadows in his or her eye-sockets. This technique is known as fill-in flash and may even be offered in your camera's flash menu as such. In days of old photographers needed considerable skill to get the best results when using fill-in flash but the low power of many digital compacts' flash units means that they can simply be switched-on at full power and are unlikely to have any visible effect that is not an improvement over pictures taken using direct sunlight alone.

A simpler solution is to move the child into the shade, such as might be found under a beach umbrella. This would probably be a sensible tactic for the child's well-being in any case but has the added advantage for photography of creating a soft and relatively shadow-free lighting effect. Be aware, however, that any background beyond the shaded area is going to be very much more brightly lit and could therefore cause large areas of whiteness in the finished picture. This can be very distracting and is an area in which digital compact cameras often perform less well than a compact camera loaded with film.

This is an extreme example of the post-capture tidying that can be done to a picture. The original photograph was a spontaneous portrait that was subsequently cropped and masked to give a more formal feel in order to create a picture that could be used for identity purposes (in this case, a driving licence) without – of course – changing any of the person's facial features!

Making improvements – positioning and environment

Talking about moving the child into a shaded area leads neatly on to the second area of improvement that is likely to result in better pictures of babies and children, which is position. This refers to the position of both

the subject and the photographer. A young child who has sunk down into a deep sofa may look very cute but might also benefit from being lifted up and placed down again on top of a fresh cushion. Similarly, if you enter a baby's room and see it sleeping in an extremely appealing or amusing pose then obviously you should take a picture at once but if the camera angle means you are looking down onto the baby or facing straight up its nostrils then clearly a second picture should be taken from a different position.

The biggest positional improvement is likely to come from dropping your own position down to the level of the baby or child. This puts the child on a more equal footing and allows the picture to emphasize the child's individual identity. The second most important improvement will come from changing the lens setting and your proximity to the child: getting very close can result in distorted facial features and inevitably means distracting the child whereas staying further back and moving the zoom lens to a telephoto setting often results in pictures that look more natural on account of both the photographic perspective used and the degree to which the sitter acts independently of the camera.

Another reason for wanting to change your position is the location of objects in the environment that you cannot move. For example, a baby sitting in a high-chair in front of a window beyond which there is a brightly lit garden presents two very common problems: the bright outdoors might confuse the camera's exposure meter (leading to the baby being rendered too dark) and the window is a highly reflective surface that will create a horrible bright spot if the picture is taken using flash. The answer, if possible, is to turn the high-chair around and position yourself between the window and the baby so that the light comes from behind you. Alternatively, try arranging the high-chair at a slight angle so that the light comes from over one of your shoulders (a favourite piece of lighting advice that is as old as the Kodak Box Brownie camera).

While doing all of these moves it makes sense to do a bit of tidying-up at the same time. A brightly coloured mug or dirty plate on the high-chair's table can be very distracting, no matter how natural you may think it is. Indeed, the dilemma about whether it is better to photograph a truly natural scene or to improve the environment is best resolved by thinking about what the picture is meant to show. If it is a portrait of the baby then a cleaner picture is likely to be better whereas if it is to show off a bib that was given as a present then maybe it would be better to reveal how effective the item of clothing has been.

Candids

Although some of what has just been said may seem to qualify many pictures of children as candids, in reality a candid picture is often only a single frame that is taken without anybody realizing that a camera has been in action. Some people dislike the idea of candid photography, fearing that it borders on intrusiveness, but at their best candid photographs

This is a true candid picture in the sense that the young women had no idea that they were being photographed and went about their conversation uninterrupted.

provide an invaluable record of a moment in time. Henri Cartier Bresson described the essence of photography as a search for the 'decisive moment': candid photography and its cousin, street photography, are perhaps the purest distillation of this search.

Trying to decide whether or not any specific candid or street photograph succeeds on the level that Cartier Bresson envisaged is a matter of subjective judgement and for this reason such pictures often divide viewers. One person's amusing situation may be another person's embarrassment so it is wise to tread carefully when engaging in candid photography. This is especially true when photographing children that are not your own: I have personally been accosted more than once when taking pictures that I thought illustrated the innocence of children at play simply because somebody else thought my own motives were less innocent. This is an awkward situation for any photographer to encounter and the best advice can only be to avoid taking pictures of other people's children in public places unless you have previously secured their consent (in which case, of course, the pictures are likely to be rather less candid and the object of the exercise may be defeated). The same is also true if you take pictures of adults in situations that might cause concern.

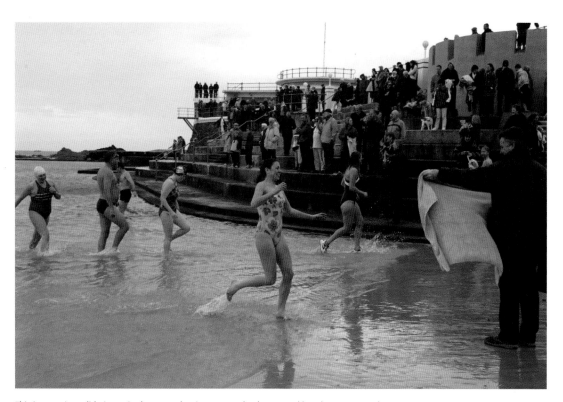

This is a semi-candid picture in the sense that it was completely unposed but those portrayed were participating in an event (Jersey's annual Christmas Day swim) that is regularly photographed.

One solution to this problem might seem to be to move further away from the subject and adjust the camera's zoom lens to a telephoto setting so as to close in on more distant details. However, this is equally, if not more, dangerous than working at close range because it suggests an air of sub-terfuge. In fact the safest type of candid photography is done in a situation where people expect to be photographed and don't mind being caught slightly unawares. Weddings and family gatherings are good examples.

Having found a suitable environment the secret of good candid pho-tography is not to raise the camera to your eye when taking pictures. You might think that digital cameras, some of which have fold-out or multi-angle LCD screens, would make this easier but in fact the traditional advice has to be clarified for digital camera users. As well as not holding the camera to your face you must also avoid looking at the camera because people follow each other's gaze and if you look at the camera to compose a picture then the people in front of you may spot what you are doing. So be brave and shoot from the hip. The great thing about digital photography is the absence of film costs, so if the majority of your candid pictures don't come out it doesn't mean you have wasted your money. Not only that but also the review screen means you can disappear into a

This is not a candid picture at all since the people in the picture were asked for their permission to be photographed. It is, however, 'candid style' in that the poses were unchanged and no attempt was made to direct the picture.

corner to check your pictures then re-emerge to have another go after seeing how you got on previously. Finally, and at the risk of stating the blindingly obvious, do make sure that your camera's flash is turned off before attempting any candid pictures!

Groups

It is not very common to want to take formal group pictures of people but when the need arises there are a lot of expectations riding on your ability to produce a good photograph so it helps to know some of the tricks to use.

The first thing to realize is that 'firing squad' pictures, where everybody is lined up straight across the picture, tend to look awful. Fortunately, tactics for dealing with this situation are seen daily in newspapers and magazines. One trick is to get different levels by having some people squat, kneel or sit on the ground while others stand behind. Another solution is to bring some people forward of the main group – perhaps a bride and groom with well-wishers behind. Alternatively you might consider a completely different approach, such as getting everybody to lay on the ground

This family portrait is a traditional group picture that was deliberately arranged with the sunlight coming from behind the group and using on-camera flash to provide frontal illumination. The result is much more attractive than would have been obtained if the sunlight had been directly on everybody's faces.

with their heads together then photograph their faces coming into the pictures at every different angle. The last idea suits less formal groups especially well, such as dance troupes or groups of actors.

The next thing to think about is props. At a wedding the bride and groom wear their props, as would a sports team. If the group is of work colleagues you might arrange to have an appropriate backdrop, such as the building where everybody works. The prop might also be something that somebody holds, or holds on to if it were a horse, for example. Remember that a group of people is normally brought together by something that they have in common and it makes sense, if at all possible, to include this thing in the picture.

The lighting across the entire group should be as uniform as possible. Once again a shady tree can be useful outdoors on very sunny days but flash is unlikely to work well because the low-power units that are contained within digital compacts rarely have enough brightness to cover a reasonable size group. This problem gets even worse if you find yourself having to move back to get everybody in the picture. You will also find that if you have moved some people forward from the rest of the group

then the camera's flash will be incapable of giving the same amount of light to everybody, so either the people at the front will be too light or the ones at the back will be too dark. This problem is not as serious when using a digital-SLR that is fitted with a more powerful flash unit and superior metering but even so, once again, you might like to think about switching-off the camera's flash and asking everybody to hold still to get a more natural looking result.

Don't forget that digital cameras normally have a self-timer function somewhere in their menus so there is no excuse for not including yourself in the picture. Or rather, there is no excuse provided that you have given some thought to how the camera will be secured if you are not there to hold it. The best answer is a small tripod or clamp that can support the camera on a flat surface or by attaching it to a ledge, bar or tree branch. Such devices are especially useful when going on holiday as this is one time when you are very likely to want to be able to include yourself in some of the pictures. Beware, however, that some multi-purpose camera supports have a spike on one end and may not be allowed in carry-on aircraft luggage so make sure that you place them in your hold bags as a precaution.

When taking portraits that have a context, whether they are of an entire group or just one person, is very helpful to have some clues in the picture to hint at what the context might be. This is a portrait of John Goldsworthy, who is an official at Wycombe Wanderers Football Club.

Events

A special sub-section of children, candids and groups (not to mention still life, which is covered in Chapter 8 on studio photography) comprises all the events that people like to remember: birthdays, graduations, weddings, etc. As well as people-centred pictures there are also opportunities to take pictures that are specific to the event itself, such as cutting a Christening cake, for example. If you are inclined to record them then, with a bit of luck, you may find that you have more control over these moments than you do when taking more general pictures. It is quite reasonable to ask people to pause while you get into a better position before they blow out the candles on a cake, for example. It is also possible that you will be able to prepare the spot where a particular event will take place so as to increase your chances of getting a good picture.

As before, lighting will be a primary concern, closely followed by the location of any highly reflective surfaces if you will be using flash. Bear in mind that flash will swamp less intense light sources, such as candles, and that you may be forced not to use flash if you want to capture the atmosphere of a special moment. This is turn could mean using a long exposure time that risks having the image blurred, so ruining the resulting picture. In these circumstances it can be useful to select the slow-sync or night scene flash mode, if your camera has this option. But be warned: do not try this for the first time on an important occasion in case the results are not to your liking!

A good tip when photographing people indoors at an event, or indeed in any situation, is to think about using indirect (bounced) flash. This is only possible if you have an external flashgun that either has a swivel head or can be hand-held and pointed up towards a white ceiling. The light will then scatter from the ceiling and illuminate the scene from above, creating an effect that is reminiscent of natural outdoor lighting on a cloudy day. Provided that the flashgun is mounted in the camera's hotshoe and is fully compatible with the camera's automatic exposure system you need not worry about any of the technicalities that are involved in this technique.

Events can be fun as well as formal, in this case something as simple as a trip to the hair-dresser. Using the screen on the back of the camera to compose the scene has enabled the camera to be positioned more freely in the picture than if it had been necessary to look through the viewfinder directly.

Bounced-flash was used for this portrait of baby Nerissa and granny Jacqui, which means that the flashgun was turned so that it was aimed not directly at the subject but at a nearby white wall (in this case) or ceiling. The surface scattered the light to provide a softer and more natural illumination than would otherwise be obtained. The distance travelled by the light from the flashgun to the subject (A + B in the accompanying diagram) is further than via the direct route (C) so its brightness is diminished: modern digital SLRs used with matching accessory flashguns, which feature the swivel-and-tilt movements needed for bounced-flash work, can allow for this automatically.

Events are also a good time to get photographs of people who might not see each other very often, perhaps because they live in different parts of the world and have come together just for this one occasion. This being the case, do not be afraid of taking people outside or into a larger room to get a really nice group portrait instead of cramming everybody around the sofa and having to contend with the limitations that this will impose.

If you cannot benefit from full automation then a quick and largely successful technique is to set the camera to ISO100 sensitivity and the flashgun to full power, then to select the lens aperture number that is calculated by dividing the flashgun's metric guide number (which will probably be a number between about 28 and 45) by the distance from the flashgun to the subject via the reflecting surface. Despite being a very simplistic approach this technique works well and can always be checked by reviewing the image just captured on the camera's LCD screen. As was mentioned earlier, more information about lighting techniques is given in Chapter 8, in the context of studio photography.

Holidays

Right at the other end of the picture-taking spectrum are holidays, which are occasions when almost nobody wants to spend much time thinking

Holidays provide an ideal opportunity to photograph people engaged in activities, especially at tourist sites where these things are provided as photo-opportunities. As would be expected, the camera's flashgun was switched off for this picture of a glass-maker at work so as not to spoil the natural effect of the torch's flame.

about photography. In short, holiday photography should be as easy as possible – so make sure that you have read your camera's instruction book and beware of buying a new camera specifically to take on holiday.

Just as important as the ease of use of a camera is its durability, especially if pictures will be taken on beaches or while skiing. Photographers who already own a digital camera that might not be rugged enough to survive safely in an electronics-unfriendly environment should consider buying a suitable housing. Often these are designed to allow cameras to be used at modest depths underwater but they also provide all-round protection against the elements. Several digital compacts have matching housings so check to see whether yours is one of them before risking it in a potentially damaging environment. If, on the other hand, you are in the market to buy a new camera (and are sure that you will have sufficient time to familiarize yourself with it before going on holiday) then by all means consider one of the more rugged, weatherproof models if you think you will spend some of your time taking pictures under inclement conditions.

The mechanics of photographing people on holiday are no different from those of any other type of photography except that the location is often of prime importance. There is little point in taking your own picture of St Paul's Cathedral, however, if your version is virtually the same as the image available on postcards, which may also have been taken in better

When visiting landmark attractions it is a good idea to put yourself or a family member in the picture to record the people who were there. In years to come it will probably be more interesting to look back at how the people have changed rather than simply to look at the landmarks themselves.

weather and from a slightly better vantage point. It is far cleverer to do one of two things: either make sure that you or members of your party are in the picture or try to go for an unusual angle or detail when photographing a well-known landmark.

If you do go for putting a person in the picture, try not to place your subject dead-centre: a favourite tactic is to place a person or people to one side of the frame and show the famous sight or landmark in the other two-thirds of the picture. It used to be difficult to keep everything in the picture sharp when such pictures were taken on film but the smaller sensor size used in most digital cameras reduces the severity of this problem. Here too, as before, it is often best to switch off the camera's flash unit except, of course, when photographing landmarks at night.

The camera's integral flash unit will definitely not have enough power to illuminate a distant building or statue but it will light the people standing in the foreground. The danger, therefore, is of having well-exposed people but a pitch-black background. Fortunately, this is a common situation that is akin to the candles problem mentioned earlier and the same slow-sync or night mode flash setting could well be the answer here too. When this mode is selected the camera's flash will fire and then the shutter will remain open afterwards to record natural light from the scene in the background. Once again it will be necessary to support the camera on something steady (a clamp may be more convenient than a tripod when on holiday) in order to avoid getting a partially blurred image.

Finally, there are a few practical considerations to bear in mind when thinking about holiday photography. The first is to make sure that you take plenty of memory cards with you as it may be difficult (or very expensive) to buy the right type in a foreign country. The second is a similar thought about battery power: if your digital camera has a dedicated battery charger make sure you remember to pack it! A small number of digital cameras can also operate using universal rechargeable cells and if yours is one of these then it makes sense to take some spare batteries of this type in case the others fail.

Last of all, the best holiday pictures are taken by people who recognize the limitations of their cameras and their own desire not to be weighed down by a multitude of accessories. Your digital camera's manufacturer may well offer supplementary lenses that let you take wider views or get closer to distant subjects than would otherwise be possible but often it is nicer just to carry a pocket-size package and settle for taking pictures that suit the basic camera. Similarly, don't worry about trying to get the best quality settings for every situation: simply set the camera to fully automatic and, if possible, select raw-file format because this option gives the greatest versatility for improving the pictures when you get back home. Until then you should concentrate on enjoying your holiday!

Lily stamen photographed using a Sigma SD9 digital SLR with Sigma 105 mm macro lens. The lighting was provided by a home-made twin flash system. Photograph © Dr Andrew Stevens.

Nature

This chapter covers animals and birds, natural landscapes and close-up photography. These are all areas that require careful consideration to obtain the best pictures and are also areas where there are often elements that are beyond your control. It might seem that flowers, for example, can be cut and positioned however seems best but ultimately you are limited by the way in which the bloom has grown and developed in relation to the rest of the plant. As is true in other areas of photography, starting with the perfect subject is the best way to get the highest chance of ending up with the perfect picture.

Although there are exceptions, nature photography is almost always undertaken in colour and should be free from potential spoilers such as grain in film-based photography and both noise and Moiré effects in digital photography. It is also necessary to think carefully about the position from which pictures will be taken, the best lens (focal-length) to use and factors in the environment that may detract from the main subject of the picture.

Domestic animals

Most people will try to photograph a pet at some time or another. Sleeping pets are an easy subject, but there is always a chance of the creature seeming dead. Such pictures are therefore last resorts rather than first choices except, for example, when the pet happens to be sleeping in an unusual place. Even so, amusing locations are best exploited photographically using a pet that is very much awake. Some years ago there was a surplus of images, many seen on greetings cards and calendars, depicting kittens peering out of vases, flower-pots and knitting baskets or playing with shoes, balls of wool and each other. Although these images are now rather dated commercially they still provide ideas for ways in which pets can be arranged in a deliberate manner, assuming that your pet is willing to play along with you. In all cases it is best to have an assistant to handle the pet because you are very unlikely to be able to do this yourself at the same time as taking pictures.

It is much more likely that you will want to photograph your pet while it is engaged in an activity of its own choosing. In some instances the crucial factor will be how quickly you can lay hands on a camera in response to some spontaneous photogenic behaviour. In this situation you need a camera that can be used quickly and with a minimum of fuss. You might also want to switch off the camera's integral flash unit if it is not strictly needed as the harsh lighting that it gives will probably be as unflattering to your pet as it would be to a person. This comment is significant because the basics of successful pet photography are the same as they are for babies and young children: snap first and improve afterwards. This applies just as much to a hamster on its wheel as it does to a dog stealing a morsel from the kitchen table.

If you are lucky you may be able to get your pet to repeat an action if you failed to photograph it the first time. This can be especially useful when larger pets are playing out of doors and you want to move around to get the sun at a better angle. It is worth bearing in mind, however, that if you are only wanting to remove a distracting red children's bucket and spade from the background then maybe these elements should be removed using image manipulation rather than risk distracting the pet from its activities.

Domestic animals often have predictable modes of behaviour that can sometimes be very photogenic – even if, in this case, the behaviour is not very hygienic!

If a pet is sleeping outdoors you may be able to persuade it to open its eyes and maybe even prick up its ears if you draw near to take a picture. Beware, however, that the pet may simply get up and move off if it feels that you have invaded its privacy. Similarly, an unknown pet may become aggressive if cornered so approach strange animals with extreme caution, no matter how docile and cute they may look from a distance.

The best practical tip for getting good pictures of pets is to get down to their own level: do not simply photograph them from above looking downwards because, as with young children, this robs the creature of its individual identity.

Farm animals

The same tip regarding level applies to larger semi-domesticated animals, such as horses, except that it in this case the creature's head is likely to be very close to human head-height anyway. Although horses, ponies and, to a lesser extent, cows are appealing subjects it is perfectly possible to take striking and successful pictures of other animals, including pigs and chickens, for example. Eye-contact works well in many cases and any coloured plumage or markings should normally be clearly visible.

This picture works especially well because of the complementary-colour background. Taken at the Jersey Lavender Farm using an Epson PhotoPC-850 Z digital compact.

Larger animals have their own environments that make excellent back-drops for photographs. Stables, cow-sheds and even pigsties can all create striking pictures and benefit from using available light rather than on-camera flash. It is not even necessary to get close to the animals. For example, you might see a field with a mass of pig shelters stretching into the distance and the geometrical patterns that these create can be an interesting picture in its own right; so too can white sheep scattered across a green hillside. It is often a good idea to include the surrounding landscape as part of the image, although always remembering that the animal is the main subject of the picture. So one might photograph horses sheltering in the corner of a field or cows leaning over the fence waiting to be herded in for the night. Effectively these are pictures of country life as well as of the animals themselves and embody the much wider meaning of nature photography.

Animals in zoos

The environment is much more problematic when photographing animals that reside in zoos as in this case, if you want your pictures to look more natural, there is a balance to be struck between including some of the surroundings but excluding anything that immediately identifies the location as a zoo. If your intention is to show the zoo environment, of course, then obviously your approach must be somewhat different.

Politically, zoos have suffered in recent years having lost their primary purpose as collections of animals to educate people who had never traveled abroad and, prior to the advent of high-quality wildlife television programs, had never seen the movement and scale of anything other than native creatures. Now that we have become accustomed to these alternative ways of learning about animals it has become fashionable in some circles to portray zoos in a negative way, emphasizing the extent to which animals are caged. The best zoos have addressed these criticisms and have relinquished animals that they cannot house in comfort. They have used the space liberated to extend the compounds for other animals and have even established uncaged areas for some creatures. Zoos today are places where animals should be happy and, in the case of endangered species, bred to support their existence in the wild. This being the case, photographs of animals in zoos should now fairly reflect a positive environment and show animals engaged in meaningful activity.

The fact that compounds are larger means that it will often be necessary to use a long focal-length lens or zoom setting than before. On the other hand, it also means there is a better chance of not having to peer through a wire mesh as the larger compounds usually have a moat or other distance barrier to ensure the safety of visitors and animals alike.

A good zoo may offer a members' scheme to support its activities, giving free or discounted access to the facilities. It may also issue a newsletter with details of events, which will provide ideas for what might be good

Zoos that have large outdoor enclosures often require the use of long focal-length lenses but can reward suitably-equipped photographers with some very natural looking pictures. Cropping tightly helps to remove the obvious tell-tale signs that indicate the animal in the picture was in captivity.

to photograph. The problem with visiting a zoo as a one-off event is that you have to accept whatever conditions you find, and if this means the sun is at the wrong angle then there is very little that you can do about it. If you are in the fortunate position of living near to the zoo then you can resolve to return at a different time of day, or even different time of the year, in search of a better picture.

My home zoo in Jersey, the Durrell Wildlife Conservation Trust, has some excellent open compounds with animals that are free to roam, as well as traditional glass and wire enclosures. It is probably fair to say that in a zoo of this type it is impossible to have a lens that is too long to use! Picture-taking opportunities are everywhere and all that is likely to ruin an outing is non-photographer friends becoming impatient as you request 'one more minute' while waiting for an animal to turn towards the camera.

Technically, animals in zoos should be photographed with the lens set to a low aperture number (such as 2.8 or 4) in order to minimize distractions in front of and behind the creature. This same tactic also helps to make wire meshes become invisible but if you do use this tactic you must

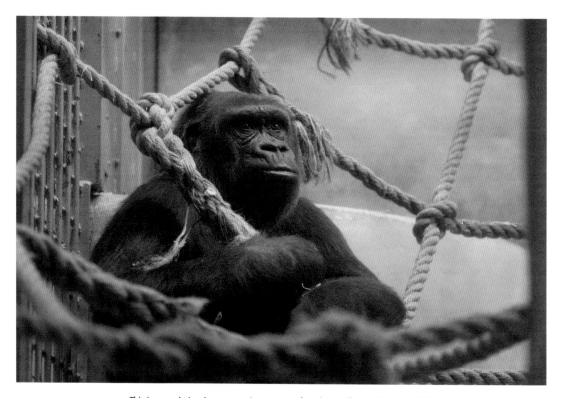

This is very obviously a zoo environment. In fact the gorilla was behind a thick glass window, in which distracting reflections were avoided by cupping a hand around the lens to seal it against the glass.

get very close to the cage and should always attempt to have a gap in the mesh dead-centre in the frame. Sadly, if the weather is fine the camera will not automatically set a low aperture number so manual intervention is often necessary. As has been pointed out previously, this can be done most simply by selecting Sport/Action mode, but for even greater control you should switch to aperture-priority exposure, if your camera offers it, and set the aperture to the smallest number available. It is then absolutely essential that you focus accurately on the animal, rather than on the grass in front of it or the tree behind. For maximum peace of mind it is useful if your camera indicates in the viewfinder exactly which area of the picture has been used for focusing. All interchangeable-lens digital SLRs do this, as do some hybrid cameras, but it is very unlikely that you will be able to take the best zoo pictures using only a digital compact.

A tip that will work with any camera, however, is to avoid reflections from glass surfaces by placing your camera so that the front of the lens is touching the glass. Some care is needed, however, because the front of the lens might move during focusing and it is important that you do not inhibit this. Fitting a soft (rubber) hood to the lens is a good way to make better contact with the glass: failing that you may be able to create a makeshift hood by wrapping your hands right around the camera against the glass. All you are trying to do is prevent the light from any bright objects behind you from showing as reflections in the glass. This same precaution, though in a rather different context, is also discussed later in this book in Chapter 8 on studio photography.

Birds

Most animals are fairly static in comparison with birds. Birds that are domestic pets and are quite tame can be photographed with relative ease, but wild and garden birds are more challenging. As with animals in a zoo it is often necessary to use a long focal-length lens and a small aperture number in order to get a tightly cropped composition that is free of distractions. If you cannot close-in sufficiently on a distant bird then it may be possible to crop your picture after capture and enlarge it to get a better view than you could obtain in the flesh. This technique, which is discussed again elsewhere in this book, can be surprisingly effective so do not worry if you feel frustrated at not being able to get a close-up view at the outset. The only disadvantage is the fact that backgrounds tend to be more distinct in cropped and enlarged pictures so there is still a good reason to invest in a long focal-length lens if bird photography is your passion.

An alternative approach is to place your camera close to where you expect a bird to land and to do your picture-taking by remote control. You can do this either using a simple remote control trigger (similar to the wireless systems used for studio flash heads, as discussed in Chapter 8) or by running a cable from your camera to a computer with appropriate

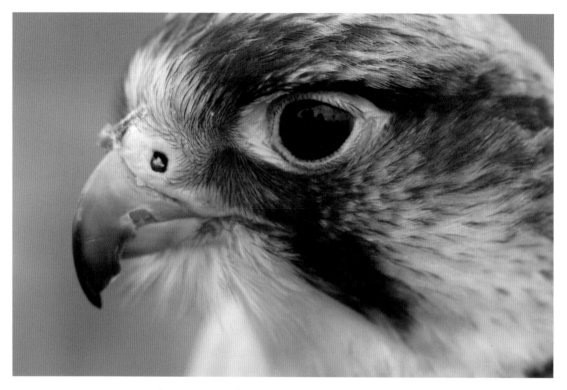

Sometimes it is easier to photograph well-mannered exotic birds than it is to photograph timid garden varieties. This falcon was photographed at close-range while being held by its handler at a wild bird centre.

software installed. Remote control triggers are standard accessories in many camera manufacturers' product ranges and have even been included free-of-charge with Olympus cameras, for example, in the past. It is important to make sure that the remote controller has sufficient range and an unobstructed view of the camera: check also that the camera does not switch itself off automatically after a short time (this action can normally be disabled in the camera's menu).

Computer-based remote control has the advantage of providing a preview image on the computer screen so you know exactly what you are photographing and how the camera has been set up. The necessary software is not normally provided with digital compact cameras but is a standard option for many digital SLRs. If you do go down this route make sure that the connecting cable is secured to things other than your computer and camera alone so that if something pulls on the cable the wire is more likely to break than to cause the camera or computer to fall. Expensive though these connecting cables can be they are considerably less expensive than a new camera or computer!

A less arduous tactic is to photograph birds in captivity. Zoos and aviaries often provide only limited success as such pictures tend to be very static but specialist bird centres, where the creatures are much freer to roam, can be much more rewarding. This is especially true if the centre provides demonstrations and allows close access to the birds when they are outside their cages, as is sometimes the case at bird-of-prey centres for example.

Landscape composition and flora

Lighting

The most important thing when trying to photograph a good landscape is the lighting: sadly, this is the one thing over which you have very little control. Historically, landscape photographers have used tinted and graduated filters to enhance the mood of a scene but, as was pointed out at the start of this chapter, it is still necessary to start with the appropriate raw materials. The best landscapes are often taken when the sun is low in the sky or when it appears from behind a break in the clouds. In both cases the light emphasizes the texture of the land, revealing every ploughed furrow and giving grass the appearance of a woollen blanket. Early in the morning and, to a lesser extent, late in the evening are therefore the best times for a landscape photographer to be roaming the countryside.

Composition

The problem with the countryside is that it is so vast and yet photographs need a point of focus in order to work well. Sometimes it is possible to place a feature, such as a noble tree or winding river, within the picture to provide this focus but on other occasions it is necessary to fall back on some of the basic rules of photographic composition. The most useful of these rules is the so-called Rule of Thirds, which says that pictures are more visually pleasing when elements within them divide the picture into thirds. The elements used can be as obvious as the aforementioned tree or river but they could also be far more subtle because their positioning gives them greater presence. A lone sheep in the distance could be placed on one of the vertical thirds (to the left or right of the centre of the picture) and the horizon should normally coincide with one of the horizontal thirds if it is included in the composition. Similarly, a sloping hillside could run through a vertical third and the path of a tractor might go from left to right along one of the horizontal thirds. Note, however, that you should not attempt to include all of these things in one picture as the result is likely to look very messy: one or two Rule of Thirds elements in a picture is normally quite enough.

An even more obvious compositional device is to decide whether an upright or horizontal format will suit the picture best. In a vertical picture

there is more room to emphasize the foreground as well as to include a variety of heights in the frame. A horizontal picture, on the other hand, emphasizes wide open vistas and is often better suited to extreme wide-angle (short focal-length) pictures.

One of the biggest pitfalls in landscape photography is a failure to convey enough depth in the picture. It is stating the obvious to say that photographs are two-dimensional and the challenge is to give a strong sense of three dimensions within this limitation. One way to do this is to use lines that extend from the front of the scene into the distance: these may be paths, hedges or even lines of crops. The lines can be either straight or ambling and the effect that each arrangement gives will be different. Another trick is to include the same object at different distances in the picture. Clearly the object that is closest to the camera will appear biggest and any at greater distances will be proportionately smaller, so providing visual clues to the viewer about the separation of other objects within the same picture.

Having mentioned the need to convey a sense of depth, it is necessary to discuss where best to focus the lens when objects at a variety of distances need to be rendered sharply in the finished picture. When working with film, landscape photographers previously made use of the hyperfocal distance (see Box 6.1) but changes in lens designs have made this technique much more difficult to implement with modern cameras. The safest tactic is therefore simply to focus on your chosen compositional

The smaller picture above is the least powerful because the horizon has split the frame in two, thereby dividing the viewer's attention equally between the field and the sky. In the landscape-format versions, opposite, the sky adds drama to the field without competing with it. Moving closer to the flowers has created an even more eye-catching but less serene result. It is always a good idea to photograph several variations of a scene if time allows. Photographs © Victoria Byers-Jones.

Box 6.1 **Hyperfocal distance**

The hyperfocal distance is a lens setting that exploits the idea that things in a photograph do not have to be truly sharp to appear to be in focus, they only need not to be more than acceptably unsharp. This concept has already been explained in detail in the context of movement blur and focusing accuracy so need not be reiterated here. To use the hyperfocal distance it is necessary to perform a series of calculations but these can all be skipped if the lens is marked with a depth-of-field scale. It is also necessary to be able to focus the lens manually and to know the distance at which the lens has been focused. This last point clashes slightly with the ethos of auto-focus lenses and it is not surprising that the depth-of-field scale and a visual read-out of the focused distance have both fallen from grace – the former to an even greater degree than the latter. As a result, the hyperfocal distance is harder to set on a modern camera than it used to be on fully manual cameras of old. Nevertheless, so useful is the technique that it is worth explaining in brief.

The '22' markings adjacent to the focusing window here mark the limits of depth-of-field for this lens when it is set to its smallest aperture. To use the hyperfocal distance technique the '∞' symbol should be set against the right-hand '22' marking rather than the centre focusing line.

The aforementioned series of calculations allow the maximum and minimum object distances that will render acceptably sharp images to be calculated for any given focused distance (taking into account other factors). The fact that the region of sharpness extends both in front of and behind the focused distance means that the most distant possible objects, which are normally said to be located 'at infinity' do not need to be focused on because by focusing slightly in front of them they can still be rendered acceptably unsharp. This is the principle of the hyperfocal distance. Instead of focusing at infinity to photograph a distant scene the infinity mark (which is denoted by an icon that looks like a figure eight on its side) is placed at the farthest limit of the depth-of-field for the prevailing aperture setting. This is illustrated in the accompanying picture. When this has been done it turns out that everything from infinity to half of the focused distance will be recorded with acceptable unsharpness and will therefore appear to be in focus. At present there is no automated system that takes advantage of this principle though in theory it would be very easy for camera manufacturers to design an algorithm that would set the hyperfocal distance instead of the true focused distance if the latter turned out to be the infinity setting. Perhaps such as option will be offered in the future.

In the meantime, if your camera lenses do have a depth-of-field scale then you can use the hyperfocal distance technique by setting the infinity mark to the further depth-of-field marker for your chosen aperture number, which is likely to be at least 11 or higher, and shoot away safe in the knowledge that you have secured the greatest amount of depth-of-field possible.

feature, which was probably placed on one of the thirds of the picture, then to recompose the image after locking the focus by maintaining half-pressure on the shutter release button. You may even be able to select an off-centre focusing area manually, in which case there is no need to separate the focusing and composing parts of the picture-taking process.

A further factor to consider when composing landscape pictures is the height above the ground from which the picture is taken. It is too easy to take all of your pictures from just short of 2 metres above the ground because this is the average height of most people. But just as it is important to get down to the eye-level of animals and children so it is also worth thinking about the optimum position from which to take landscape pictures. Often these too benefit from a lower-than-normal camera height so it makes sense to think about this possibility when choosing a tripod for landscape photography: look not only at how sturdy it is when fully extended but also how easy it is to use at low levels.

The formal lines that exist in box-garden designs make it easy to create a sense of depth in such pictures with minimal effort. Lines may be more difficult to find in general but they are always worth seeking out if possible.

Exposure time

If you are taking pictures in the early morning and using a low sensitivity (ISO) setting in order to get noise-free images, you may find that selecting a high aperture number (such as 11, for example) forces you to use a rather long exposure time. This is not necessarily a problem because landscapes do not contain a lot of movement, but it does mean that you should support your camera on a sturdy tripod. In fact a tripod that is light enough to carry comfortably across fields, but also rigid enough to provide a very secure platform, ought to be considered as one of the most valuable accessories for landscape photography.

The beauty of a good tripod is that it not only allows you to use long time exposures but actually positively encourages you to do so. There are some great effects that you can create by exploiting what movement there is in landscape pictures. Grasses or cereal crops waving in the wind acquire a softness that is extremely appealing and moving water blurs to look like a billowing silk fabric. Typical exposure times required to achieve these effects are around 1/8s or longer and clearly pictures of this type would be impossible to take without using a good tripod.

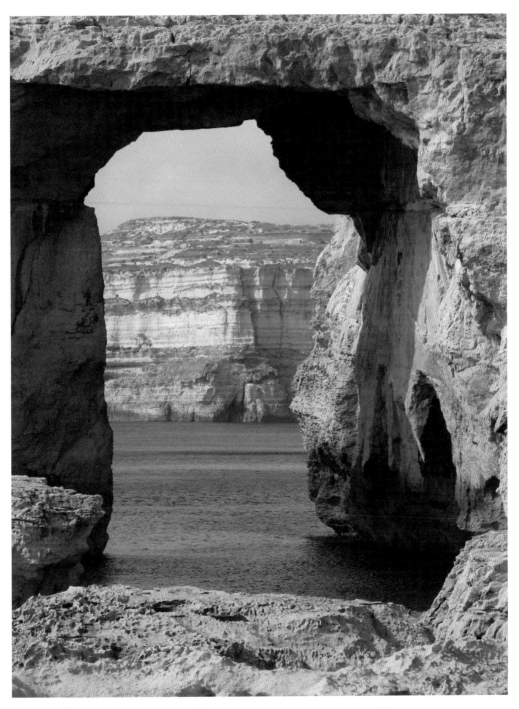

Using the middle-distance arch to frame Gozo's limestone layers beyond has created a sense of perspective in this picture: the foreground rocks complete the three-dimensional effect.

These two pictures were taken in normal mode and macro mode using a Kodak EasyShare P880 camera: although the second image is a much tighter composition it is not 'macro' in the strict sense of the word.

Macro

There is a very precise definition of macro-photography, which is photography where the image of the object is the same size or slightly larger than the size of the object being photographed. Anything that is above ten times life-size is said to be micro-photography and anything that is less than life-size is simply close-up photography. That said, the term 'macro' is often used nowadays to signify any pictures taken at close range. Many digital compact cameras have a macro mode that exploits this second definition in that the setting is used specifically to focus closer on objects that are fairly small and would otherwise be lost amidst a mass of extraneous details even if the image size is not actually the same as the object size.

Photographers who use digital SLRs are able to fit dedicated macro lenses in a range of focal-lengths. As with conventional photography the focal-length of the lens determines the distance between the camera and object in order to record a certain image size. It is therefore perfectly possible to take true macro (life-size) photographs with a variety of different lenses but in each case the camera will be a different distance away from the object. This is important because it is sometimes necessary to use special close-up flash equipment and there needs to be room to place this between the camera and the object.

The twin-flash arrangement that is much favoured in close-up and macro-photography is clearly visible in the reflections seen here. Photograph © Dr Andrew Stevens.

Macro-photography requires a blend of patience and technical skill. The backgrounds in these two pictures have added to their success, one by being dark and the other by providing an almost surreal landscape on which the fly has landed. Both photographs © Dr Andrew Stevens.

The most useful type of close-up lighting is a small ringflash unit that attaches to the front of the lens and provides almost shadowless illumination. Some such units are fully dedicated to specific cameras, which means that exposure is handled automatically by the camera along with focusing. If you are serious about doing macro-photography then you should check on the availability of such accessories before deciding which camera system to buy as you could otherwise find that you have purchased a camera that does not have a matching macro ringflash.

In days of old it was sometimes necessary to remove the camera's pentaprism housing or attach a right-angle viewfinder accessory to make it easier to see through the viewfinder when the camera was low on the ground to photograph a wild flower in situ, for example. These days it is more common, and much more convenient, to tilt the camera's LCD screen if necessary or to operate the camera from a laptop computer that is connected to the camera by cable. The important thing to realize is that although the methods have changed the basic principles have not. Macro work remains one of the most challenging, but also most rewarding, areas of nature photography.

GUEST PHOTOGRAPHER: ANDREW STEVENS

Dr Andrew Stevens is a photographic researcher who also has a keen personal interest in macro-photography. Here he explains the advantages of shooting macro images using digital cameras.

Macro lenses usually only go up to a maximum magnification of life-size. This means that using 35 film, with a frame size of 36 × 24 mm, an object with these dimensions completely fills the frame when the lens is focused at its most close-up setting. When the same lens is mounted on a digital SLR equipped with an APS-C size sensor, such as my Nikon D100, which has a sensor with dimensions 24 × 16 mm, an object only 24 mm long now fills the frame, giving an effective magnification 1.5 × greater than that possible using film. In other words, instead of getting a fairly ordinary shot of a whole butterfly you can now easily get an attention-grabbing shot of just the butterfly's head. Bellows or extension tubes can be used to achieve the same effect with film but these attachments are cumbersome and usually result in some loss of image quality. In addition, the working distance (the space between the object and the end of the lens) is reduced when using accessories to increase magnification, so the digital worker also has more room to manoeuvre around subjects. This is important because insects can be easily frightened away by a lens that is too close.

Borage flower and Hoverfly. Photographed using a Nikon D100 digital SLR fitted with a Tamron 90 mm macro lens. Lighting was provided by a home-made twin macro flash system. Both photographs © Dr Andrew Stevens

The Four-Thirds system, as championed by Olympus E-series cameras, has an even smaller sensor than the D100, making it better still for high magnification shots thanks to an effective magnification almost double that which can be achieved with film. The depth-of-field, which is always so tiny when working close up (often only a millimetre or so) is also greater compared to film. Simple calculations show that the depth-of-field at 0.5 × magnification using the Olympus E1 is 2.5 mm at an aperture setting of f/16, compared to only 1.6 mm when using a full-frame 35 mm camera at the equivalent 1 × magnification. There is also an exposure advantage in favour of digital because the 0.5 × magnification reduces the light falling on the sensor by only one F-stop whereas the 1 × magnification required to get the same image on film means a two F-stops loss of light.

Results in the field using a number of different digital SLRs have supported these figures and advantages such as these can make all the difference as to whether an insect shot works or not. Finally, old macro lenses and accessories originally designed for film work surprisingly well at high magnification when mounted on digital bodies: it is easy to experiment and a very competent macro system can be assembled at little cost.

The only slight drawback when shooting with digital is that, to my mind, TTL flash systems for digital SLRs have not quite been perfected yet. This is disappointing as, more often than not, flash is vital for high-magnification macro shots. I normally use a twin-flash system or a ring-flash mounted on the lens. With film the results are normally reliable but with digital they are somewhat less so. On the other hand, the ease of image review with digital means that it is simple enough to use manual flash control and check the exposure and lighting on the LCD screen.

Horse racing at Les Landes race course, photographed using a Nikon D1H. Action pictures such as this are best taken using a long focal-length lens (a Nikkor 300 mm f/4 in this case) fitted to a digital SLR that responds quickly when the shutter button is pressed. This picture works especially well thanks to the leading jockey's red silks, which provide the dominant colour in the photograph. Examples of the sorts of pictures that can be obtained when photographing the same subject using other types of digital cameras are shown on the following pages.

Action

Many pictures could be considered to be action subjects, including children playing in a garden and a falconry demonstration. The factor that determines whether these are pictures of people or birds, rather than action shots, is the motivation behind the picture. If the children are less important than the activity in which they are engaged then the picture might well qualify more as an action picture than as a portrait. Similarly, if you were to photograph a marathon with the deliberate aim of photographing a particular person, and were keen to get the nicest rather than the most dramatic picture of that person, then again this is more like portraiture than action photography. But if the activity itself, be it a sporting event or dance performance, is the primary subject of the picture then this is action photography.

This distinction is important because it affects the types of techniques that are used and the criteria by which success or failure will be judged. It also determines how much time is likely to be spent photographing the activity: if only one person is important then after that person has performed the rest of the activity is immaterial, whereas in true action photography picture-taking often continues for as long as there is something to photograph. By the same token, the chances of getting a great picture are better if the action is the subject of the picture because you are then free to turn your camera in whatever direction you choose. If the resulting great picture happens to be of a famous person or a relative then that is all the better but a great action picture should stand or fall on the extent to which it conveys the drama, atmosphere, colour, dedication, speed, concentration and other factors that are important to the activity concerned.

Location choice

You will almost always be limited in the locations from which you can photograph action subjects. Sometimes, as in the case of motorsport, this will be for reasons of safety but at other times it may be simply so that you do not intrude on the enjoyment of an audience who may be watching the event. It is for the latter reason, for example, that stage plays have

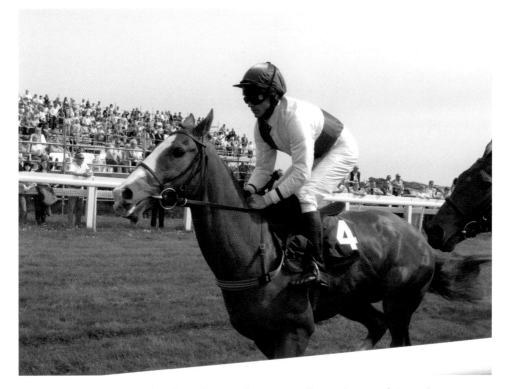

These two pictures, also taken at the Les Landes race course, illustrate that types of pictures that can reasonably be expected when using more modest equipment. The picture above was taken using the Kodak EasyShare P880 hybrid camera, which has a fixed zoom lens and suffers slightly from shutter lag. It is very hard to compensate for shutter lag and in trying to do so the shutter has been pressed a shade too early in this case. The picture opposite was taken using Epson's R-D1 digital rangefinder camera, which has a limited range of lenses and has to be focused manually but is responsive enough for confident use of panning.

photo-calls that are not public performances but at which the press is able to take pictures without a paying audience complaining that its view is being obstructed.

If you are going to an event with the primary intention of taking pictures you may be able to gain privileged access of some sort by making appropriate inquiries in advance. Do not imagine, however, that you will be admitted into areas from which the general public has been excluded unless you have documentary evidence that explains why you should be an exception to the general rule. Health and safety considerations are paramount and if you are not allowed to go where you really want to go then you will just have to do the best job from a permitted location.

It always makes a lot of sense to try to find out as much as you can about the staging and venue in advance for anything that you want to photograph but action subjects are the most deserving cases for this advice. This information should enable you to anticipate the direction and

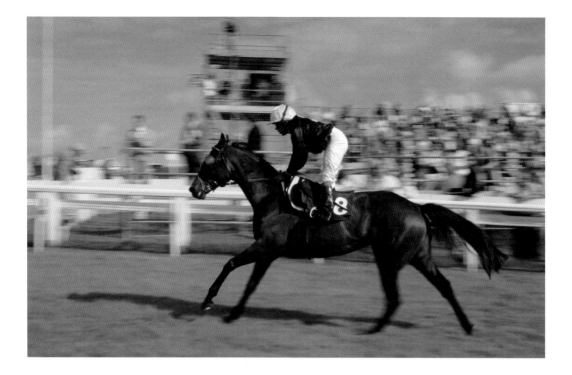

brightness of the lighting and the distance and angle from which you will be viewing the action. At this stage you may have to make a tough decision and decide whether or not you will be able to get the type of pictures that you really want. If you attend the Wimbledon Lawn Tennis Championships and have seats for Centre Court that are half way up a stand then you will never get the types of tennis pictures that are published in books and magazines. You must therefore decide whether to take some pictures that simply convey the atmosphere of the event or whether it would actually be better just to sit back and enjoy the match.

This comment is important because by photographing an event and concentrating on the action you will probably miss some of what happens. It is not uncommon for professional sports photographers to leave an event without being sure who won or what the final score was. This lack of awareness may be too great a sacrifice to make if you are a fan of that particular sport, in which case photography must come second. There is also another reason why this factor is important and that is the inescapable fact that the best action pictures are usually taken of the best action events. In other words, a really good high-jump picture is likely to be of a really good high-jumper in action: no matter how good the access you might be given it is unlikely that you will ever get a great picture if the athlete concerned is not of a high calibre. This does not matter if the high-jumper is a friend or relative because in this situation the person is probably more

Circus juggler, photographed using only available light from the public seating area. The camera, a Kodak DCS 14n, was fitted with a vibration-reduction Nikon lens that enabled a long exposure time to be used even though the camera was hand-held: as a result, the rising and falling balls are slightly blurred (the highest ball is close to the top of its arc and is therefore almost stationary).

important than the activity (as was pointed out at the start of this chapter) but it does need to be kept in mind if you are after great action pictures.

Lens choice

Assuming that you are indeed after great action pictures, from whatever viewpoint you have, the first thing to think about is lens choice. A long focal-length lens will let you close in on distant subjects but may also be very unwieldy if you are seated in a grandstand. A shorter focal-length will show more of the settings and will also allow you to include some of the other spectators, which may improve the picture even though your initial assumption may be that other people's heads just get in the way. Careful use of spectators can frame more distant action and therefore focus attention on it rather than being an unwanted intrusion into the picture.

It is tempting to think that long focal-length lenses are essential for good action and sports photography and although that is often true it is not always the case. Sometimes the situation will demand a shorter focal-length lens, perhaps because you are sitting close to the edge of a circus ring, and at other times a medium focal-length can provide greater flexibility than a longer lens simply because it allows you to recompose the picture after it has been taken (see below). When you are using an interchangeable-lens digital SLR you should therefore carry a range of lenses or a couple of zooms that will cover a wide range of possible needs. If you have any other sort of camera you will be limited by the lens that it has – unless, that is, you have purchased accessory lens adapters that give a wider or more magnified field of view.

Camera choice

The suitability of a camera to action photography depends to a large degree on its design. This fact is recognized by the manufacturers of professional digital SLRs who offer separate *highest-speed* and *highest-quality* cameras. The primary difference is pixel count, which is normally thought of as a parameter that is fixed at the camera-design stage. More recently, however, digital camera manufacturers have got clever and started offering a trade-off between speed of capture and the number of available pixels used within a specific camera body. This is a welcome development as it increases the versatility of a single camera body and therefore makes a greater range of picture-taking opportunities accessible to people who only want to invest in one digital camera.

The second factor that slows down many cameras, and therefore makes them less well suited to action and sports photography, is the time taken to save pictures on the memory card. This in turn is linked to both the speed of the card itself (not all cards save pictures equally quickly) and the size of the pictures being saved. The former factor can be monitored by reading current magazine reviews but in general it is true to say that the major manufacturers, including SanDisk, Lexar and Kingston, tend to use the latest technology in their high-performance cards and that these are likely to be the quickest. The size of the files depends both on the pixel count of your camera and on the format in which the pictures are saved. Smaller files, from lower pixel-count cameras using JPEG compression, tend to be saved quickest. In this sense a lower-resolution digital camera may well prove better than one with the highest possible pixel count and JPEG files could be a wiser choice than TIFFs or raw-format data even though they offer less potential for improving the quality of captured images later on.

Professional digital SLRs adopt a completely different approach and overcome the problem of writing speed by incorporating a memory buffer that can store subsequent pictures while the first ones are being transferred to the card. This is the best possible solution but it costs money and as such is not generally found on less expensive digital cameras.

Camera settings

Whatever type of camera you have it is important to know which settings will give you the best combination of characteristics for action photography, bearing in mind that the choices you make will almost certainly be quite different from those used for landscape and people photography. It is probably stating the obvious to say that if your camera has subject modes then your first thought should be to select the sport/action setting. This will cause the camera to select a short exposure time with a correspondingly small aperture number (such as 2.8 or 4) so that any movement in the picture will be recorded with as little blurring as possible. If you have a camera that offers full manual control or shutter-priority mode then you

Taken in the early dusk, this picture of a seaplane taking off is back-lit by the setting sun. Despite falling light levels an exposure time of 1/1000s was needed to prevent camera shake that might otherwise have been visible owing to the long focal-length lens used. The camera was an Olympus E-1 fitted with a 300 mm lens that is equivalent to 600 mm on a full-frame 35 mm camera. The relatively short exposure time has almost frozen the movement of the propeller blades: an exposure of about 1/250s would have given a nicer result in this respect but would have meant mounting the camera on a monopod for extra stability.

can determine exactly which exposure time you want to use, which is preferable to using sport/action mode if the latter does not display any exposure time (shutter speed) information.

Sometimes you will not want to have the very shortest exposure time because you might decide that a small amount of blurring will add to the mood of the picture. In golf, for example, the end of the club moves very fast indeed and can be blurred while the player's face remains completely sharp. In addition, the position of a golfer remains stationary overall so it is possible to aim a camera at a player then release the shutter at the correct moment without having to worry about the golfer moving out of the picture. This is very different from the situation that applies in most other sporting disciplines, where it is often necessary to track a player's movements before and after a picture is taken. The only common exceptions are pictures in which the competitors move across a large part of the arena that is entirely within the frame, such as is seen in a high-angle photographs of cyclists, runners and motor racing, where the picture is primarily of the track itself.

This is an unusual example of panning (see Box 7.1) in that the camera was moved downwards to track the diver, resulting in blurring of the background that takes the form of near-vertical streaks.

Box 7.1 **Panning technique**

Panning is a technique that allows you to use a longer than normal exposure time without the subject having an excessive amount of blur. It only works with movement that is reasonably smooth and across the field of view, not towards or away from the camera. As it happens, sideways motion is more likely to producing blurring than forwards/backwards motion so the requirement for panning is in keeping with the situations where it is most likely to be needed. The technique is as follows.

Start by identifying the direction from which the action will arrive and the direction in which it will leave the point where you would like to take your picture. You will need to aim your camera at the incoming action and swing your whole body, if possible, to follow the action as it passes by. This is best done standing up, with your resting position being dead-ahead, facing the point where you hope to photograph the object. Next, pre-focus your camera on something that is located in the position where you wish to photograph the moving object: if there is nothing suitable in the same place then try to focus on another object at the same distance. Although this pre-focusing move can be done by setting the camera to manual-focus mode (if it has one) it is easier to exploit the fact that many digital cameras focus when the shutter release button is pressed just half-way down and will hold this focused distance for as long as half-pressure is maintained on the shutter release. You should be able to tell if your camera works in this way because you will see some sort of in-focus indicator light come on as you start to press the shutter release: you may even hear the lens focusing.

Daimler Dart SP2, photographed under low light by panning the camera. Taken using a Contax SL300R-T* compact set to ISO400 and f/2.8 with an exposure time of 1/125s.

All that needs to be done now is to hold the pre-focus setting, by maintaining half-pressure on the shutter release, and turn the camera towards the direction of the incoming action. Do not worry if the viewfinder looks out of focus and definitely do not release your pressure on the shutter button! As the moving object comes into view try to place it in the middle of the viewfinder and turn your body as it passes while keeping it in the centre of the frame. When the object reaches the point where you pre-focused just push the shutter button down the rest of the way and a picture will be taken. All being well it will seem as if the moving object was stationary and the background was speeding past: the subject should be hardly blurred at all and the background will be blurred in the direction that is opposite to the movement of the camera (and the object itself).

This technique can be used with a variety of different exposure times depending on how quickly you have to pan the camera and how much blurring you want to have in the background. A good starting point is around 1/100s but times as long as 1/10s can be very effective. Beware, however, that at longer exposure times there starts to become a problem with overall camera shake, which introduces random blur into the picture and can completely ruin the intended effect.

Even if you do not want to use creative blur in your action pictures, panning is still a useful technique to master because it overcomes the problem of reaction times. In particular, if you set up your camera on a tripod, perhaps to support the weight of a long focal-length lens that has been fitted to capture some distant action, then you will only be able to get a perfectly composed picture if you can press the shutter button at the exact moment when the object reaches the appropriate position. Most people have reaction times of between 0.1s and 0.2s, to which must be added the camera's own reaction time. The latter can be considerable, especially for hybrid cameras with an EVF, and throughout this period the object will continue to move away from the perfect position.

Pressing the shutter button slightly in advance can improve matters but this is best done not looking through the camera as the field of view may not be big enough to see the object a sufficient time in advance. Alternatively, by panning it is possible to minimize both time delay problems because the object is always in view and you can check how early the shutter button needs to be pressed by reviewing each image to see if the camera is firing at the ideal moment to get the perfect composition. When you get really good at panning you should try to compose your pictures with slightly more room in front of the moving object than behind it: this helps to accentuate the idea that the object is moving away from a confined area into more space on the other side of the picture.

In the days of film photography the best advice was always to use the lowest ISO film possible and the same advice also applies to the sensitivity level set on a digital camera. This in turn may force you to use a longer exposure time than you might have first anticipated but before worrying about this consequence you need to know what length of exposure time is required to get an unblurred picture. This can be done by calculating a value based on the speed of the action (the time it takes to cross the field of view) and the maximum allowed movement before any blur is seen, which could be taken to be the distance between two pixels but might more reasonably be related to the resolution of the human eye, which could easily be a number that is ten times less demanding. For more information about this theoretical approach refer to Chapter 4 on exposure and focusing.

A quicker and easier approach is to pick a couple of possible exposure times, perhaps 1/125s and 1/1000s, and to take some test pictures that can be magnified and inspected on the camera's review screen.

When taking pictures of cricket, where the action often takes place in a predictable place (around the stumps), it is convenient to mount the camera on a tripod to keep it aimed in the appropriate direction all of the time. It is not necessary to keep looking through the viewfinder provided that your finger is always on the shutter.

Depending on the nature of the action, its size in the viewfinder and the instant at which the picture is taken you may be surprised about how long an exposure time can be used with very successful results. Even longer exposure times can be used if the camera is turned to follow action that takes place in a predictable direction. This panning technique is best suited to such activities as motor racing, cycling and air displays, as explained in detail in Box 7.1.

Composition and cropping

In action photography composition is used to emphasize movement and drama. The Rule of Thirds, which we looked at in the context of landscape photography, is still relevant but it is no longer the dominant device used. Moving objects are normally arranged in a picture so that there is more space in front of them than there is behind, but the Rule of Thirds tends to be too extreme in this respect. The idea is simply to suggest that there is room for the moving object to move forwards so placing it slightly off-centre is normally enough. Similarly, the fact that Western text is read from left to right and Western eyes scan a page in this direction means that any moving object which is photographed moving the opposite way has its motion accentuated because the eye sees the front of the object first and the rear of it last. If the object were photographed moving from left to right the eye would effectively overtake the object as it scans across the image and this would reduce the illusion of rapid movement. On the other hand, left-to-right movement is good for conveying a sense of serenity, such as might be created in a picture that had a horse-and-cart ambling across the frame.

When photographing dynamic objects there is another compositional device that is equally important but is without parallel in landscape photography: this is the trick of tilting the camera and is especially useful when photographing motorsport as it suggests cornering. To work well there must be nothing in the picture that betrays the fact that the camera has been tilted. This means no visible horizon and especially no horizon on the sea, which everybody knows is horizontal owing to the force of gravity. Also watch out for known vertical objects, such as trees and flagpoles. When photographing motorsport from a slightly elevated angle, however, the background may be composed entirely of the track surface, which is ideal for the tilting treatment.

These two compositional devices can be applied when the picture is taken but if the framing is slightly more spacious then it is possible to recompose and tilt the picture afterwards using an image manipulation program. Although this appears to go against my philosophy of preferring to create the perfect picture at the moment of capture it is a more realistic way to proceed in many cases as it minimizes potential problems caused by having to think about several things at once – particularly when a racing car is speeding past at what may be well over 100 mph!

This pair of pictures shows a cropped improvement (*top*) and the original as-shot composition (*bottom*) of an Alfa Romeo taking part in the Rally of Jersey. The camera was tilted to add drama to the picture but in the as-shot picture this fact is betrayed by buildings on the extreme right of the picture and a spectator at the top of the frame also being tilted. Cropping the picture has removed these tell-tale signs and produced a much more powerful final image as a result.

There are also technical considerations, linked to the type of camera used, that limit the amount of compositional accuracy that can be used at the picture-taking stage. High-speed action photography is best done using a digital SLR as this is the only system that will respond quickly enough when the shutter button is pressed. Many digital compacts and hybrid cameras have a significant delay between the moment that the shutter button is pressed and the instant that the picture is taken. During this time the object will continue to move and if you have tried to compose the picture exactly as you want it to look then you will almost certainly find that the captured image does not match your original vision. This problem tends to be worst with cameras that have electronic viewfinders (EVFs) because the camera has to switch its sensor from image-preview to image-capture before the picture can be taken. This also means that at the instant that the picture is taken the viewfinder freezes, and although this is also true, in a slightly different way, for digital SLRs the black-out time is much shorter in this case and is therefore easier to accommodate.

Using colour

Colour plays an important role in action photography, either as a way of identifying the best object on which to focus or as a way of selecting a vantage point so as to avoid distractions. The colour red tends to advance in a picture and the colour blue tends to recede. (Hence the trick that is sometimes used on website pages to give the illusion of red words floating in front of a blue background.) This means that a red car, or a jockey wearing red silks, tends to leap out of the picture more than any other. As an added bonus, red makes a strong contrast against both green grass and a blue sky and so stands out and helps to give a sense of depth in a picture where there may not be the opportunity to use other compositional tricks. On the other hand, try to avoid dominant red advertising boards or red-clothed spectators in the background of your picture unless these things are an intrinsic part of the image. Similarly, red's attention-grabbing effect is diluted if there are multiple occurrences of it in a picture so bear this in mind when deciding on the characteristics that will define your perfect picture.

Once you have realized the strong effect that colours can have on a picture, and that this effect is particularly important in action and sports pictures, you will probably be able to explain why one picture can seem better than another even though the elements within the two images are essentially the same. It is no surprise, therefore, that colour is an important part of many sports and, unless sponsorship dictates otherwise, a team or athlete's colours will often be chosen to provide a particular effect: it is no coincidence that modern Ferrari racing cars are red, especially when it is realized that (having been born out of the Lancia motorsport team) they were originally light blue!

A high viewpoint and a long focal-length lens were used to take this picture of the dragon-boat races that take place in Jersey's harbour every year. The boat appears foreshortened and the depth-of-field is narrow, thus focusing attention on the drummer. The fact that the picture contains mostly only two colours, orange and blue (with flashes of white in the sea and on the drummer's arms) gives this picture a very graphic overall effect.

Quiet moments

Although it is tempting to think that action photography is all about the moment that a cricketer is bowled-out or a sprinter crosses the winning line there are also some quieter moments that offer great picture-taking opportunities. You might spot a moto-cross rider covered in mud, or a boxer having his hands bandaged prior to putting on his gloves, or the anguish of competitors who see their own performance bettered by others, or marshals handing out drinks to marathon runners, or a stack of tyres waiting to be used in a motor race. In many ways these are harder pictures to get because they are less stereotyped and you have to work harder to spot them when they occur. A second obstacle may be the need not to distract competitors who are preparing for an event, nor to get in the way of a support team that is readying the equipment or the course. It is often the case that people who engage in an activity expect to be photographed when they are in action but require privacy at other times: this is something that you must respect.

You may be lucky enough to get portrait opportunities if you are personally known to the competitors, but given that relatively few readers of this book are likely to be personal friends with world-class sports people it may be thought that this suggestion of personal friendship granting better access is at odds with my earlier observation that the best action pictures are of the best exponents in action. Quieter moments, however, have a similar quality regardless of the standard of the participant and are just as likely to be observed at local events as they are in international

From the seat that I had at the Belgian Grand Prix it was impossible to take a typical motorsport action picture so I waited until the end of the race and then used the video screen to frame a more atmospheric photograph. The departing spectators add a useful sense of scale. Taken using a Canon EOS D30 digital SLR.

competitions (if not more so given the previous comment about competitors' privacy).

The final piece of advice to anybody tackling action photography is therefore to be realistic about what can be achieved in terms of access, equipment and respect for the event and its competitors. Tempting though it is to concentrate fully on your own picture-taking, never forget that the event is being staged for the benefit of the competitors and spectators not just one photographer! Consideration for others and your own personal safety must always be paramount.

Professional studio photography benefits from equipment that is often too expensive or too large to be used in a temporary studio at home. This portrait was taken using a very large Bron Para reflector: the size of the reflector can be judged by looking at the smaller picture, (opposite) where the model provides a sense of scale.

CHAPTER 8

Studio

Whereas Chapter 5 on people served as a basic introduction to some of the techniques and situations that apply when taking pictures of friends and family, this chapter is a much more advanced approach to the same subject. That said, although many pictures taken in the studio are of people this chapter will also mention some of the techniques that are useful when photographing objects, which is the area of photography known as still life. It should also be pointed out that the word 'studio' does not necessarily mean a purpose-built room: it could just as easily refer to any room that is turned into a photographic space for the afternoon.

In all cases the fundamental principle is one of control: in a studio everything should be under the photographer's control. This being the case, studio work is about making, rather than taking, photographs. Other locations offer their own possibilities but a studio should contain nothing that has not been placed there deliberately by the photographer. And the most important thing that needs to be arranged is the lighting, so that is where this chapter is focused.

The best place to start when thinking about studio lighting is with the natural lighting that we take for granted every day. Outdoors there is a

single light source, the sun, and because of this we are used to seeing scenes that are lit by a single source. There are also secondary sources that reflect the sun's light, such as sand and white café tables, which lighten shadows cast by directional sunlight. On an overcast day, when the sun is hidden behind a bank of cloud, the lighting is as soft and non-directional as it ever gets: there are no obvious shadows on the ground and nobody has to squint to protect their eyes from the glare. In essence, these three conditions provide the ideal starting points for studio lighting techniques but first it is necessary to know something about the equipment that is required to create these effects.

Basic equipment

If you own a digital camera that can control a remotely placed *external flash-gun* then starting in studio photography can be very easy indeed. Such systems are likely to comprise a high-end digital SLR in combination with a suitable model from the camera manufacturer's own range of flashguns. Most digital-SLR manufacturers offer systems with this capability: the only exception is Fujifilm, whose digital SLRs are based on Nikon bodies and use Nikon flashguns. Within reason the external flashgun can be put in any position and the camera will automatically adjust the flashgun's output by remote control (see Box 8.1) to ensure that perfectly exposed pictures are obtained.

Different types of light sources give different types of lighting effects, as these three pictures illustrate. The darkest image, where the illumination is confined to a very small area, was lit using a focusing spot whereas the image that has an equally strong shadow but a lighter general background was lit using a flood light. The third picture, which is largely shadow-free, was lit using a ring-light.

More probably you might want to try studio photography with an existing camera that does not have a flash remote-control facility. In this situation you should buy a *hand-held flash meter* and learn how to interpret its readings. Fortunately, flash meters are very easy to use. The cheapest type, which is perfectly adequate for most purposes, is an incident meter that simply measures the brightness of the flash illumination falling on the subject. It is held close to the subject and, provided that the light is coming essentially from the front, is simply pointed towards the light source. More generally, the meter is generally angled half-way between the direction of the flashgun and the direction of the camera so that it is measuring the light that is bounced towards the camera after reflecting off the subject. In all cases the flash meter is connected to the camera using the same system as is used for the lights, which may be either by cable or using a wireless interface. When the flash meter's reading button is pressed the flashgun fires. The brightness of the light reaching the subject is then indicated either numerically on an LCD screen or via a series of lights arranged alongside a printed scale. The number indicated is the optimum lens aperture for the prevailing sensitivity (ISO) setting. Moving the flashgun closer to the subject will give a brighter reading and means that a higher lens aperture number (such as 11 instead of 8) must be set on the camera to give the correct exposure.

Whenever external flash lighting is used the camera should be set to external flash mode, if one is provided, or else to full manual control. If the latter is required then the exposure time should be 1/60s to be safe (some cameras will work with shorter times but others may not) and the aperture should match the reading on the flash meter: the camera's own flashgun should be switched off. Provided that there is a reasonable amount of ambient light in the studio the camera will still be able to auto-focus on the subject: if not, you will have to increase the ambient illumination. In any case the camera is likely to warn you that its settings will cause under-exposure. This is completely normal because the camera has no knowledge of how bright your flash illumination will be and is basing its assessment on the non-flash light level. Fortunately, the review screen provides an immediate opportunity to check that the aperture indicated by the meter has indeed produced a correctly exposed picture.

This is important because tests of digital cameras undertaken by myself and fellow technical author John Clements have regularly found that it is necessary to adjust the aperture away from the value recommended by a flash meter in order to get the best results. If the captured image on your camera's review screen seems to be too dark then you should take a second picture after setting the lens to a lower aperture number (changing it from 8 to 5.6, for example). Conversely, if the image is too light then you should repeat the exposure after setting the lens aperture to a larger number. As has been stressed previously, for best results do not to make this judgement visually but instead use the exposure histogram, if your camera has one. Remember, only the histogram can truly reassure you that the brightness range of the subject is entirely within the tonal range of the sensor.

Although a lot of professional studio photography is done using flash there are also continuous lights that use lamps similar to those found in domestic and office lighting. These are much easier to use in terms of judging their lighting effect but they can be uncomfortable for the model because they can generate a lot of heat. The smaller cylindrical lamp, shown here at the bottom of the picture, is the modern equivalent of the earlier bulb-shaped lamp.

The same principles apply regardless of whether you are using an external camera flashgun or a special studio flash head: all that is different is the size of the equipment and the way in which it is adjusted. External flashguns that are not remotely-controlled need to be set to manual and the most common ways to alter their brightness is either to change the manual power level (if this feature is provided) or by moving the unit towards or away from the subject. The latter alters not only the brightness but also the quality of the lighting, so if at all possible the former method should be used.

A third option is to use a *diffuser*. A translucent diffusing panel can be placed in between the subject and the flashgun or a diffuser can be fitted over the flashgun itself. These diffusers both reduce the brightness of the illumination and soften the quality of the light. The difference between a bare flashgun and a flashgun that is separated from the subject by a diffuser is similar to the difference between direct sunlight and the quality of light obtained on a slightly overcast day when the sun is behind a layer of translucent clouds but still casts shadows. Suitable diffuser panels are offered in a range of sizes (one metre will be more than big enough for most purposes) by several manufacturers, including Lastolite and Photoflex.

Advanced equipment

Unsurprisingly, given the earlier comment about it being better to adjust the output of a flashgun than to move it when trying to adjust the brightness of the illumination falling on the subject, special studio flash heads offer a wide range of manual power levels so that different effects can be created with relative ease. There is not enough room here to go into great detail about lighting equipment but readers are advised that the author has written a separate book devoted to this subject, *The Practical Guide to Photographic Lighting for Film and Digital Photography* (Focal Press, 2001).

Box 8.1 Flash triggering

When a flash goes off the burst of light that it generates lasts for a very short time; typically about a ten-thousandth of a second. This is very much faster than anything the human eye can see and the only reason we can 'see' the flash is thanks to an effect, known as persistence of vision, that causes bright lights to be retained in our visual memory after the light source itself has been extinguished.

The most important point about all of this is the extreme brevity of the flash duration and the need to ensure that the flash's light covers the entire area of the sensor surface at the appropriate instant. This is achieved by opening the camera's shutter and, if necessary, switching the sensor from preview to image-capture mode a split second before the flash fires so that everything is ready when the crucial ten-thousandth of a second arrives. The problem, therefore, is one of accurate synchronization.

Any flash unit that is built into a camera is always properly synchronized because the same electronic circuitry controls the exposure settings and the light source. Similarly, external flashguns that are fitted into the slot on top of the camera (the hotshoe) are also easily synchronized. Things become a bit trickier when the flashgun is separated from the camera but often there is a special circular (Flash-PC) socket on the camera into which a flash cable can be fitted to link to the flashgun. Failing this, if the camera has a hotshoe then it is possible to buy a small adapter that provides the necessary circular socket on a block that fits into the hotshoe.

In all of these cases there is also the option to use a wireless link instead of a long cable if the flash unit and camera are some distance apart. This is an especially useful tactic if there are small children around who might pull on the flash cable, thereby causing either the camera or the flash head to fall over. Cable-free wireless links come in both infra-red and radio versions. Infra-red triggers are especially handy because many studio flash heads will respond to infra-red triggering signals without the need for a special receiver whereas radio systems need both a transmitter on the camera and a receiver connected to one of the flash heads.

Finally, there is the trickiest situation of all: what do you do if you want to use studio lighting but own a digital compact camera that has neither a circular flash cable socket nor a hotshoe and therefore cannot interface with external flash heads? One answer might be to rely on the integral photocell contained in (or easily attached to) studio flash heads. This is a light-sensitive switch that fires the flash head instantly in response to another flash firing and is most commonly used to ensure that all the flash

units in a multi-head arrangement go off at the same time. The same device will also trigger the flash heads as soon as a camera's own small flash unit fires so seems to offer the perfect way to make sure that all the flash units go off at exactly the correct moment.

Sadly, this system is not entirely straightforward to use in practice because many digital cameras fire a series of pre-flashes to collect exposure and focusing data before the picture is taken. The danger is that these pre-flashes will trigger the studio lights, thereby leaving the lights drained of power and unable to respond when the picture-taking flash follows immediately afterwards. If you encounter this problem then you should buy a special digital camera flash trigger that connects to the flash head and ignores the pre-flashes but fires the flash head when the exposure flash is released by the camera.

Studio flash units have a series of controls, often located on the rear panel, that allow their brightness to be adjusted and other settings made.

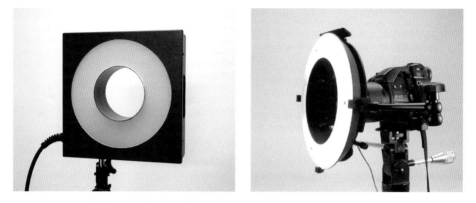

Right-lights provide a very soft lighting effect with a rapid fall-off that helps the subject to stand out from a darker background. The square version here has a flash tube inside its housing whereas the circular version has a continuous-light source.

It is worth noting, however, that as well as studio flash heads it is also possible to buy very bright *continuous lights* that use similar technologies to those employed in domestic light bulbs. The advantage of these lights is the fact that their effects can be judged by eye: the twin disadvantages are much less photographic brightness than is provided by flash lighting (despite their high visual brightness) and the considerable amount of heat that they generate, which can be uncomfortable and a safety hazard. Fortunately, there are also low-heat studio lights that use photographic-quality fluorescent tubes but which do not cause the various colour casts seen when pictures are taken under domestic or office fluorescent lighting. Nevertheless, these are specialized items of equipment and will probably only be encountered in dedicated professional photographic studios and rental companies.

More important than the light sources themselves are the various accessories that can be attached to them. The range of accessories offered by different flash manufacturers is one of the factors that cause photographers to choose one brand over another. Flash heads normally come with a standard *reflector* that is bowl-shaped and throws the light forward onto the subject: a similar, but much more compact, reflector arrangement is built into camera flashguns and even the integral flash units contained within digital compact cameras. Importantly, however, the reflector that comes with a studio flash head can be removed and replaced with different sizes and shapes of reflecting or diffusing accessories.

Larger reflectors tend to give a softer lighting quality, especially when used at close range, without a serious loss of brightness. This distinguishes them from diffusing accessories, which always reduce the light to some degree. A special and very efficient form of diffuser is the *softbox*, which as its name suggests is a box-like structure with a translucent panel at the front. These accessories, which also come in a variety of different guises (such as Octa and Quadra lightbanks from Elinchrom, for example), are manufactured in various sizes from a half-metre square to panels that are

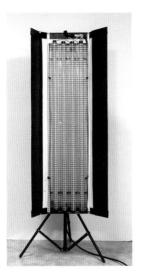

This is a KinoFlo light that is equipped with photographic-quality fluorescent tubes. KinoFlos are available in both daylight and tungsten-balanced types and are used to create a natural lighting effect that is similar to an overcast sky.

2 metres or more across. The smaller the softbox the smaller is the area that it can light evenly. Therefore half-metre designs tend to be used for taking head-and-shoulders portraits whereas the 2-metre strips are most likely to be used for full-length pictures.

A less controllable way of adjusting the lighting quality is by using *umbrellas*, which are fitted to flash heads so that the light either reflects from the inside surface or shines through a diffuser layer. Some reflecting umbrellas are double-sided so that they can be used with either a white side or a metallic surface. Natural white gives a good soft result; silver gives a brighter but harsher quality; gold warms the light to give what are sometimes regarded as more flattering skin tones. The problem with umbrellas is the fact that they tend to scatter light over wide areas. This makes them ideal for creating simple-to-use lighting arrangements, such as are required for large-volume portraiture, but the lack of control that they bring means they are very rarely employed in creative professional photographers' studios.

A few accessories are intended for lighting subjects from the rear so as to create an eye-catching highlight in a person's hair, for example. The important thing here is that the light must not fall onto the front of the camera lens as this will cause flare that will reduce image contrast and may also overlay ghostly geometric shapes on the picture. Therefore the two most commonly used accessories of this type are the *snoot*, which is an open-ended conical tube, and the *honeycomb*, which is a grid containing small cells that resemble, unsurprisingly, the shape of a honeycomb. Both of these accessories limit the degree to which the source's light is allowed to spread out. Honeycombs are often the better choice of the two not only because snoots tend to get much hotter but also because different densities and depths of cells can be used to create different effects when honeycombs are employed. When dealing with continuous lighting, honeycombs are referred to as *egg-crates* and snoots are

never deployed because in this case it is more efficient to use a lens arrangement to focus the light into a small area. (Lens-based accessories are less common for flash equipment because the shape of the flash tube makes its illumination poorly suited to this type of manipulation.)

The final item of lighting equipment that may come in useful in a studio is a set of *reflector boards*. These are normally made of polystyrene, white on one side and black on the other, and follow a similar range of sizes to that in which softboxes are made. The white surface is used to reflect light into shadow areas, so creating a softer, more flattering lighting effect. The black side is used to create dark edges on whatever is being photographed, whether it be a person or an item of glassware. Careful use of black poly-boards can transform a picture by creating a better sense of depth on account of emphasizing sideway-facing surfaces that are responsible for conveying the illusion of three dimensions in a two-dimensional picture.

Lighting arrangements

It is perfectly possible to take some excellent studio-style portraits with most mid-range digital cameras using nothing more than a single off-camera flashgun, a basic flash meter and a small (half-metre) diffuser panel. The secret of success resides simply in knowing where to place the light source (flashgun and diffuser panel).

The usual places to position a single light source are either directly above the line between the sitter and the camera lens or directly above the nose-line of the sitter (even if the model's head is turned away from the camera). Alternatively, the light can be placed to one side with the model facing the camera. These arrangements provide what is traditionally known as butterfly and Rembrandt lighting effects. In all cases the effect is most striking, and therefore potentially least flattering, when a bare flash is used: the effects can be softened by interposing a translucent diffuser panel or by fitting a softbox to the flash head.

The advent of digital imaging brought computers into the studio and lighting manufacturers responded by offering computer-based lighting control systems, such as this one from Elinchrom.

If two flash sources are available then there are two distinct ways in which to use them. The first is by creating a symmetrical, and therefore very soft, lighting arrangement comprising one source to each side of the model either with softboxes attached or by reflecting the heads' light off white poly-boards angled towards the subject at 45 degrees. The second approach is to retain a single light as the main light and to use the second unit either as a general fill-in or positioned behind the subject, probably with a snoot fitted, to provide hair lighting.

The easiest way to get a soft fill-in lighting effect is to aim the second flash head into a corner of the room where the ceiling meets two walls somewhere in front of the model. The power of the light should be such that if the main light is switched off the flash meter reading will drop by between one and two aperture numbers. For example, if the flash meter reading with both lights switched on were f/8 (corresponding to an aperture number of 8) then the reading using only the fill-in light should be between f/5.6 and f/4. Note, however, that the walls and ceiling from which the fill-in illumination is bounced must be white or nearly white because any obvious colour on the walls or ceiling will be carried by the fill-in illumination and will put a colour cast on the picture. This cast will not be easy to remove because its strength will vary across the image depending on the relative brightness of the main light and the fill-in light in each individual area of the picture.

Using three lights allows both fill-in and hair lighting to be used if so desired, and as more and more lights are added it becomes possible to fine-tune the lighting in several different areas of the picture at the same time. Some of these possibilities, both simple and more complicated, are illustrated in the examples at the end of this chapter. Remember, however, that natural lighting always has one source or is non-directional: arranging lighting with two competing main lights is considered to be bad practice.

As well as arranging the lights in front of the subject it is also necessary to light the background. In this case there were two lights in front of the model (left and top) and two lights at the rear to make the background nearly white.

Lighting techniques for still life

The biggest difference between photographing people and photographing inanimate objects is the need to flatter, or at least satisfy, the former whereas the latter express no opinions so can be interpreted however the photographer sees fit. In theory the same basic (natural) lighting principles apply to still life as they do to portraiture but in fact it is more usual to start off by considering what style the picture is to have and what technical difficulties (such as polished surfaces) have to be overcome.

A simple lighting technique that is easy to use and suits a wide range of still life subjects involves placing a large softbox directly above the set. The hardest thing about this arrangement is finding a secure way to support the light: in a professional photographic studio a boom arm is used but in home studios it is sometimes sufficient to support a crossbar between two tripod stands. In terms of natural lighting comparisons, the resulting effect is similar to an overcast sky that creates no shadows and has a low risk of specular reflections. Given that the angle between the direction of the lighting and the position of the camera is likely to be about 90 degrees, it follows that the only surfaces that will reflect the light directly into the camera lens will be at about 45 degrees: many objects do not have any surfaces at this angle and are therefore easily photographed in this way.

Curved surfaces are more problematic because they encompass a wide range of different angles and it can be difficult, if not impossible, to avoid reflections of the light source. In fact, these reflections can be used to emphasize the roundness of a surface, especially when the reflections are of a hard-edged rectangular softbox. If it is necessary to tame these reflections then sometimes it can be sufficient to fit a polarizing filter over the camera lens and rotate it to find an angle that dims the reflections to an acceptable level. Often, however, it is only possible to extinguish the reflections entirely by fitting a second polarizing filter over the light source but these filters need to be rather large and are therefore very expensive. Note also that some polarizing filters can inhibit cameras' auto-focus operation so always test a polarizing filter on your camera before buying it!

Fortunately, the theme of this book is digital photography and it is only natural to observe that an image containing unsightly highlights can

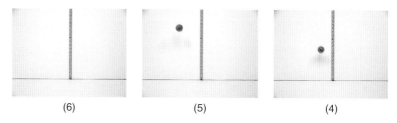

| (6) | (5) | (4) |

These six pictures of a bouncing ball were taken using continuous lighting. The images have been adjusted in Photoshop using Auto Contrast, which has resulted in a rather unnatural but very bold image quality. The sequence should be read backwards (from right to left) as the ball was thrown into the scene from that side.

be retouched using an image manipulation program to achieve a much more pleasing result. That said, it should be kept in mind that highlight areas tend to be devoid of surface details and that these can be awkward and time-consuming to recreate so if at all possible it makes sense to control the lighting before the picture is taken.

Another lighting technique that is used for still life pictures is backlighting of translucent objects. Often the object concerned is placed on a horizontal piece of glass below which is a white surface that is illuminated by two light sources placed on opposite sides. The lighting arrangement is essentially the same as when illuminating a flat piece of artwork for copying, except that in copying the artwork is placed on the illuminated surface whereas for back-lighting the object is forward of the surface. When such pictures are taken the light travelling through the translucent object will be dimmer than the light travelling through the areas of surrounding glass and any visible areas of white background will therefore be over-exposed. This problem is overcome by masking off these areas with black card. As well as avoiding over-exposure this also solves the problem of reflections of the camera being seen in the glass. Incidentally, the same potential problem also explains why professional photographers sometimes stick matt-black tape over shiny parts of their cameras and why they often shun white and brightly coloured clothing.

The final piece of advice for anybody deciding to have a go at still life photography is to keep things simple. Start with high-quality objects that are of modest size and which contain no tricky features such as shiny surfaces. Watches, for example, are both rather small and often contain a myriad of reflections so ought to be avoided, whereas matt-glazed pottery would be a much wiser first choice. Flowers, especially larger and more ornate blooms such as lilies and orchids, are also good choices.

But if all this talk about lighting techniques seems off-putting then remember that many great artists used nothing more than natural window light to create their masterpieces and you could do well to adopt the same tactic. If you do go down this route then instead of buying lighting equipment you should purchase a sturdy tripod because the exposure times involved are likely to be quite long and any blurring could ruin your pictures.

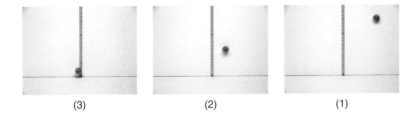

(3) (2) (1)

Studio Example 1: Hair shoot

The following two pictures show the lighting arrangement and the final result obtained in a shoot that was lit using continuous tungsten ('hot') lights. Most of pictures during this session were shot on film but a Ricoh RDC5300 digital compact camera was also used to record the lighting set-up and to produce some quick pictures to show the model (including the frame shown opposite). If this had been a professional shoot then, at that time, the instant pictures would have been taken on Polaroid film: as it was the pictures were done as personal work for the photographer and the hairdresser/stylist so it was necessary to keep the costs as low as possible. This cost-saving, once all the necessary equipment has been purchased, is a clear advantage in favour of digital photography.

The background was lit by a 2000W blonde, which is an open-face light that has an integral bowl reflector. Its effect is to create a bright central area surrounded by gradual fall-off: in the portrait shown here the background light is slightly too bright for the digital camera's sensor but worked well on film. The main light (another 2000W lamp) and the fill-in light (1000W) were both diffused through translucent panels arranged to opposite sides of the camera-to-model axis. There was also a fourth lamp that provided 800W of back-lighting to create the highlight on the model's shoulder. The light levels were sufficient to give f/4.5 at 1/60s on

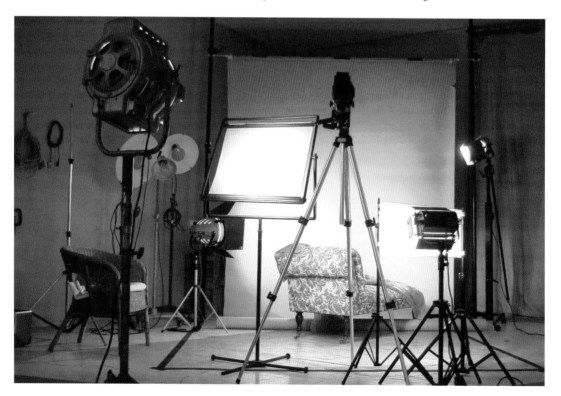

ISO64 film: the RDC5300 was simply set to fully automatic and did a good job of judging the exposure and the colour balance for itself. If the digital images had been the final product in this case then the background light and back-light would both have been turned down slightly because it is clear that the RDC5300's sensor did not quite have enough accommodation in its tonal range to render them with sufficient subtlety. At the same time it would not have been advisable simply to reduce the exposure overall as this would have lost the textural detail in the hair, which was the focus of the picture.

This example illustrates the now widely recognized fact that switching from film to digital capture is basically straight-forward but does involve a slight retuning of specific techniques, including lighting, to match the requirements of the digital medium.

Studio Example 2: Mark and Marie

The same lighting was used for both of these pictures and was chosen specifically to allow changes of pose without having to rearrange the lights every time. A large (2-metre) softbox was turned horizontally and supported on a conventional floor-standing tripod to light a wide area with even illumination. The high angle of the main light is clearly betrayed by the

shadows underneath the couple in the seated pose. A second flash head was aimed into the corner of the room opposite the couple so as to provide soft fill-in illumination. This combination is a very safe and versatile arrangement that is reasonably foolproof. As can be seen in the pictures, Mark and Marie enjoyed themselves during the session and the ability to capture spontaneous expressions such as these depends to a large degree on not having to worry about the lighting.

If you look at the pictures carefully you will be able to see a reflection of the horizontal softbox in the couple's eyes. You may also notice that in Marie's eyes in the standing portrait it is possible to see some other areas of white that are not as bright: these are the white walls of the studio closest to the corner in which the fill-in light was placed. The fact that these walls can be seen illustrates why it is so important not to have any brightly coloured surfaces in the studio as these could easily show up as coloured reflections.

The back-drop to these pictures was a warm, almost flesh-coloured roll of background paper. The paper was arranged in a gentle curve so as to give no clue about where it changed from coming down the wall to running along the floor. No image manipulation has been applied to these pictures other than to remove some dust blemishes that were probably caused by dirt getting onto the sensor when the camera's lenses were being swapped over. The camera used was Kodak's full-frame DCS Pro 14n and the lenses were conventional Nikkors that were originally designed for film cameras.

Studio Example 3: Lindsey

This dark and rather brooding portrait was taken using flash lighting with a snoot as the main light, which was a rather unusual choice. The reason why this was done was to contain a brighter pool of illumination on the model's face with less light reaching the rest of her body. It is important to realise that a snoot does not create a hard-edged disk of light but rather gives the sort of effect seen here. The main reason for this is the fact that the inside surface of a snoot, although coloured black, reflects light out at different angles as well as the straight-ahead angle defined by the aperture at the front of the snoot. If a hard-edged pool of light is required it is necessary to use a lighting accessory that has a lens in it to focus the light in one place: these accessories are available in both flash and tungsten versions (such as the one shown overleaf) but they are generally expensive and rather heavy.

The snoot's effect was tamed using fill-in illumination bounced off a white wall slightly to the left of the picture. It is not possible to see a reflection of the fill-in light in the model's eyes but the tell-tale sign is the change in density of the shadow on the model's neck and the highlights on her lips. It is clear that there is more fill-in illumination coming from the left of the picture and that the shadows cast by the main light are strongest towards the right owing to the fact that the dark background has not

reflected any of this fill-in light back. The whole mood of the picture has been kept dark (low-key) with the aim of simulating a look that would have been obtained if the picture had been lit using tungsten lighting.

The lighting scheme used was the traditional 'butterfly' arrangement that is so called because the shadow under the model's nose is supposed to look like a butterfly in flight (seen head-on). To get this effect the main light needs to be almost directly above the line of the model's nose, which means directly above the camera if the model is looking straight into the lens. That can be a difficult arrangement with which to work as there is a danger of stepping back from the camera and knocking the light if it is behind the camera, or of inching the camera tripod forward and hitting the lighting stand if it is in front.

The camera used here was an Olympus E-10 set to ISO80 with an exposure time of 1/30s and an aperture setting of f/11. The picture contains more noise than would normally be expected from such a low sensitivity setting but that is not a problem in this case because it adds a slightly gritty feeling to the image – an effect that would have been achieved in the past by using a more grainy film than usual. The E-10 has only four million pixels, which in theory is not enough to allow the picture to be used the size it is here. A common guideline is that the size of a picture when it has a resolution of 300 pixels per inch is the maximum safe size

Dedolight 400 fitted with focusing spot attachment

for publishing the image in a book or magazine. The E-10's pictures comprise 2240 × 1680 pixels, which divided by 300 gives approximately 7.5 × 5.6 inches, so the maximum size ought to be about half of the area of a page in this book. The fact that the picture has been enlarged without any serious loss of image quality is thanks to the application of an image enlargement program. This technique is discussed in more detail in Chapter 13 dealing with supporting software.

Studio Example 4: Still life

Both subjects shown here (the eggs below, and the jugs overleaf) were photographed under studio conditions but lit by natural daylight. This is important because it emphasizes the point that a studio does not have to contain expensive specialized lighting equipment. The light in both cases came from a large overhead window and the same effect could easily be created in a domestic conservatory – because that was in fact exactly where the pottery picture was taken. This location stresses an second point: studio-style pictures do not have to be taken in a dedicated photographic space but rather only need somewhere that can be pressed into photographic service at a certain time.

Having explained how easily pictures like this can be taken it is necessary to admit that the pottery picture was captured using a Kodak Digital Camera Back on a medium format (Hasselblad) camera. The quality offered by this, now discontinued, system was excellent and although it would be unreasonable to expect a more modest camera to produce exactly the same results many digital SLRs are now capable of getting close to this high standard at considerably lower cost. The pictures of the natural and deformed eggs illustrates this fact, having been captured using an affordable but very capable Nikon D70s. The only item of equipment that these pictures have in common is a sturdy tripod on which the two cameras were supported.

As-shot and colour-corrected versions

Theresa Robinson pottery, photographed using natural overhead light provided by a glass-roofed conservatory.

The area in which high-end digital cameras are set apart from other digital capture systems is the ability to perform full colour calibration rather than having to rely on a simple white-balance setting. As a result the pottery picture was perfect straight out of the camera whereas the eggs had to be corrected manually to remove a colour cast and improve the contrast: these changes are illustrated by the accompanying as-shot and improved versions of the picture.

CHAPTER 9

Printing Systems

Although the ability to view pictures instantly on a camera's in-built screen is one of the defining characteristics of digital photography, there still comes a time when paper prints are required. One reason for this is that it is far easier to pass prints around a gathering of friends or family than it is to circulate the camera itself, or even to huddle over a computer. People often like to view pictures in their own time, pausing longer on some than others, so regimented viewing of a series of pictures displayed on a television screen is not ideal either. Then there is the matter of framing and permanent display: it is true there are electronic systems that will exhibit a picture directly from file but attractive though these gadgets may be they are limited in terms of size at an affordable price. Finally there is the advantage that a print is a document that can be filed with other documents, such as a holiday map or a baby's Christening certificate. Documents are important not only for the present but also for the future and it should be noted that digital photographs, more than any other photographic medium that has gone before, are the ones most in danger of being ephemeral and ceasing to survive for the benefit of future generations. Therefore, the inescapable reality is that there is still a great deal to recommend the traditional concept of a photograph as an image on a sheet of paper.

Digital photography provides unique controls that allow images to be enhanced in a way that suits the particular subject portrayed. By comparing the main picture opposite with the smaller version here it is possible to observe that the final image features a considerably higher colour saturation level. This change was made to produce a more dramatic finished print of the Pompidou Centre in Paris.

Modern digital cameras have screens that are large enough for pictures to be viewed by a small group of people, especially when the camera is mounted on a stand. For viewing by larger groups the camera's pictures can be displayed on a television screen.

The thing that has changed, however, is the greater variety of ways in which such prints can be produced. It is possible to take a camera storage card to a High Street minilab and get prints made in much the same way as they would have been created previously from film. It is also possible to get the pictures transferred from the memory card and stored on a CD so that the card can be erased (or reformatted) and used all over again. If you have a high-speed Internet connection it is even possible to send image files electronically to a processing lab for printing. The prints are normally returned by post and there is often the option to have back a CD of the original files as well if required.

If you have a truly great image that deserves turning into a really big print then professional processing labs can output digital image files to almost any size desired: be warned, however, that because the costs are considerably higher it is very important to have a good grasp of the technicalities that are involved. A lab will be able to advise you about the resolution (often 300 ppi at the output size) and file type required to generate a good quality print at the size specified. Advice will also be available about compression levels, colour spaces and how to calibrate your own computer screen so that the images you view at home will match the prints produced by the lab. More will be said about colour in Chapter 16 on colour quality but the comforting fact is that anybody who masters digital printing at home should have no trouble extending the same knowledge to include large-scale prints produced by professional labs.

Online printing

The best reasons for considering online printing services are convenience and quality. You do not need to step foot outside your door yet can receive prints that have been produced using equipment that could cost much more than your entire house. The two most common reasons that people give for not getting prints made using online services are payment security and inconvenience. The first concern is understandable given scares about Internet credit card fraud but reputable online printing companies go to

PhotoBox is one of the most successful online printing services: it operates a next-day delivery service to most UK addresses.

great lengths to protect their customers, knowing that just a single experience of online fraud could ruin their businesses. Far greater fraud risks may perhaps be encountered on less tightly designed e-commerce sites, but even so the true risk level for online printing looks small. Two simple tips to help ensure your online security are to use a reputable service, such as PhotoBox in the UK, and always to check that the website you are dealing with changes from http to https (secure hyper-text transfer protocol) and that a locked padlock appears at the bottom of the screen before you reveal any personal financial details.

Online printing is inconvenient in the sense that although you don't need to leave your house there is an inevitable delay between sending the image files and receiving your prints. This is unavoidable but online printing services go out of their way to make the overall experience as easy and user-friendly as possible. PhotoBox, which is also one of the Internet's longest-running and most successful online printing services, has a slick and easy-to-use interface that handles up-loading of image files for printing within the website. This means that there is no need to close the web browser and open a separate e-mail program nor to have downloaded any special software in advance.

The best thing about third-party printing in general, whether it is undertaken by a High Street minilab or an online service, is the fact that your images are output on conventional photographic paper, not as inkjet prints. Photographic papers and dyes have a long-proven ability to withstand fading and splashes, which inkjet prints sometimes cannot. In addition, it is not often appreciated that photographic prints made from digital image files are at much the same price level today as they have been for many years and can actually work out cheaper than inkjet prints made at home.

Desktop systems

Despite the advantages in favour of third-party printing it is currently the case that the vast majority of people who engage in digital photography also do at least some of their own digital printing at home. This situation is

Nature subjects, which often have delicate tones, need to be printed using a system that offers high colour fidelity. In many cases the default settings for desktop printers, especially when loaded with glossy papers, are too brash and should be adjusted manually. More is said about this topic in Chapter 14 which deals with fine-art printing.

analogous with the early days of film photography when many enthusiasts had home darkrooms, except that digital printing is a much more comfortable experience than having to work in a darkened and often stuffy environment surrounded by potentially toxic chemicals. This makes digital printing a less demanding experience that is more pleasurable for more people, which is precisely why it is so popular. It is not even necessary to own a computer as printers can be bought integrated into camera cradles or as stand-alone devices that can interface directly with cameras or data storage cards. Nevertheless, in practice it is the norm for most people who own a digital camera and printer also to own a computer of some sort.

There are two common desktop-printer technologies: inkjet and dye-sublimation.

Inkjet printers

Inkjet includes all printers described by any word that ends 'jet', such as BubbleJet and DeskJet (brand names that are used by Canon and

(*top*) Back in 2001 Epson launched its Stylus Photo 895, which was the first printer to incorporate Print Image Matching technology in an attempt to improve the quality of digital prints. (*bottom*) Today image quality is generally very high indeed and it is possible to produce prints directly from the camera with little need for an intervening computer. The printer shown here is one of the compact models in Canon's Selphy range.

Hewlett-Packard respectively). All inkjets use liquid inks that are squirted onto the paper by some means. In the case of Epson printers the squirt is provided by tiny mechanical plungers that work a bit like miniature syringes. Today's Epson inkjet printers are in many cases the standards by which similar models from other manufacturers are judged. This does not

Printers that offer direct printing feature a user interface that offers control over features such as the number and sizes of images to be printed. In the earliest printers this interface was provided via a television screen but modern machines have integral colour LCD screens, often with additional monochrome information displays.

mean that Epson printers are the best in every case, but it is certainly true to say that the longest-lived of Epson's printer lines are among the very best models available in their own market segments.

Another method of squirting ink is by using heat, which causes the ink to expand and eject itself from the nozzle towards the paper. This sounds like a relatively crude system but in fact it works very well, especially in compact print heads. Canon, which uses this type of thermal technology, makes some very small inkjet printers that are far smaller than anything offered by Epson.

Dyes versus pigments

A complication within the inkjet arena arises from the different types of inks used; in particular, dye versus pigment inks. Dyes have colourants that are fully dissolved in the liquid carrier. No matter how finely you strained the liquid nor how much you shook it the colour would always remain throughout the liquid. Pigments, on the other hand, are very fine specks of solid colourants that are suspended in the liquid. Using an ultra-fine filter, or with very strong shaking indeed, it would in theory be possible to separate the colour particles from the carrier.

There are a number of reasons why pigments may be preferred over dyes and vice versa. Dyes can define a wide range of bright colours and are fully absorbed in the coating that is applied to all proper inkjet papers. (A distinction should always be made between coated inkjet papers and uncoated plain paper, which does not give the same bright colours and high sharpness as is obtained when using coated inkjet papers.) Pigments, on the other hand, are more fade-resistant and tend to dry quicker but initially had a reputation for poor neutrality and lack-lustre colours. As a result, by far the majority of desktop inkjet printers use dyes, or dyes for their coloured inks and pigment for the black. The best Epson printers, however, use entirely pigment-based inks but are aimed at users who are prepared to pay a bit extra for both permanence and colour fidelity.

Box 9.1 **Primary colours**

There may be some confusion between the primary colours of inkjet printing, which are cyan, magenta and yellow, and the primary colours of light, which are red, green and blue, not to mention the primary colours of painting, which are red, blue, yellow and white. These are all different systems that are used to create a gamut (range) of colours in different situations: none of these is more correct than the other except in the sense that each is the preferred choice for a particular set of conditions. In the case of red, blue and green light, for example, when all three colours mix the result is white whereas mixing red, blue and yellow paints gives a colour that is nearly black.

The two sections show the far-off (yellow) view of a computer screen and a close-up enlargement of the same screen proving that the yellow sensation is created by a combination of an equal amount of red and green light.

Given that white is a mixture of many colours (hence why white daylight can reveal all the colours of the rainbow) it is logical for the red, blue and green primary colours to be known as the additive primaries. Similarly, the cyan, magenta and yellow of inkjet printing, like the blue, red and yellow of painting, combine to give almost black, which is an absence of colour, and are therefore known as the subtractive primaries, or secondary colours. Digital cameras that have an arrangement of coloured filters over the front of their sensors to record colour information can use either additive or subtractive primaries and may even add additional colours to their filters to improve the colour rendering of particular hues.

The nicest demonstration of the effect of combining different colours is given by examining a computer screen that has been

filled with a bright yellow colour. If you look very closely you will see that the screen actually comprises tiny dots or stripes of red and green against a black background: there is no trace of yellow! Our eyes interpret an equal mixture of red and green light as something that we call yellow. If the light comes from red and green sources that are quite separate, such as red and green light bulbs illuminating a promenade, then we see the individual colours but if the sources are so close as to be indistinguishable, as in the case of a computer screen, then the colour effects are combined and we see a yellow result.

All desktop printers, whether they use dyes or pigments, contain cyan, magenta, yellow and black inks. These give the initials CMYK, where K stands for 'key', which is black in printing-industry terminology.

The number of different inks available to an inkjet printer affects the smoothness of image tone that it is capable of producing. The printer driver shown here reveals that there are six inks in this particular case.

Another sub-division among inkjet printers is made according to the number of different inks that they use. The minimum number of inks required to create full-colour images is four: cyan, magenta, yellow and black. This gives the initials CMYK, when K stands for 'key', which means black (as in the term keyline – a black rule that butts to the edge of a photograph). The reason why these colours are chosen is that they are the ones that can be combined to create every colour when applied to a white sheet of paper. The black is there because cyan, magenta and yellow alone give a dark brown, not true black.

Unfortunately the only way to create a lighter colour is by placing fewer ink droplets on an area of white paper. This can lead to a slightly dotty appearance and was a common complaint levelled against early inkjet printers. One solution was to reduce the size of each droplet so that more could be used, thereby giving the illusion of the colour being diluted more homogeneously, but an even better solution was to add diluted colours into the ink-set. Six-colour printers add light magenta and light cyan inks to the traditional foursome: light yellow is not needed because this colour has quite a low visual density from the outset. The result is a less dotty print that has a smoother, more continuous tone. Following this success a seventh, light black, ink was added to improve the tonal gradation of monochrome images and to provide more subtle mid-tones in general. Epson subsequently added a third black, called light-light black, in its K3 (three-black) UltraChrome ink-set and other manufacturers have promised even greater numbers of inks in the future.

Attractive though greater numbers of distinct inks may be, from an image quality point of view there is a cost trade-off to be considered. The lightest inks, especially light magenta and light-light black, tend to run out very quickly, especially when printing portrait images, and are likely to need frequent replacement. This was never so bad in the case of Canon printers that have always had separate cartridges for each colour but it was extremely annoying for users of other printers that had one cartridge for black and another that contained all of the colours in one unit. Fortunately, it is now more common for all high-specification desktop printers to use individual cartridges for every colour, as has always been the case for large-format inkjet printers that are aimed at photographic labs. That said, rapid replacement of the diluted colours still adds to printing costs and can also be a huge inconvenience if the inks run out at the wrong time (when the shops are shut and online suppliers are out of stock). Modern printer drivers acknowledge this fact and whereas they previously warned of low ink levels only when the cartridges were close to being completely exhausted, Epson's K3-based printers now give progressive notifications that start when the ink level has fallen to just 20% remaining. This is a welcome development but it is still prudent to keep spares of rapidly consumed inks on hand in case replacements prove difficult to buy on the spur of the moment.

Other factors

As noted above, the search for better and better image quality also led inkjet manufacturers to chase smaller and smaller droplet sizes. These sizes, or volumes to be more correct, are measured in picolitres (pl) and have nothing to do with the printer's resolution (dpi). But like all things, there is a downside to small inkjet droplets, which is that the overall printing time is increased. Some inkjet manufacturers have got around this problem by employing variable droplet size technologies, wherein small droplets are used for subtle hues and changes in colour but larger droplets are used where there is a more uniform colour over a significant area. In combination, this two-tier approach gives a better balance of overall image quality and printing speed.

These improvements, together with the use of ink-sets that include diluted colours, have largely solved the initial complaint levelled against inkjet prints, which was that they were dotty, slow and lacked the smooth tonality seen in photographic prints. When inkjet manufacturers overcame this problem they proudly proclaimed that their printers had achieved 'photographic quality' but as soon as the prints started being treated as photographs and placed on display the problem of poor image longevity became quickly apparent.

The same problem affected photographic prints in the past and was solved by locking the dyes into more stable compounds within the paper's emulsion to reduce the fading effect of bright illumination, especially from the ultra-violet component of daylight. Photographic prints are now expected, on the basis of both accelerated tests and real-time experiments, to last at least 100 years and in some cases considerably longer depending on the technology incorporated in the paper. Inkjet manufacturers responded by designing ink-and-paper combinations that performed similarly well in accelerated tests but came unstuck when real-time experiments, including some conducted by the *British Journal of*

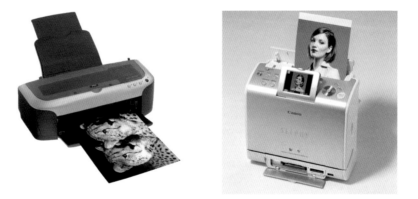

Large format printers like this A3-format Epson Stylus Photo take up a lot of space and there can be a good case for buying smaller models, such as the upright Canon Selphy ES1, if space is tight.

Photography under my editorship, proved that the predicted lifetimes were wildly optimistic. It is not so bad when all of the colours in a print fade at an equal rate, as this simply makes the print go a bit lighter overall, but if one ink fades faster than the others then a noticeable colour shift can appear very quickly, resulting in a rapid drop in image quality. This was exactly what happened with the first 'photographic quality' inkjet prints, apparently due to interactions between the different inks rather than any inherent instability in the pure inks themselves.

Modern inkjet inks and papers have moved on and most combinations are now very stable but it is still important to choose a pairing of ink and paper that gives good immediate image quality and offers long-term stability if the prints are pictures that will be treasured for years to come. Price should be a secondary consideration, though in practice it is often the first thing that people look at when buying inks and papers. This in turn can lead to the use of cheaper third-party consumables that may be a poor choice in the long run.

In addition, inkjet printer manufacturers take a dim view of users installing other suppliers' inks, and usually warn that this tactic will invalidate the machine's guarantee. On the one hand this is understandable since the printer manufacturer has designed each machine for particular inks and is the only party that has full access to the exact specifications to which each model is built. Independent inkjet suppliers must therefore develop their inks through a certain amount of trial and error. On the other hand, if a third-party supplier succeeds in offering something that the original manufacturer cannot then you may very well feel justified in exploring those possibilities. It does not matter which stance you take provided that the printer manufacturer's disclaimer is recognized: in short, if anything goes wrong it is your responsibility to bear the consequences, whether that is a damaged printer or prints that fade unacceptably quickly. More to the point, if these problems arise and you have only used the manufacturer's own materials then you will have a good case for making a claim against the printer manufacturer, which you could not do if you had used mixed brands as each manufacturer could simply blame the others.

Dye-sublimation

Although the vast majority of desktop digital printers are inkjet types a significant number use dye-sublimation technologies. Despite higher costs, slower throughputs and more limited print sizes, dye-sublimation prints were popular when inkjet printers were unpleasantly dotty but they went on to drop from favour when inkjet prints improved in quality. Today's dye-sublimation printers are cheaper, quicker and easier to use but are still confined to smaller sizes and are therefore carving a niche for themselves as the technology of choice for applications that demand a compact format.

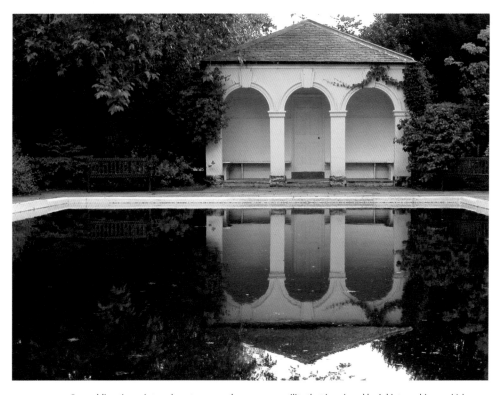

Dye-sublimation printers do not possess the same versatility that is enjoyed by inkjet machines, which can take a variety of different types of paper, but are a very reliable way of producing straightforward prints such as this at modest sizes.

Dye-sublimation printers work by transferring colours from a ribbon onto the paper by the action of heat. The colours are held as solid dyes that convert directly to a vapour phase and then condense on the paper: this process of going from solid to vapour and back to solid, without an intervening liquid phase, is called sublimation. Hence the name dye-sublimation, though other variations are also used by some manufacturers, such as ICI Olmec's dye diffusion thermal transfer (D2T2). In all cases the ribbon contains sequential patches of yellow, magenta and cyan dyes, sometimes with the addition of a fourth 'overcoat' layer that protects the image surface. (Good blacks can be obtained from dye-sublimation printers without any need for a black colourant thanks to the covering power of the colours that are used.)

Because the ribbon has to be slotted inside the printer to mate with the internal motorized advance mechanism it is normally only possible to use the printer manufacturer's own ribbons. Similarly, because dye-sublimation is effectively a contact process, where the coloured sheets have to be the same size as the images produced, it is common for dye-sublimation printers to be confined to enprint (4 × 6 or 5 × 7 inch) sizes: very few

Combined camera-dock-and-printer designs have been favoured by Kodak for some time as a simple way of allowing photographers to turn their digital images into paper prints with a minimum of fuss. As in larger machines of the same type, prints are created using colourants that are loaded on ribbons (the magenta ribbon being visible here) and transferred to the paper by the action of heat.

dye-sublimation printers go to larger sizes such as 8 × 10 inch or A4 format and those that do exist at these sizes tend to be very high-quality, rapid-throughput machines that are ideally suited to demanding professional applications where reliability and the need to be able to produce hundreds of prints with minimum intervention are paramount.

The appeal of a dye-sublimation printer is its great ease-of-use, which applies just as much to small-format models as it does to the larger professional machines. People who dislike the considerable bulk of many desktop inkjet printers and need only postcard prints may therefore prefer the diminutive proportions of smaller dye-sublimation printers. As an added bonus such users also enjoy freedom from the types of printing problems that are discussed in the next chapter.

Pictures such as this can be difficult to print well on account of the fact that despite being a coloured image it contains a lot of monochrome tones that will readily betray a lack of colour calibration at any stage in the printing process.

CHAPTER 10

Printing Problems

In theory, desktop digital printing is completely straightforward. Simply connect the printer to the computer, or load a camera memory card in a stand-alone printer, select a picture and choose the print command. After a few moments a finished print will emerge. The problems start, however, when the print does not quite look how you hoped it would. One huge area of potential difficulty is colour management but that is discussed separately in Chapter 16, which is devoted to colour quality. More immediately addressed here are matters relating to other aspects of image quality, such as lines on the print, smudging and severe overall colour casts. These are things that apply particularly to inkjet printing: generally speaking dye-sublimation printing raises fewer problems of this type.

Line faults

White lines on an inkjet print that go across the sheet, perpendicular to the direction in which the paper emerges from the machine, are invariably due to blockages in the print head whereas coloured or black lines in the same direction may be due to dirt sticking to the print head. Lines that

Various accessories are available to help provide some certainty about colour quality when printing images, including this easy-to-use Kodak kit that comprises both digital images and correct-appearance prints.

appear in the opposite direction, along the print in the same direction as the paper travels through the printer, are normally due to still-wet ink being marked by the transport mechanism or by ink that has been left by previous prints being deposited on the current image. There are different solutions for each of these four causes.

If there are pale or white lines running across the print that are thought to be due to *blocked nozzles* then you should run the house-keeping utilities that are supplied within the printer software and select Nozzle Check (this is the exact term used in the case of Epson printers). A pattern will be printed on a sheet of clean paper and by examining the pattern it is possible to decide whether or not there are any blocked nozzles. If so, run the Head Clean utility then repeat the Nozzle Check to confirm that the problem has been solved. If not, repeat the entire process. It is very rare indeed for a printer to require more than two head-cleaning operations, which is just as well given that this procedure consumes a fair amount of ink. Even better news is to be had in the fact that modern printers are much more resistant to clogging than were printers of old, so this problem should be disappearing into the mists of time.

One of the most common reasons for having to clean the head is still *infrequent use* of the printer. Epson recommends that for trouble-free printing it is best if ink cartridges are used up within six months of being installed. Confirmation of this cause comes from the fact that people who have regular nozzle-blockage problems while printing often find their troubles disappear when new ink cartridges are fitted. The other common reason harks back to the perils of using *third-party inks*, as mentioned in the previous chapter. In principle there is no reason why these inks should not work perfectly well but the most troublesome stage is when changing from one type of ink to another and doing this on a regular basis risks setting up problems. If you are using third-party inks specifically to obtain features that are not provided by the inkjet manufacturer, such as inks that imitate toned monochrome prints, then the sensible solution is to keep one inkjet printer for use exclusively with the manufacturer's own inks and to have another printer that is dedicated to the alternative ink set. Although this may sound extravagant, inkjet printers are relatively cheap and the extra outlay for another machine will often pay dividends in saved time and frustration, not to mention the ink costs avoided by not having to perform repeated cleaning operations. More thought is given to this topic in the next chapter, which deals with fine art printing.

Lines that run in the direction of print travel are invariably due to *ink problems*, rather than problems with the nozzles. Parallel lines that run continuously through the image area, but which do not show much outside it, are almost always due to the ink not drying on the paper quickly enough. This results in the image being scuffed by the rollers that transport the paper and is almost always caused by using either the wrong printer driver setting or a type of paper that is incompatible with the printer. Therefore you should check the printer driver setting (in Printer Properties or Preferences)

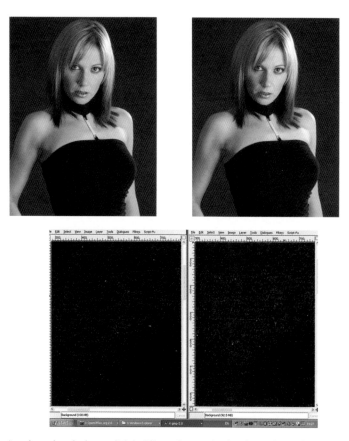

The two prints shown here look very slightly different from each other despite having been produced with exactly the same settings, on the same paper and in quick succession. Close examination of the slightly lighter/flatter print (left) shows very faint lines that indicate a nozzle blockage. Running a head-cleaning routine solved the problem. The subtlety of the problem is indicated by the relative slight differences that exist between the two enlarged sections of images taken from the background to the left of the model's head: the better print is on the right.

and if this is correct and you are using a third-party paper then you should try using the manufacturer's own paper instead. If you are already using the manufacturer's own paper and have the correct driver setting selected then it would appear that your printer may be over-inking due to a hardware fault: in this case you should contact the manufacturer for advice.

The third type of line fault comes from *previously liberated ink* inside the printer which is picked up by the paper. Normally these lines appear on the reverse side of the paper and may be confined to the leading edge of the paper as it passes through the printer. This problem is often a consequence of an earlier problem that may have been a paper jam that caused ink to be released when there was nothing to receive it. This can happen with some third-party papers that are not securely gripped by the printer's paper-feed mechanism. It can also be caused by trying to load a thick sheet

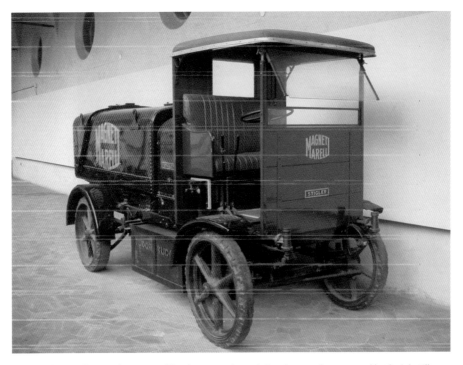

Tramlines such as can be seen on this print are rarely so obvious but are always caused by the ink still being damp as the paper is moved forwards by the printer's rollers.

of paper in the printer without adjusting the paper thickness lever (if one is provided). If the paper fails to advance then the ink that should have formed an image will simply collect inside the printer and be absorbed by the underside of the next sheet of paper that feeds through.

Cleaning

Accumulated ink can usually be removed by careful blotting with an absorbent kitchen-towel under the region where the print head traverses the paper. Make sure, however, that the paper towel is one that will not disintegrate because you may be surprised by quite how much ink can collect when an image fails to print. It could therefore take repeated mopping before the towel stays completely clean and dry.

Even if the thicker-than-normal paper does seem to feed through it may be scuffed by the print head, which could collect fine debris that gets dragged across the paper and mark the front surface in this case. The same debris might remain in place to mar subsequent prints as well and can prove difficult to remove. The tell-tale sign is lines that are often most obvious at the side edges of the sheet where the debris first strikes the paper. Use of the Nozzle Cleaning routine can sometimes solve the problem: failing that you should obtain a special cleaning sheet (which may have been

supplied with your printer). It is also worth noting that some printers, such as Epson's models, have fixed print heads whereas others, such as Canon's models, have their nozzles within the ink cartridges and are therefore replaced each time that the inks are changed. Although the latter might seem like a better way to ensure sustained image quality no matter how many prints are made the durability of fixed print heads has never been brought into question.

Smudges

Smudges are caused by the ink not being absorbed sufficiently rapidly into the paper, or rather the coating on the surface of the paper. This is a problem that can arise even after an apparently perfect print has been created and has nothing to do with scuffing inside the printer. It used to be a very common problem but is much rarer today thanks to micro-porous coatings. When it does occur it is most likely to be on textured papers, which have a top coat that provides the required surface finish but may also inhibit ink absorption into the receptor layer below. In minor cases the problem takes the form of a slight dampness that can make the print feel slightly sticky to the touch. At a slightly higher level of severity the inks may be damp enough to smudge with handling, so ruining the print. And in the worst cases the print is ruined before it even leaves the printer, the rollers inside the machine having left serious 'tram lines' through the wet ink, as mentioned above. In all cases, it is not the ink but the paper (or possibly the settings in the printer driver control panel) that is at fault.

Drying

The fact that prints can be damp to the touch is a useful reminder that the inks used are liquids and that these liquids have to be made solid in order for the print to be truly dry. Even when a print feels dry its absorbent surface coating can still contain liquids that must fully evaporate before the

A useful test image to keep on hand is a set of grey patches that can be used to spot subtle changes in colour due to minor nozzle blockages. The image should be printed both in greyscale and in RGB to ensure that the printer is as neutral when printing colour images as it is when using black ink only.

This is a real-world photograph that is genuinely difficult to print. The problem is having to keep the model's dress white and at the same time avoiding unpleasant skin tones: both of these aspects can be seriously affected by very minor shifts in the printing conditions.

print can be regarded as being completely dry. Because of this evaporation it is recommended that prints are not stacked on top of each other, nor tucked away in boxes, envelopes or sleeves until at least 24 hours after printing. If this is unavoidable then a useful tactic is to place a piece of plain photocopy paper between each inkjet print or between the print surface and the sleeve.

An interesting demonstration that can often be done with an apparently dry inkjet print that has just been created involves placing a piece of thermal fax paper on top of the image. If you leave the fax paper in-situ for 24 hours you may well find that a transfer of the inkjet image appears on the thermal paper due to the evaporation of volatile liquids that act as carriers in both dye-based and pigment inks.

Colour casts

The next type of problem is an overall colour cast. This may be caused by something as simple as a blocked nozzle, which means that some of the ink required to give a properly balanced image is not getting to the paper. Such colour casts can usually be confirmed by looking at the print carefully to

The horrible orange print shown here emerged unexpectedly from the printer, indicating a very serious nozzle blockage problem causing a lack of cyan colour in the picture. The correctly reproduced print was finally created after four successive cleaning operations.

see if there are also very fine pale lines running across it. If so then the solution is as outlined above for blocked nozzles in general.

The second most common reason for a colour cast is *low ink supply*. This too should cause pale lines to appear on the print but sometimes this is not the case. In answer to this problem Epson introduced an interactive method of measuring the ink in its cartridges so as to provide users with an accurate, rather than estimated, indication of the amount of ink remaining. The system also permits a realistic assessment to be made about whether there is enough ink remaining to produce multiple copies of a particular image. This calculation is based on the ink demand of the previous print, which may have had a different ink requirement, but it is certainly better than no such indication at all. The amount of information given about the remaining ink levels has gradually improved so that it is now fairly standard for printers to alert the user when the inks are running low but before they reach critical level. This initial notification is purely for information but ought to prompt the purchase of replacement inks before criticality is reached. A useful tip, if the coloured inks are running low and the intended print does not rely on colour for its effect, is to switch to printing with black ink only. This will rarely be a useful ploy when printing images but it can help to prolong the life of multi-colour cartridges when printing letters and website pages, for example.

As soon as the critical level signal appears, or when a lack of ink is suspected as the reason for an overall colour cast that cannot be traced to any other cause, a new cartridge should be fitted. It is generally a false economy to keep using an ink cartridge that is virtually exhausted. It is almost certainly true that running the nozzle cleaning utility (if necessary) and persisting with the near-depleted cartridge will enable additional prints to be made but the likelihood is that problems will become more frequent, leading to more ruined prints and mounting frustration. Changing the ink

(a) CH302A QP100475

(b) CH302A QP100475

(c) CH302A QP100475

(d) CH302A QP100475

(e) CH302A QP100475

These five print-outs show the state of the printing head as it was when the orange print (see previous page) was produced (*top*) and after each of the four cleaning operations. Note that at one stage the magenta head appears to become partially blocked during the cleaning process even though it initially displayed no problem.

cartridge straight away is a much less painful experience and often involves wasting comparatively little useful ink.

Yet another possible cause of colour casts is an *ink and paper mismatch* that is most commonly caused by trying to use incompatible third-party papers although third-party inks are just as likely to be to blame. To suggest that only the printer manufacturer's own products should be used may sound like a feeble attempt by those manufacturers to corner the market but this recommendation does contain more than a grain of truth. Simply changing from one brand of paper to another can be enough to shift the colour balance in the image and the extent of the colour variation

Simply changing from the printer manufacturer's paper to another brand can cause a significant shift in image colour. The warm-toned portrait was tuned for printing on Epson paper but when it was printed on another brand the image became noticeably less warm. Similarly, the colour image was natural on Epson paper but unpleasantly cold on another brand.

This is an example of true metamerism (see Box 10.1) being used to assess the quality of the prevailing lighting. If stripes can be seen on the test patches then the lighting does not conform to strict D50 conditions. The top patch was photographed under daylight and is a fairly good result but the lower patch was photographed under domestic tungsten lighting, which is clearly not suitable for critical print viewing.

caused by using a different paper, even one of the same designated type as the printer manufacturer's own, can be truly astonishing.

Fortunately, given that printer manufacturers do not offer every type of paper you might want to use, colour shifts caused by using third-party papers can be compensated through the use of dedicated colour profiles. These are discussed separately in the next chapter and later in Chapter 16 on colour quality. It is also worth noting that some third-party papers work very well without any obvious colour casts: if you encounter such a

paper and are happy to use it then by all means go ahead as manufacturers normally place no limitation on paper choice. As previously noted, the same is most definitely not true of third-party inks.

Last on the list of causes of colour casts is the effect of the *viewing conditions*. A print that looks great under household tungsten lighting could have a slightly different colour when viewed by natural daylight. The magnitude of this effect depends on the type of image: a picture that features bright colours is less likely to show the effect than one that is made up of near-neutral tones. The situation is worst when a monochrome image is printed in full colour but is totally absent when the same image is printed as a greyscale file. This topic, which is often discussed in the context of metamerism, is dealt with in Box 10.1.

Box 10.1 **Illuminant effects**

Why do some inkjet prints appear to change colour under different types of lighting? And why does exactly the same digital file show no such effect when output as a traditional silver-halide print? The answer lies in the colourants used to create the print. In an ideal world the spectral reflection characteristics of the ink-set should be flat overall, but in practice this is not the case. The closer a colour set gets to having a flat overall response, the less illumination-sensitive its colours will be. A great deal of work has been undertaken in the photographic arena to ensure that traditional prints are as good as they can be: this was not always the case but it certainly is today. Similar work has also been undertaken to prolong the longevity of conventional prints, leading to a situation where, for most purposes, modern colour prints can be thought of as a resilient, high fidelity medium.

Inkjet printing is a much newer medium and is still evolving. Just five years ago it was necessary to choose between high-stability pigment prints that suffered colour shifts under different lighting conditions or more consistent dye-based prints that were more susceptible to fading.

From this conundrum was born a need for limited colour (narrow gamut) pigment inks that made it possible to produce neutral and slightly-tinted monochrome prints that were reminiscent of toned darkroom prints. This niche was filled by products from specialist companies such as Lyson and PermaJet. More recently full-colour pigment inks have improved so much that there is less need for specialist products as it is now possible to produce full-colour, neutral monochrome and tinted results from a single ink-set, confident in the knowledge that the prints will look good almost regardless of the illuminant used.

Occasionally people still talk about the so-called metamerism problem, meaning the phenomenon whereby prints appear to shift their colour according to the illuminant used. It is useful to clarify this terminology because metamerism is actually the effect whereby two colours that look identical under one light source are seen to be different when illuminated by a different light source. The light source always has an effect of some sort but the human eye is good at adapting to different types of lighting and if its affect on a print goes unnoticed then it can be ignored. Kodak has a useful little set of reference patches, the Kodak Color Viewing Light Selector, that uses true metamerism to provide a quick guide to the colour temperature of the incident illumination in order to determine whether or not it is suitable for critical print viewing and slide projection (see p. 181).

Colour shifts exhibited by inkjet prints are not this same effect since they are not a matched pair of targets that become mis-matched when the lighting changes. It seems that the problem in early pigment prints was due to physical scattering of the light by the pigment particles: this is the same effect that causes the sky to seem to be blue even though it is illuminated with white light coming from the sun. Changes made to the formulation of pigment inks have removed this problem and the only need now is to ensure that prints are assessed under the correct viewing light so that the optimum colour balance is achieved. This does not necessarily mean a strict D50 (5000 K) environment that is the most technically correct so much as the same illuminant as that to which the prints will be exposed when they are displayed. Truly perfectionist printing labs make test samples and inspect these in-situ at the point of exhibition rather than simply relying on setting the printer to an absolute standard that may be technically correct but might still not provide the best visual result.

Image deterioration

Moving on from problems that occur at the printing stage, the next big issue is longevity. This is much less of a problem than it used to be but if fading occurs then the factors to consider are the print's exposure to light, heat, humidity and oxidizing gases, as well as physical damage. The last issue is easily overlooked but there is little point in having a print that could last for 50 or 100 hundred years if it is stored in a shoebox that is slightly too small, causing creasing of the paper. Even worse, if the shoebox is placed in a cellar it may suffer from water damage and in an attic it might get attacked by birds. Even under what could be considered more

normal conditions, displaying a print adjacent to a photocopier or on top of a television set can subject the image to small quantities of ozone gas, which is a powerful oxidizing agent that may cause loss of colour over a period of time.

In general, the highest longevity is to be expected from matched inks and papers, though it is also true that there have been some spectacularly bad exceptions in the past. 'Matched', in this context, does not necessarily mean inks and papers with the same brand name as the printer in which they are employed but it does normally mean the same brand name between the two consumable components. There are several companies in the third-party market that offer matched inks and papers, including; Lyson, PermaJet and Fotospeed.

It would be nice if there were a way to predict the likely longevity of an inkjet print instead of having to rely on the manufacturer's claims, which will almost certainly be based on the most favourable data available. The way that predictions are normally made is through accelerated tests that subject prints to very bright lights, which are then extrapolated to an equivalent amount of light over a longer period of time. If, for example, a certain print lasted 100 hours without noticeable fading under a light that was 50 times as bright as typical display illumination then the actual expected lifetime would be 5000 hours of normal illumination. If the print is assumed to be illuminated only half of the time (not at night) then the total lifetime would be claimed as 10,000 hours, which amounts to just under 14 months. These figures, it should be pointed out, are merely by way of example: today's inkjet prints should last much longer than this without any changes being perceptible in the image.

Image sizes

As larger inkjet printers have dropped in price the temptation to print images at bigger sizes has increased. Whereas an A4 print was once considered plenty big enough modern A3 printers are so affordable and reliable that larger formats are now a practical prospect for home printing. This in turn has brought a new problem to the home-printing arena, which is the requirement to have image files that are suitable for printing at larger output sizes without a visible drop in image quality.

Before considering this problem it is worth clarifying the difference between the two terms 'pixels per inch' (*ppi*) and 'dots per inch' (*dpi*). Printers and other output devices are specified in dots per inch because it is by using dots that they produce their physical images. Digital pictures, on the other hand, are composed of pixels and are scaled to a particular size by specifying the pixel density in pixels per inch. Suppose, for example, that you were to take a picture on a digital camera that has a sensor comprising about six million pixels in an array measuring 3000×2100 pixels: if this image were scaled to a pixel density of 300 ppi, by dividing each of the sensor's pixel dimensions by 300, then the maximum print size that could be

CHAPTER 11

Fine-art Printing

Such is the affordability, quality and ease-of-use of modern A3 desktop inkjet printers that almost anybody can now think seriously about producing high-quality prints at larger sizes than were previously possible at reasonable cost. As sizes increase so too do the options for creating framed

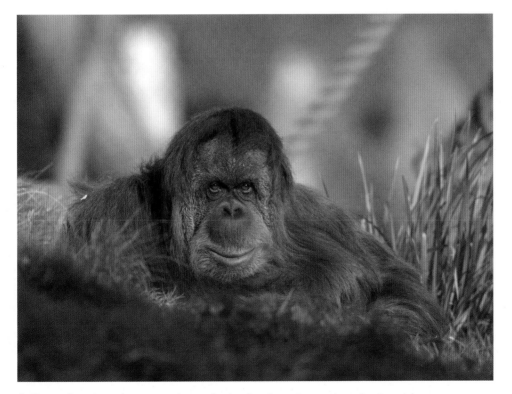

If a fine-art picture is one that can appeal to people other than those who were there when it was taken, or who feature in the picture, then clearly the subject must be impersonal yet eye-catching. Animals are a safe, if rather unsophisticated, subject to choose.

The fact that greater creativity is often associated with black-and-white images has led some camera manufacturers to include an on-board monochrome mode. In the case of Epson's R-D1 cameras there is also an option to create filter effects: the examples here show simulated green (*top*) and red (*above*) filtration. The full colour version is shown opposite.

prints for wall exhibition but there is an important distinction to be made between prints that are simply big enlargements and those that have additional merit in their own right. The definition of a fine-art print is one that is appreciated for what it is rather than what it depicts: the subject is important only in general not because of its individual identity. Think of Leonardo da Vinci's *Mona Lisa*, which is obviously a portrait of a woman but is applauded for its form and execution rather than its

likeness to the sitter. It is perfectly possible for a fine-art print to have individual appeal but it must also have more than that if it is to justify the fine-art label.

Another definition arises by observing that a fine-art print is one that somebody who is not directly connected with the execution of the image might want to buy. This is less helpful because it suggests that mass-produced posters that are bought in their millions by anonymous buyers should be regarded as fine-art works, which is not normally considered to be the case. The reason why posters do not qualify is the fact that they are produced en masse whereas a fine-art print needs to be individually crafted. It does not matter whether there are multiple copies of the image (there are multiple copies of Vincent van Gogh's *Sunflowers* but nobody would deny those fine-art status) but individual attention must have been paid to each one. Artists' etchings, which are printed using a small-scale mechanical production process are therefore no more or less works of fine art than are individually crafted inkjet prints.

A note on terminology

There is a certain snobbery that looks down on the terms 'inkjet' and 'photo-graph', preferring instead such alternatives as 'giclée' and 'silver print' respectively. Giclée has a precise meaning in the context of inkjet printing and was the word coined by Jack Duganne at Nash Editions as a more ele-gant alternative to the term 'IRIS print', which was used previously on account of the name of the printing machine first used for producing high-quality, large-format inkjet prints. The word giclée is derived from the French verb *gicler*, meaning to squirt, spurt or splash and the noun *gicleur*, meaning nozzle or jet. It is sometimes used today to indicate a fine-art

inkjet print but is shunned by other people on account of its specific reference to IRIS inkjet printers and the implication that it is a purely reprographic process. Modern alternatives include 'Epson prints', 'pigment prints' or even 'original digital prints'.

The last term needs all three words because, as Harald Johnson points out in his excellent book *Mastering Digital Printing* (Muska & Lipman, 2003), there is a difference between an inkjet print that is a copy of an artwork in another medium (an oil painting for example) and an inkjet print that is an original work in its own right. Ironically, the term giclée originally applied to the former situation – inkjet prints that were merely copies of something else. Nowadays it is relatively rare, and sometimes considered both ill-informed and pretentious, to use the term giclée in the context of digital photographic prints. It is more common to use the terms 'pigment print' or 'original digital print', the manufacturer-specific alternative being less popular probably on account of its more mechanical connotations (just as 'IRIS print' originally gave way to 'giclée').

Equipment choice

Reference to IRIS and Epson prints highlights the fact (although artists may wish to focus attention on more creative matters) that the method of production of an inkjet print is almost as important to its fine-art status as the image itself.

Printers

Being aimed at the pre-press market, IRIS printers were large-format machines that were very expensive both to buy and to run. Photographers who wanted to have digital fine-art prints made were initially compelled to use these machines because there was nothing else available of comparable quality, but that meant the technology was beyond the reach of most people. Worse still, pre-press proofing machines were never designed to produce prints that would last for many years. This led firstly to some important work

AL0853 QP101589

Fine-art inkjet printers routinely feature seven or more different inks. This nozzle test pattern was generated using an Epson Stylus Photo R2400, which uses three different densities of black ink as well as five coloured inks.

on inks that offered greater longevity and secondly to some photo-artists observing that if deterioration occurred it would be a simple matter to reprint another image that was identical to the first in its perfect form. Although this stance was meant to combat concerns about photographic image longevity it back-fired to a certain extent by allowing collectors to view inkjet prints as ephemeral objects that were inferior to more durable media. Nevertheless, Johnson records that the first fine-art photography exhibition comprising only digital prints was staged as far back as 1990, which was the same year that Adobe released version 1.0 of Photoshop.

Epson's first inkjet printer was announced three years later but it was only with the arrival of the A3 format Epson Stylus Photo EX desktop printer that the technology finally became affordable and desirable as an in-house printing system for individual photographers. This model gave way to the 1200 and then the much-loved 1290, which still survives today in the guise of the 1290s. The Epson Stylus Photo 2000P arrived in 2000 and was the first desktop printer that used pigment inks throughout. Its successor, the seven-colour Epson Stylus Photo 2100/2200, was a significant improvement in terms of its prints' immunity to the effects of different illuminants (as discussed in the previous chapter) but it was still not perfect for the production of monochrome prints. All of that changed with the arrival of the Stylus Photo R2400, which introduced an eight-colour version of Epson's highly durable UltraChrome ink-set, called K3 (three-black). At this stage, in 2005, it became possible to have just one printer that was equally at home producing both full-colour and monochrome prints. It is therefore probable that the days of stand-alone monochrome printing systems for general use are now drawing to an end.

The reason why monochrome printers were previously in such high demand was due to the simple fact that inkjet manufacturers initially concentrated on the colour market. Not only that, but it is likely that they did

Fine-art inkjet papers are likely to be clearly identified as such. In general, fine-art printing is done using matt or semi-matt papers rather than glossy papers.

not really understand the needs of monochrome workers, many of whom were seeking a digital equivalent of the great darkroom papers, such as Agfa Record Rapid and Kodak Ektalure. To a degree this failure to appreciate the needs of some of the most demanding of all photographic users still persists today because, although printer and ink technologies have improved enormously, the best printing papers are still third-party products.

Ink-sets

Despite the arrival of genuinely multi-purpose printers, it is still worth stressing the existence of third-party monochrome ink-sets for other printers, including some older models that might otherwise be thought obsolete. Therefore, before discarding an old printer it may be worth checking whether there are dedicated monochrome ink-sets available for it as this could well prolong its usefulness. Better still, there are monochrome ink-sets that are continuous flow systems, wherein the ink reservoirs are external bottles that are connected to the printer via flexible tubes, which can work out much cheaper than using a printer manufacturer's own inks.

As was noted in the previous chapter, using third-part inks may invalidate the printer's guarantee but this is largely academic for a machine that is out of warranty. The biggest problem arises when the old and new inks mix, leading to blockages. This can be avoided by using special rinsing solutions that flush out the old inks before the new inks are loaded. These cleaning fluids are normally available from the same companies that supply third-party inks and are certainly offered by both Fotospeed (www.fotospeed.com) and PermaJet (www.permajet.com).

To print a monochrome image using monochrome inks installed in a colour inkjet printer the simplest tactic is to convert the image to a desaturated RGB file: this ensures that all of the inks will be used and has the advantage of providing a good on-screen image preview. Some of the available ink-sets are small-gamut types, which means that they have the ability to create a limited range of tints that are similar to darkroom toner effects. Tint adjustments are undertaken by moving the curves for each of the different colour channels in accordance with the precise toner effect required. Unfortunately it is no longer possible to preview the print when this method is adopted as the on-screen image acquires some very odd looking colours on account of the changes made to the RGB channels. This limitation is one of the primary reasons why it is useful to have the ability to print tinted or neutral monochrome images from within a standard printing environment.

Image improvements

The simplest improvements to any image are often obtained just by using an image editing program's automatic functions to adjust brightness and contrast (or levels). The general rule is that if an image looks good on the

These pictures were both taken in the Rodin Sculpture Garden in Paris, where any picture-taking session would have to include at least one image of *The Thinker*, Rodin's most famous sculpture, but to settle for that alone would be to ignore other compositional opportunities elsewhere in the garden. Taking better pictures is sometimes about thinking beyond the obvious.

computer screen then it should look good in print – assuming that the screen has been properly calibrated.

Colour calibration

This is done using an external device that attaches to the front of the screen and analyses a series of grey and coloured patches that are created

Fine-art photography has historically been associated with black-and-white prints: this particular image was shot on film then scanned and printed digitally as a more convenient alternative to traditional darkroom printing.

As has been stressed elsewhere in this book, it is very useful to have standard test images that you can use to determine the colour fidelity and general quality of your printer's output. This is Photo Disc International's test image, which can be downloaded free of charge from the Internet.

These four views of Valletta's Lower Barrakka Gardens, in Malta, took about fifteen minutes to photograph and were taken as an exercise in trying to find different ways of framing the same subject. My own preference is for the two landscape-format views but other people may prefer different versions.

by the calibration software. Colour calibration of this type was formerly very expensive but is now cheap enough to be considered essential for anybody who is hoping to produce high-quality fine-art prints. Further information about colour calibration techniques is given in Chapter 16

dealing with colour quality. More immediately, it is important to realize that the illumination falling on the computer screen can put a colour cast on any images displayed, so for really critical work your computer should be in a room that is entirely free of brightly coloured objects.

If you view an image on a colour-calibrated computer screen and are happy with what you see but then obtain a non-matching print the problem will almost certainly be a lack of colour-calibration in the printer itself. There was a time when this was a really serious problem because two printers of exactly the same make and model, loaded with the same inks and the same papers, were previously prone to producing significantly different prints from exactly the same image. Generic calibration software that was supplied with the printers was simply not adequate to cope with the variations that existed at that time. The only way around this variation was to characterize each individual printer using a process known as profiling (see below). This is less important today because printers and consumables are all much more consistent but it is still useful to have a fully calibrated system.

The biggest argument in favour of calibration is freedom from variations that can suddenly appear when changing inks, papers or printers. On the simplest level this could involve nothing more than printing a test image containing a full range of grey tones and colours, then using manual colour adjustments in the printer driver to achieve the most neutral and colourful results by compensating for any failings seen in the test print. So if the grey tones all seemed slightly magenta, then the magenta level would be decreased (or the green level increased) to obtain better neutrality. The optimum settings could then be saved and reloaded every time that same ink-and-paper combination was used in the printer.

This can work well in some cases but it is often rather time-consuming. In particular, it is not uncommon for different colour casts to be seen in different densities of grey tones and it is therefore necessary to compensate separately for highlight, mid-tone and shadow areas. Here, as elsewhere in topics related to colour quality, achieving better and better results becomes harder and harder as the overall level of image quality improves. Nevertheless, if you do decide to adopt this tactic you can download the excellent image-packed PDI (PhotoDisc International) Photo Test Target from www. webstir.com/color_management or ImageXpert's more technical Virtual Test Target from www.imagexpert.com. Simply by viewing these test images on screen you will be able to spot any serious display issues if their grey patches do not look completely neutral: it is absolutely imperative that the screen is made neutral before you attempt to match your printer to it! The same test images can also be output to your printer to check its own colour-handling.

Interestingly, the WebStir URL given above also includes a link to a target that can be used to confirm whether or not your printer is a true CMYK device or one that works in RGB regardless of the fact that it uses CMYK-based inks.

Printer profiling

Mention of printer operation leads on to the topic of profiling, which is introduced here with specific reference to printing but continues in Chapter 16, which is devoted to colour quality. The approach discussed here is unique in that it can be executed at no additional cost. The secret is to choose an inkjet paper from Fotospeed's excellent range then to take advantage of the company's free custom profiling service. Users of papers other than Fotospeed's own can also take advantage of the company's custom profiling service by paying a small fee.

I have no hesitation in personally recommending Fotospeed paper because the company's quality and depth of products is so good. An especially rewarding choice is Fotospeed DWFB Platinum Gloss, which resembles a top-quality fibre-based photographic paper in weight and feel. These qualities are not surprising given that the paper was formulated by darkroom and digital maestro Danny Chau, who has long searched for a digital paper with the characteristics of the best darkroom products. The same

The mid-price Pulse X-Rite colour analyser, which can be used to generate customized printer profiles.

This is the test target that Fotospeed e-mails to users of its papers for them to print out and mail back for analysis to generate a customized printer profile.

paper is also available directly from Danny Chau (www.chaudigital.com) under the brand name of Da Vinci.

Fotospeed's free profiling service involves requesting and taking delivery of an electronic test image that is printed without any adjustments whatsoever. The resulting print is sent by post to Fotospeed where it is read using a spectrophotometer that compares its measured colours with standard values and collates the differences to create a profile for your very own printer and inks. Fotospeed then sends you the profile electronically, via e-mail, for you to install in the profiles folder on your computer. Initial instructions are contained inside every pack of Fotospeed inkjet paper and full details are supplied with the test image.

File enlargement

The topic of image size was introduced in the last chapter in the context of resolution and maximum enlargement, but it is not necessary to accept the limit imposed by the original file. There is some excellent software on the market that does a superb job of enlarging image files so that bigger prints can be produced than were previously possible. For example, I have printed files from a Nikon D1H, which has just under three million pixels, up to A3: this is far in excess of what ought to be possible and was achieved using FixerLabs' SizeFixer software. Also highly recommended is Genuine Fractals, which has the advantage of being available as a Photoshop plug-in so that resizing pictures can be done at the same time as other image enhancements. More details are given about this technique in Chapter 14, which deals with additional software.

Image output

When producing fine-art prints careful thought should be given to the layout used. What size should the paper be, how big should the image be

When printing an image the software (Photoshop in this case) will probable offer options for background colours (yellow here for clarity only!) and border-lines.

ME0409 I03193

When printing with black-and-white inks the set normally comprises subtle hues of grey that allow toned effects to be simulated. The extent of the colours used is very slight indeed, giving rise to the term 'narrow gamut', as shown here.

on the paper, where should it positioned and should any other graphic devices be used?

Paper size and quality

The first question will answer itself to a degree on account of the maximum size allowed by your printer. Commonly this will either be A3 (297 × 420 mm) or its over-size variant A3+ (329 × 483 mm). Your printer's driver menu will list the various sizes of paper that can be used, so scan this list first to decide which format you prefer. When aiming to produce a fine-art print you should definitely not start off simply by seeing which papers are in stock at your local computer store: remember that fine-art printing should be a carefully considered activity where everything is done to suit the needs of a specific image.

Allied to the choice of paper size is the look and feel of the paper that you will be using. Obviously there may have to be a trade-off between physical size and aesthetic appeal if your ideal paper is not available exactly

The composition of this picture follows the classical Rule-of-Thirds principle. The man's eyes are approximately one-third of the way down the frame and one-third of the way across it; the horizon is also approximately one-third of the way down; the dog's head is approximately one-third of the way up the frame; the tree that Mr Frost is holding is approximately one-third of the way from the right side of the picture (and breaks the horizon in a position that is symmetrical with his head). All of the elements except the dog, which ran around a lot, were deliberately arranged to create the final effect seen here. This award-winning image was printed using PermaJet Portrait Classic paper with PermaJet monochrome inks in an Epson 1290 A3-format inkjet printer.

as you want it but do bear in mind that larger sheets can always be trimmed-down to give smaller formats if required. Danny Chau's paper is a particularly good starting point if you have come to digital printing from a conventional photographic background but do also look at papers with a more natural fibrous texture, which are often referred to as 'watercolour' or 'cold pressed': PermaJet's Portrait Classic is a good example of this type.

Image size and cropping

Not only do you have to decide on image size (discussed above) but also on whether it should be cropped for printing. There is a theory that every image has an ideal size at which it should be viewed but identifying this size can be tricky unless you have a lot of experience. A photograph that is

intended to convey a feeling of intimacy, such as a portrait of a baby, will often suit a small image size; a straight-forward photograph will often look good at a medium size and more involved pictures will often benefit from being bigger. Portraits can look slightly disturbing, or at least confrontational, if they are printed larger than life and viewed at relatively close range. Nature subjects work well at larger sizes provided that they contain plenty of detail and are pin-sharp: be warned that faults in deficient images are quickly exposed at larger magnifications. Abstract pictures often work well at larger sizes, especially if their subjects are not obvious and their effects are due to the shapes, colours and textures contained in the image. Pictures containing bright colours often work better bigger but this does not mean that more muted colours and monochrome pictures should be printed smaller: the reason for making brightly-coloured pictures bigger is purely to make the competing elements easier to view. For a greater insight into the effect of image sizes there is no better tactic than to visit a good art gallery and view the displayed works with this context in mind. Looking at pictures in a book, where all of the images are equally constrained by the page size, is not an acceptable alternative.

Borders

A completely different approach is to think about the size of the borders surrounding the image and then to deduct these from the paper size to obtain the image size. One possibility is to have no borders at all, in which case the image is said to be full-bleed, but this is a rare choice in fine-art printing (even though it is the norm in painting). Borders are preferred because they can help to compensate for the use of cheaper frames than are traditionally employed for paintings: they also give the image room to breathe and provide space in which to place a hand-written title, signature, date and edition number (see Box 11.1). The fact that these things are hand-written rather than being printed with the image is one of the hallmarks of the fine-art process and helps to prove that the image has received individual attention. Traditionally, pencil is used for adding these details because inks can add contaminating substances to the paper and may cause it to deteriorate over time.

A good starting size for images printed on A3 paper, in my opinion, is around 24 × 36 cm or 24 cm width and whatever (lesser) height the image happens to be. Square images can be printed on sheets that are either upright or landscape format, resulting in much wider borders either above and below the image or to the left and right. There is no hard-and-fast rule here but if the picture is of a subject that is stronger across the image than up-and-down then I would tend to go for a landscape-format print overall and vice versa. You should also consider whether the border area should be equal above/below and left/right of the image. It is unlikely that all four will be equal unless you have an image that matches, or can be cropped to, the format of the paper but you will always have the opportunity to make pairs of opposite border areas

the same size. It can look very odd to have different amounts of space to the sides of an image but it is quite common to have a wider border below the picture than there is above it. Truly avant-garde images can benefit from uneven borders all around but this tactic can also date images as things that are contemporary today can look passé tomorrow.

Many programs will also allow you to apply other graphic devices to the print, such as a tinted background instead of a plain white border or a line butting the image area to separate it cleanly from the surrounding border. Coloured borders do not look very professional and keylines can look rather clinical so both might be shunned: that said, I often use a three-point black keyline around my own images. If you dislike the idea of a keyline but want to avoid having white parts of the image fade into the borders then one trick is to go to the Levels option in your image editing program and check that the output level does not exceed 250. By default it should be 0–255 and by compressing the top end you will ensure that areas which would previously have been pure white are now a very light shade of grey.

Box 11.1 Limited editions

One of the ways in which the individual status of fine-art works is guaranteed is by giving each print a unique number. The edition number is a declaration of the maximum number of copies that will ever be made of the work and also lists the position of the current image in the edition. For example, 3/12 on a print would indicate that there will only ever be a maximum of twelve copies of this image and this one is number three. Some people get rather devious and say that each different size of print is a different edition but this tactic is generally frowned upon. If you want to produce additional prints, either after the series is complete or in the meantime without using up edition numbers, then each unnumbered copy should be identified as an 'artist's proof'. It is up to you to decide on a suitable edition total before you start numbering any prints but I have never used a total higher than 12 on the grounds that I tend to get bored of printing the same image time after time and would rather move on to something new. Also, the theory of pricing limited editions is that the cost increases as the edition runs out, so people who buy early copies should pay less than those who buy the last few. Although it makes life easier you are not obliged to sell the numbers in any particular order provided that the same number is never sold twice and the edition total is never exceeded. These rules will probably never be that important to you unless you become very famous but it is good practice to stick to established protocols from the outset.

The danger of this approach is that it can make the image look slightly flat or even a little dirty, which is why I prefer to stick with a keyline. For a softer keyline simply change from black to a shade of grey or select a narrower rule: these are all areas for experimentation and can only really be decided in the light of personal preferences.

After-treatment

It should not be necessary to say that fine-art prints should be treated with the utmost of respect. They should be stored flat in a rigid print box inside polyester sleeves – but should not be stored until they are completely dry. As was pointed out previously, prints may very well feel dry to the touch as soon as they leave the printer but that is most likely to be because the ink has soaked into the coating instantly, not because the carrier has already evaporated. Therefore, in order to avoid trapping the carrier liquid in the paper, or even transferring it to the back of the print that is stacked on top, prints should always be allowed to air-dry overnight if possible.

Do not spray your prints with protective coatings as these may do more harm than good in the long run, especially if the inks had not fully evaporated when the coating was applied. Similarly, do not stick or write anything on the back of the print except using a pencil, and apply only very light pressure. If the print is to be fixed to a window-mount for framing then the tape used must be conservation-grade, as must the card that is used for the window-mount itself. I tend to write the technical details of the printing process on the reverse of the paper, such as the printer, inks and paper used: this is partly as a reminder to myself and partly because when technologies are superseded it eventually becomes impossible to replicate prints made using earlier systems. This in turn gives earlier prints a certain additional appeal in the sense that they can no longer be repeated and are therefore unique in their own way.

This picture was taken using an Epson R-D1 digital rangefinder camera set to raw mode: the file was subsequently converted to a TIFF image then retouched to remove small distracting items on the beach. Does this mean that the picture is no longer a true reflection of the original scene?

Image Editing

In an ideal world digital photographs would be perfect at their moment of capture but in reality things can go wrong and it is nice to be able to improve the quality of pictures after they are taken. When using film this is difficult for most people because film developing and printing is a largely automated process, though there has always been the option to have pictures hand-printed and improved to some degree, but at greater cost, if the image is really important. Similarly, there are skilled retouchers who can remove blemishes from, or even add hand-colouring to, photographic prints. That said it is easier and more convenient to make improvements to digital images because the necessary equipment will probably already be on hand: instead of spending money it is only necessary to devote some time to the process of learning new skills and applying them when the need arises. Therefore it is generally more tempting to improve digital images than it ever was to improve pictures taken on film.

The process of modifying a digital picture is known as image editing and takes two forms: *image correction* involves making modifications that improve picture quality whereas *image manipulation* involves changing the visual content of the picture. This distinction is important because in some circles, notably photojournalism, there is a philosophy that says the content of a picture is sacrosanct and should not be changed even by simply cropping the image. All that can be done on this level is to accept or reject an entire picture – a process that is known as picture editing (rather than image editing). Opinions are more divided, however, over purely technical factors such as an overall colour cast: the theory here is that if the photographer wanted the colour cast then it should remain but if it is unwanted then it can be removed. Although the colour of an image can have an effect on the viewer, and indeed bloody crime and battle scenes are sometimes printed as greyscale images in newspapers and magazines to avoid disturbing readers too much, the essential content of the picture remains unchanged.

This is a very different situation from one in which a photograph is taken and then an element that was never there is added later. In this case the content of the picture has changed and the picture is no longer the same

image. There is, however, still a slightly blurred area that harks back to the unwanted colour cast mentioned above: if in a different picture there is an unwanted element in the background of the picture then is it purely a correction to remove this or has the image now been manipulated? One refinement of the distinction is to say that any change that affects an image overall can be counted as image correction but anything that has an effect on specific areas counts as manipulation. This, however, would mean that removing redeye counts as image manipulation, which may not be entirely logical.

Many a long night could be spent debating this topic but suffice it to say that there was once a move among UK press photographers to have newspaper pictures labelled according to whether or not they had been manipulated, but this has not happened. Maybe agreement could not be reached; maybe the idea was too difficult to check and implement; maybe it was felt that readers could make up their own minds. That said, readers may not be able to decide on the veracity of some images and there have already been documented cases of image manipulation being applied to war photographs, resulting in the photographers concerned being sacked by their employers in order to protect the reputations of the picture agencies involved. In one case (which arose during the Israeli bombardment of Beirut during the summer of 2006) the photographer said that he was only trying to remove dust from the image and that the greater amount of smoke seen in the final picture was simply a consequence of thoughtless corrective retouching. Although this argument was not sufficient to save his job, it does confirm the fact that a distinction is perceived between image correction and image manipulation – and also confirms the uncertainty of that same distinction.

Raw formats

As has already been mentioned at various stages in this book, by far the best tactic is to capture pictures in raw-data format if you anticipate making any corrections to your digital images. This is because the raw data represent the original information recorded by the sensor before any adjustments have been made. The only factors that are totally fixed in a raw-data image are the image resolution, sensitivity setting (ISO) and exposure conditions (aperture and exposure time) used when the picture was taken. Also fixed, but with a small amount of room for correction, is the overall exposure level. Everything else can normally be changed, including the colour balance, pixel dimensions, contrast, saturation, sharpness and certain techniques for noise reduction.

The best software to use for making image corrections is likely to be the most sophisticated raw-data software supplied by your camera manufacturer. Unfortunately, this is not necessarily the same as the cut-down version that may have been included with the camera free-of-charge and you may well find that the fully specified program is a rather expensive additional purchase. It is generally true to say that if a camera only has a

By far the most important advantage of taking pictures in raw format is the ability to adjust the image data in its original form, thereby obtaining the best possible image quality when the picture is converted into a more accessible format, such as JPEG or TIFF. This sequence of pictures shows the step-by-step process that was used to improve one particular image. The original image was too dark and had an unattractive colour cast so was improved in stages as follows: open the original raw image, adjust the brightness, adjust the contrast, locate an area that should be neutral colour (the white of the baby's eye), click on that area to neutralize the colour cast then finally readjust the brightness and exposure together to give the desired look (which in this case is a high-key effect).

raw-data image format then it is likely to be supplied with a very competent raw-data program but if the camera offers several image formats, of which raw-format is just one, then the raw-data program supplied may be more limited. The reason for this is easy to understand: if users are compelled to use raw-data then the manufacturer needs to offer a high level of support but if raw-data is simply an option that some people might choose to use, in the same way that they might select a higher-specification lens, then it is fair for a manufacturer to charge for this extra capability.

That said, any camera manufacturer that places its raw-data software in the commercial arena risks inviting competition from other software companies chasing the money that will be spent on these programs. So whereas there were once no commercial raw-data programs there are now several alternatives vying with the camera manufacturers' own software. In some cases these can overtake the manufacturers' own programs, at least until the latter leap ahead once more. A rather unwelcome consequence of this broadening of access to raw-data images is the fact that some photographers have started to expect and even demand compatibility between third-party programs and camera manufacturers' file formats. This issue has been most fiercely debated in connection with Nikon files that do not enjoy universal compatibility with third-party programs. It is my opinion that if Nikon continues to release top-quality imaging software of its own, as is certainly the case at present following the arrival of Nikon Capture NX, then universal compatibility is unimportant and may even be counter-productive. The problem is that compatibility can restrict technical advances and by maintaining its independence Nikon is unbridled by external limitations: this in turn means that Nikon may be able to offer levels of functionality that are not available to manufacturers that have agreed to adhere to external standards.

A similar argument explains why Adobe's universal raw-data format, *.dng, may not suit all digital camera manufacturers. After all, why should a camera manufacturer be confined in its pursuit of new techniques by a third-party company? This is the very reason why the already-existent standards, JPEG and TIFF, are not sufficient for all purposes. More to the point is the fact that digital camera users who lament the lack of implementation of Adobe's format should not campaign for its inclusion so much as investigate why it is not suitable in a particular case. Criticizing companies that retain control over their own image processing technologies is not justified if the only rationale is a desire to have a standard format that is simply more convenient. It should always be kept in mind that raw-format images are saved in this way not for reasons of convenience but rather to provide maximum image quality.

Archiving your images

Before starting any work on correcting or manipulating the images transferred from your camera it is fundamental to be able to protect images that

must be preserved at all costs or delete those worth no further attention. It is a good habit to save all of the images captured, perhaps by collating pictures over the course of a week, month or even year (depending on the rate at which you take photographs) then writing these files to a CD or DVD that can be stored separately so as to give the pictures an existence independent of your camera and computer. This means that if you lose your camera or your computer becomes damaged you will still have a collection of pictures. It is also a good idea to save a copy of the appropriate raw-conversion software together with the pictures, if applicable. This copy would never be used unless your working copy were lost so there should be no worries about infringing the licence for the software, but do check this point in the End User Licence Agreement (EULA) that is displayed when the software is installed.

It is a good idea to ensure that your back-up is on a standard medium that will guarantee maximum access in the future. The best choice at present is to use conventional CDs since these have only one physical standard and are cross-platform compatible among different computer operating systems (Windows, Mac and Unix) and can also be played in standalone CD and DVD players. By comparison there are already multiple DVD standards and two major systems vying for superiority in the next generation of DVDs: choosing the wrong one of these options now could have a serious effect on the accessibility of your images in the future. So although CDs may seem to have a rather meagre capacity, which means several need to be used where just one DVD would suffice, do bear in mind that the purpose of an archive is to provide truly accessible storage for as long a time as possible.

You should also think about indexing your pictures as they are archived because it is fairly easy to do this as part of a routine procedure one CD at a time but can become much more laborious if left until a later date. More will be said about this in the next chapter but the need to have a permanent back-up that is independent of your current hardware cannot be stressed too much.

Image corrections

Once the master files, straight from the camera in whatever form they were captured, have been archived it is time to start thinking about improving those images that are worthy of further attention.

When making changes to digital pictures using image correction software of any type there are two ways to proceed; either by making visual assessments about the image's appearance or by relying on technical adjustments. If you prefer the former approach then you must, without fail, calibrate your monitor as any inherent colour cast or unnatural brightness on the screen will cause you to adjust your images incorrectly. If you prefer to apply technical settings, such as using white-point adjustment and referring to the histogram to confirm that the image has the fullest tonal distribution, then monitor calibration is less important but it is still useful as a way of

This picture was taken at the Tate Modern gallery in London by available light using a 35 mm lens on an Epson R-D1. The lens, which was designed for film-camera use, has caused slight vignetting (darkening) towards the corners of the picture. A lens correction was therefore applied to the image in the manufacturer's software (Epson PhotoRaw) before converting from raw format to TIFF.

In an ideal world images should not need correcting post-capture but for this to be the case the camera manufacturer must use clever tactics to produce as-shot pictures with optimum quality. Fujifilm has managed to achieve one aspect of this with its Super-CCD Type SR sensor, which preserves detail even in a picture's brightest highlights.

It is normal to see differences between the histograms of identical images taken at different ISO settings. This is the reason why colour calibration (profiling) of digital cameras, as discussed in the chapter dealing with colour quality, must be undertaken afresh each time that a camera's settings are changed.

confirming the effect of the adjustments made. If the numbers are correct but the image looks wrong then there is a good chance that your monitor is at fault even though it is tempting to believe the monitor and distrust the figures. For this reason monitor calibration is highly recommended (see Chapter 16 on colour quality for more details).

Exposure level and contrast

The first adjustments to make are the exposure level and the contrast, preferably by referring to the image histogram. The tones in the picture should ideally span the entire range of possible data values on the horizontal axis of the histogram. If this is not the case then choose one of the following actions:

- If the histogram goes off the scale at both ends, reduce the contrast.

- If the histogram is off-centre towards the low values of the scale, increase the brightness.

- If the histogram is off-centre towards the high values of the scale, reduce the brightness.

If the image's histogram does not cover the full scale then its contrast is too low and should be increased. If the histogram does not reach the right-hand end of the scale then the image is too dark and its brightness should be increased. Conversely, if the histogram does not reach the left-hand end of the scale then the image is too light and its brightness should be decreased. If the histogram extends beyond the end of the scale (is not zero at both ends) then the image's contrast is too high and should be decreased.

- If the histogram, once centralized, does not span the entire scale then increase the contrast.

The result should be an image that has a good range of tones right across the brightness scale, which ought to be the correct condition for most images. One exception occurs in images that have very bright and very dark regions where the word 'centralized' must be interpreted as the situation that gets all the image data within the histogram scale even if the distribution of tones is very irregular, probably with two sets of spikes at opposite ends of the scale. The other common exception occurs in images that are deliberately high-key (mostly light tones) or low-key (mostly dark tones). In these cases it can be counter-productive to centralize the histogram and then skew it again afterwards (see below) but this situation is best assessed by trial and error, always keeping an unaltered copy of the original file in case a different set of adjustments is found to be more satisfactory.

According to its histogram this is a perfectly exposed image. The variations opposite show the image appearances and histograms for four possible exposure problems that could have occurred (but which are in fact simulated here).

Colour balance

Next you should correct the colour balance while preserving the image's overall luminosity: this is normally the default mode but if it is necessary to tick a box to make sure that luminosity is maintained then make sure that this is done. Rather than trying to do colour balance corrections by eye you should identify a region that ought to be a neutral grey then use the program's automatic tool by clicking on this area and letting the software remove whatever colour cast is detected. A visual check will ensure that this has been done correctly. Good areas to choose when removing colour casts are normally the whites of people's eyes, clouds and white areas on signs or road markings. The grey-balance tool should only adjust the relative strengths of the red, green and blue channels so that they become equal: it should not have any effect on the brightness of the image but it is a sensible precaution to check the histogram to make sure that this is indeed the case. If your software's grey-balance tool assumes a strictly mid-grey value then you will have to choose a grey tone (not a white area) in which to click to perform colour correction process satisfactorily.

Having obtained a technically correct image one option is then to skew the tones deliberately so as to create either a high-key or a low-key effect. Although high-key pictures are generally thought of as comprising mostly light tones it is important that they also contain some dark tones to create a balanced effect. Similarly, although low-key images are mostly dark-toned they also include some small areas of light tone. It is therefore obvious that you cannot create these effects simply by changing the exposure but rather need to compress the image's tonal scale from one end then change the brightness to stretch the tonal scale at the other end. In practice this means reducing the highlight exposure and increasing the overall exposure to give a high-key effect and vice-versa. Note that this is an aesthetic adjustment rather than a technical one and therefore there is no 'right' amount other than whatever results in the desired effect.

Saturation and sharpness

The same is also true for other adjustments, such as saturation and sharpness. Saturation relates to the brightness (or greyness) of the picture's colours and is comparable with the different colour settings that people have on their television sets at home. Sharpness is normally used to compensate for slight softness in the image, especially when this has been caused by a lack of accurate focussing, but must be used with extreme care as it can make images look very unnatural. Fortunately, even without a colour-calibrated monitor it is easy to check the effects of sharpening visually. Note, however, that sharpening is one of the final things that should be done to any image and ought only to be applied when a picture is about to be output. Sharpening a picture earlier on can make retouching more difficult and therefore should never be done at the image correction stage unless this initial process will also be the final one. In all other situations, avoid the temptation to sharpen an image initially even though the appropriate settings are often included in cameras and their attendant image correction programs.

Standalone image manipulation programs

Switching away from camera manufacturers' own software, which is invariably purely correctional in nature, we come to the grey area that was mentioned at the start of this chapter. What follows next could involve changes that are either technical image correction or manipulation in the sense of combining elements that were not present in the original scene. It applies to everything from correcting redeye and removing blemishes caused by dust on the sensor, to camouflaging distracting areas and making large-scale changes that cause the picture to become quite different from the as-captured image.

Almost certainly the first name that will spring to mind when image manipulation programs are mentioned is Adobe Photoshop, which is the software of choice for most professional photographers. This program owes a great deal of its success to two factors. First, it was launched for Apple Macintosh computers that were initially easier to use than Windows-based computers and were therefore preferred by photographers and graphic designers. Secondly, the software has for a long time had excellent colour-handling facilities, including the ability to convert between different RGB colour spaces and from RGB to CMYK. The full version of Photoshop, which includes all of these features, is very expensive (more than the price of a mid-range digital SLR) but there are other alternatives with slightly lower specifications that are much more affordable, including Adobe's own cut-down version called Photoshop Elements. Such is their popularity that there are many books devoted to these two programs, including a wide variety published by Focal Press (find out more at www.focalpress.com).

Other programs to consider include Corel Draw, Corel Paint Shop Pro, Serif Photoplus and Ulead PhotoImpact. At the present time Microsoft also

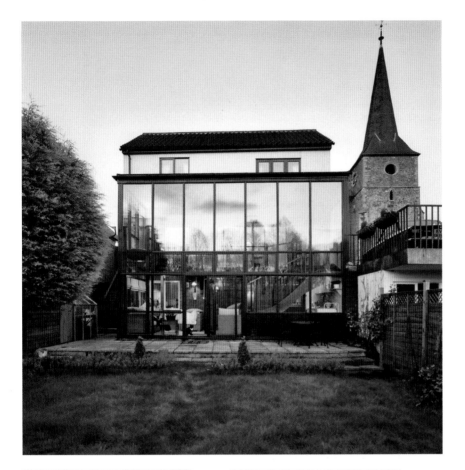

Having mastered basic technical adjustments it is time to try some advanced techniques that require the use of standalone image manipulation software in order to obtain a perfect image by combining two (or more) near-misses. In this case the model was upstairs in the best overall composition but looked better downstairs so was moved electronically. When this was attempted in the flesh the cat would never stay seated in the doorway but instead always turned and walked over to the model! Minor tidying of the final image, to remove the garden hose, for example, was done using conventional retouching rather than pasting an area from a different picture.

Redeye removal is often accomplished very successfully using automatic correction but can also be performed manually by selecting the offending pixels and using HSL adjustments to darken the area, reduce its saturation and make it less red. The most natural result is often obtained only by taming, rather than by totally removing, the redeye effect. At the same time it can be useful to retouch distracting highlights.

appears to be strengthening its presence in the digital imaging field and it seems likely that the company's current Digital Imaging Suite may be improved or supplemented in the near future.

My own recommendation, not least because it is completely free, is a program called GIMP. This software, the name of which means Graphics Image Manipulation Program, has been compiled and is still being developed by the efforts of programmers who support the concept of free software as a means of adding new features and drawing together expertise from a diverse range of sources. The only down-side is that because the software is not paid for there are no revenues from which to pay licences for technologies that have been patented by other companies. Although this means that inevitably there will be some features that are missing compared with those offered by other programs, none of these is essential for non-professional users. Not only that but GIMP has a few additions of its own that other programs do not have and cannot include unless they embrace the free-software concept, which commercial companies cannot usually afford to do. To find out more about GIMP or to download the latest version of the software visit the dedicated website at www.gimp.org.

The following pages contain three step-by-step examples of retouching and image manipulation techniques that are of increasing complexity. This book is not intended as a guide to image manipulation so these examples are quite brief but they do indicate some of the most useful techniques that can be employed. Although the examples are all based on GIMP, their basic principles are the same whichever image manipulation program is chosen. The only significant operational difference is the fact that GIMP opens as just a tool palette without a big expanse of space waiting to be filled: the remainder of the desktop stays as it was before the program was started until an image is opened. Indeed, opening and saving files is the most idiosyncratic part of GIMP and is covered in some detail in the first example.

Retouching Example1: Cosmetic retouching
Removing dust blemishes and other specks from a picture is the most common form of cosmetic retouching and involves the same basic techniques in both cases. Learning to carry out this basic procedure with skill will prove to be a very worthwhile investment in the long-term, as its reappearance in the two examples that follow this one attests. In essence, the trick is to copy an unaffected area of the image that is otherwise identical to the blemished area and paste it over the area that needs to be improved. This is very similar to the copy-and-paste technique used when writing text documents except that in this case there is much more control available other than simply choosing which formatting to use.

Start by opening GIMP and selecting the desired image via the File>Open tab at the top of the tool palette. You will notice that the format is very different from what you might expect: this is the hardest thing to get used to in GIMP. Double-click on the C:\ and you will get a list of file and folder names, among which will be Documents and Settings: double-click

Although Adobe Photoshop is the de-facto standard image manipulation program for professional photographers, the bulk of the work done on pictures for this book was completed using an alternative program called GIMP, which is free and can be downloaded from www.gimp.org. This software has excellent file support and uses standard keyboard shortcuts but looks very different from other image manipulation programs.

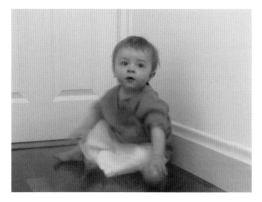

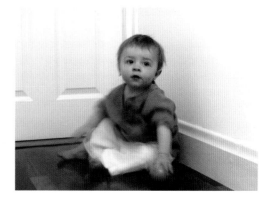

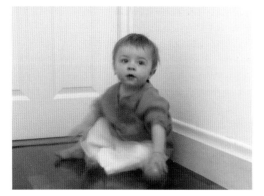

Many image manipulation programs have automatic functions that can correct images using a single click but these are not always completely successful. This particular image was originally lacking in contrast but automatic correction produced a very harsh result. Manual adjustment to give an effect mid-way between these two extremes was far more successful.

on this and you should see your user-name listed. Finally, double-click on your user-name and you will see My Documents, within which (by double-clicking once again) you will find your files and other folders such as My Pictures, My Music, etc. To go back up one level in the directory tree just double-click on the ..\ symbols. As I said before, this is the hardest part of using GIMP!

Having got your image open, make the image full size in its window, simply by pressing the numeral one key, then navigate your way around the picture via the scroll bars as normal. If the tool palette has disappeared underneath the image you can bring it back on top by clicking its tab at the bottom of the screen. You will probably find it even more convenient to shrink the image from full-screen mode, if applicable, by clicking on the box icon in the top-right corner of the window as usual. You can then move the image window to the top-left corner of the screen (by clicking on the title bar and moving the mouse while holding-down the left button), before dragging the bottom-right corner of the window to resize it so that the tool palette can be viewed at the same time.

Now choose the clone tool, which in GIMP is the rubber-stamp symbol in the tool palette. A single click selects the tool whereas a double click opens the tool options dialogue box inside which you will see the various settings that can be applied. The one that you are most likely to want to use is the Brush setting. To change this setting just click on the current icon (probably a black disk) and a list of different sizes and shapes will appear from which you can select the most appropriate choice. A fuzzy circle will probably be best but do experiment with the other options. Note also that the sizes of the brushes are fixed, not variable via a slider control as is the case in some other programs.

If you hover the cursor over the image you will see that it has a 'no entry' sign above it, meaning that you have not identified the area from which you wish to copy the image. Do this by placing the cursor over a perfect area and hold down the control (Ctrl) button while you do a single left-click. Let go of everything and you will see that the cursor now has a small circle around it: if this is the wrong size simply click on the Brush window to select an alternative option. Now all that you need to do is left-click the mouse and whatever area of image was under the point where you previously Ctrl-clicked will be copied to the current location. If it does not look right, press Ctrl+Z to undo it or go to the edit tab at the top of the image and select Undo that way instead. Have a play with the various settings to see what works best for you. If you want to zoom-in more on the image simply select a more appropriate scale from View>Zoom.

When you have finished making corrections select File>Save As and the dialogue box will take you back to the folder from which the image was first loaded. Give it a new name, perhaps by adding RV1 (retouched version one) to the file name then click OK. If you get a message that says unknown file type you need to add a suitable file ending, such as .jpg or .tif and then click OK again. Appropriate options will then be offered,

Opening an image using GIMP can seem strange because of the unfamiliar directory format (shown on the left on the window here) but it becomes straightforward after a little practice.

Shown here is the corrected version of the baby portrait that was adjusted in the main part of this chapter: it is now ready for cosmetic retouching to remove a few blemishes.

such as TIFF compression methods and JPEG quality settings. For maximum compatibility, bearing in mind that most image editing programs are less sophisticated than GIMP in this respect, select None for TIFF compression and do not change the sub-sampling or DCT methods in JPEG.

GIMP has a Clone tool that comes with a range of options and modes. The default settings are normally acceptable: only the brush is likely to be changed on a regular basis.

The final portrait.

If you click the top-left box in the JPEG window you will be able to preview the file size depending on the position of the quality slider.

Once the image has been saved you can exit GIMP either via File>Exit or by clicking the usual red-cross box.

Retouching Example 2: Area removal

It is one thing to hide the odd skin blemish or speck of dust but it is quite another to try to remove an entire area while maintaining a natural look in the picture. In this picture the boy's concentration on his hands is almost mesmerizing but the mother's hands detract from the effect because they are so large by comparison. The answer is to remove the mother's hands, which is a tall order in terms of the amount of area that has to be treated but is made easier by the plain background beyond.

Rather than opening the file from GIMP's File>Open route, pictures can be accessed using Windows Explorer then opened using Open With by doing a right-click on the file's name. If you have installed GIMP but it is not a listed program simply select Choose Program and find it in the complete list: if it is not there, select Browse and open the GIMP folder in the Program Files window. Then go to the folder labelled 'bin' and double-click on gimp-2.0.exe (bearing in mind that the numerals may be different if you have obtained a more recent version of the software). This will add GIMP to the Open With list of program files and should highlight it so you have only to click OK for the image to open. Future images can then be opened via the Open With menu by selecting GIMP directly as it will remain listed from here on.

Although the area to be covered is large in this picture, the principle is exactly the same as it is when correcting tiny areas. The hardest part is finding the best area to clone and imagining what the area should look like behind the object that you are removing. In this picture it was necessary to think about how the blanket would fall and what would happen to the tone of the background. The retouching used does not have to reconstruct real details that were previously obscured: all that is necessary is to make the picture look right. Having spent a considerable time (about 40 minutes) extending the blanket and creating a smooth initial transition from the background into the area formerly occupied by the uppermost fingers of the mother's hand, the bulk of the remaining area was retouched very

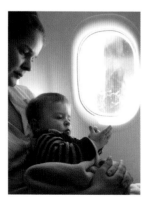

This is the as-shot image, from which the young child will be isolated by cropping and retouching to remove the mother's hands.

Using the same Clone tool that was used previously to remove blemishes from the baby's face, it is a fairly straightforward matter to erase the mother's hands by extending the background but rather more tricky to extend the blanket.

Once the blanket has been extended as far as necessary a line can be drawn across the picture and the bulk of the mother's hands erased by rapid cloning of the background (by copying from above the hands area).

After the blocking-in is complete it is useful to examine the overall area of the intended crop before smoothing-out the blocking by re-cloning the areas to give a more homogeneous appearance.

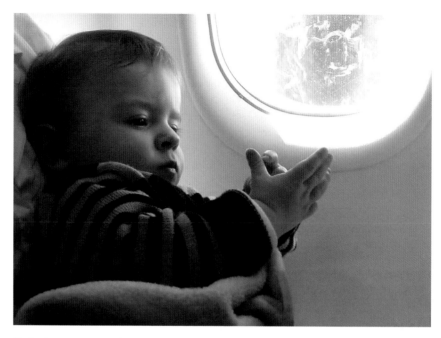

The final crop.

quickly. This created a certain amount of blotchiness that was then removed by cloning with different brushes to create a more homogeneous appearance.

When the retouched area is complete it is often useful to view more of the picture to check the fall of the light and to make an initial crop. In a picture like this it is a good idea to have retouched beyond the area that will eventually be cropped in order to give a smooth transition out of the final picture area. I tend to do crops like this in two stages; the first identifies the area that I am interested in and the second balances the various elements in the area to give the most pleasing composition. Helpfully, the crop tool in GIMP, which is selected via the scalpel symbol or by pressing Shift-C, has very clear boundary lines and features moveable corners so that the area can be fine-tuned after an initial selection has been made. There is also a pop-up window that gives additional information such as the size of the cropped area.

Once again, when everything has been done the image can be saved, via Save As, using a different file name to protect the original file in case it should be needed in the future. Note that if you opened the file using Open With then the default folder for saving images will be the 'bin' folder in the GIMP folder within Program Files so you may wish to navigate to a more suitable destination, such as My Documents, as explained in the previous example.

Retouching Example 3: Combining images

Having mastered the arts of removing blemishes and retouching larger areas the next skill to acquire is the ability to blend two different images. This is done using layers, the example here being more straightforward than some other situations thanks to its largely plain dark background. The problem to be solved here is that in the picture with the best expression the master of ceremonies' hand has been chopped off, probably because when I shot the picture I was concentrating on his face and did not pay enough attention to the edges of the picture. Fortunately, there is a second pose that is very similar, though not as good, in which the compère's hand is fully visible. The basic technique is therefore to open both of the pictures and then to scale them to the same size so that if a feature from one picture were pasted onto the other it would have the correct proportions. Resizing is done in GIMP via Image>Scale Image.

Tempting though it is to cut-and-paste the compère's head, in fact it is far wiser to transfer his hand, because viewers of the picture will focus on his expression (and therefore the head area) but should not pay too much attention to the hand unless it is badly retouched and looks unnatural. There is also another huge benefit to this tactic which arises from the fact that the added area will simply overlap the edge of the existing picture and therefore has only one side along which the two images need to be blended. So all that has to be done is to crop the second image down to a strip containing only the hand and forearm area, to resize this so that the forearm matches the 'stub' on the left-hand side of the first picture and then to copy this strip and paste it as a new layer on top of the first image.

In fact there is one other step in between: bearing in mind that the composite image will be bigger than the original image a new canvas needs to be created (via File>New) about one-third wider than the first picture. (To

In the better of these two pictures, the Master of Ceremonies' hand was accidentally chopped-off when the picture was taken. It was therefore decided to create a composite image by using the hand section from a second picture.

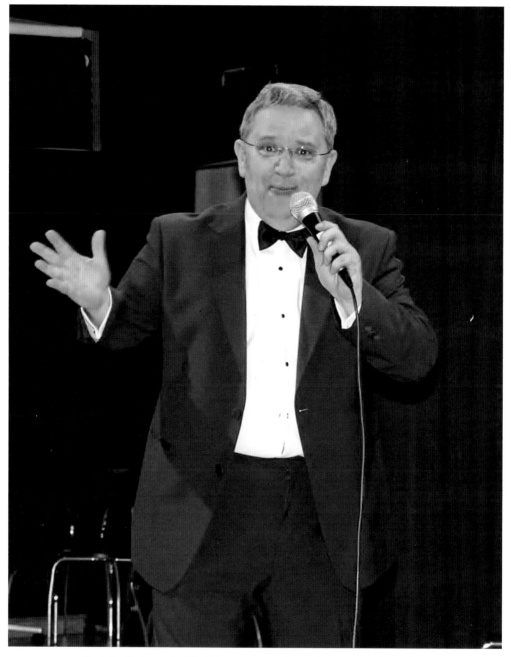

By placing the two parts of the picture on separate layers of a new canvas, then scaling
and moving the components until a perfect blend was obtained, it proved possible to produce a slightly
extended image based on the original portrait of the MC with his hand pasted-in from the second
picture at the point where it blended best, which was not at the extreme edge of the original picture.
Minor retouching was required at the boundary between the two pictures to give a seamless transition
between them.

find the correct size it is only necessary to do Image>Canvas Size for the first image and check its existing dimensions, then to increase this by an appropriate amount for the new canvas.) The first picture is then clicked to make it the active image and selected (Select>All) so that the entire image can be copied (Edit>Copy). The new canvas is then clicked to make it active and the first picture is pasted in place as a new layer using Edit>Paste Into. The cursor changes to a crossed arrow indicating that the image can be moved within the frame, allowing it to be dragged to the right of the canvas to make room for the hand-and-forearm strip on the left.

A similar procedure is then used for the strip, which is pasted into its own layer on top of the first image so that by moving it around the best match can be obtained for continuing the compère's arm. When the optimum position has been obtained the image is saved as a *.xcf GIMP file so that it can be recovered if the following stage goes wrong. Before making the final adjustments it is necessary to merge the two layers (Image>Flatten Image) to give a single-layer picture comprising both of the two original components. From here on it is impossible to move the components separately, which is why the image was previously saved in its multi-layer state. If you forget to save the layered version before flattening you can always undo this stage (GIMP supports multiple undo operations) then save the file before continuing with your work. Final retouching is carried out using conventional techniques to give the best blend and the tidiest background. The finished picture can then saved as a conventional TIFF or JPEG file so that the image can be opened and viewed using other programs as required.

This is a film image that has been scanned for electronic distribution. It has an example embedded watermark, created using Digimarc's software, so if you scan the page and open the file in a Digimarc-compatible program, such as Adobe Photoshop, you should see a small copyright symbol displayed in the image's title bar. Certainly all-electronic activities, such as compressing and e-mailing the image usually preserve the embedded watermark.

CHAPTER 13

Supporting Software

Regardless of whether or not pictures emerge from the camera in a perfect state, and therefore whether or not image editing software is necessary to improve picture quality, there are some other aspects of digital photography that will always benefit from the judicious use of third-party software. Potentially these programs are even more important than image editing programs but inevitably it is more tempting to prioritize buying software that allows you to play around with pictures rather than investing time and money in programs for less glamorous purposes, such as being able to find specific pictures in years to come when your collection has grown to many thousands of images.

The crucial importance of third-party software is stressed nowhere better than in the sphere of image enlargement. So important is this software that it could actually influence the model of digital camera that you decide to buy. The reasoning for this statement goes as follows. When buying a digital camera you will probably be tempted to look for a camera with a high pixel-count because this will enable you to make larger-size prints than would otherwise be possible. That fact is definitely true but it is the only guaranteed justification for buying a camera with a high pixel-count: improved resolution, for example, ought to come with a higher pixel-count but could be limited by the lens used. In addition, a high pixel-count will often mean smaller individual pixels and this can reduce the dynamic range of the sensor, thereby limiting image quality. Worse still, the fact that the camera has a high pixel-count means its file sizes will be larger than previously, yet it is quite possible that the difference in image quality could be only a slight improvement or even a significant degradation. The latter possibility may sound unlikely but there have been several examples of this situation arising in the past so do not imagine that it could not apply to the camera that you are about to buy!

Provided you can be sure that a higher resolution is obtained in practice, and that this does not come at the expense of reduced dynamic range, then a high pixel-count camera is the best choice: if not then it is time to consider a different approach.

Image enlargement

Conventional image editing programs include a feature to enlarge pictures by inserting new pixels into the original data. If a picture were to be doubled in its linear dimensions then the easiest way to do this would be to take each pixel in turn and to duplicate it both horizontally and vertically: this would work but it would not look very pleasing. A more sophisticated approach would be to take each pair of pixels and the insert between them a new pixel that had the average of the values of the original two pixels. This would give a much nicer result but it would ruin the definition of the image because all of the hard edges in the picture would now be smeared. A refinement could detect hard edges, by limiting the maximum difference in values that would be averaged, and simply duplicate one of the existing pixels in this case alone while using averaging elsewhere.

The methods used to enlarge pictures in conventional image editing programs are generally of the aforementioned type but none of these techniques gives the best results because in every case the software is acting in exactly the same way that the eye views a picture, so the final image will always be visually inferior to the original. For a really good result it is necessary to change the image data into another form that represents the information in a completely different way. This is the same situation as applies when changing visual data into a form that can be conveniently compressed to store pictures using the JPEG format: provided that the amount of compression used is slight it is very hard to see a visual deterioration in the image even though some of the original information has most definitely been discarded. In fact image compression is also analogous in an even more specific way because a lot of work has been done to develop more effective but less-visible ways of compressing images so as to make them quicker to store and transmit. This in turn led to a new standard, JPEG 2000, that was initially expected to replace conventional JPEG files but has not generally done so. The fact that this clearly superior alternative has not yet found widespread use is a measure of the amount of inertia that must

Although all major image editing programs, including Photoshop and Paint Shop Pro, include image up-sizing options it is usually the case that much better results can be obtained by using a separate program (or plug-in). Among the best choices are Genuine Fractals and Size Fixer (illustrated here).

be overcome once a file format becomes adopted as the universal standard, which is how the JPEG format must be viewed. A new challenge is approaching in the form of Microsoft's own image-file format, called Windows Media Photo (*.wmp), but it remains to be seen whether this can succeed where JPEG 2000 has largely failed.

A further connection between image compression and image enlargement is to be found in the fact that if the amount of data in a picture is to be increased by enlargement then clearly it makes sense not to have discarded any data previously: in other words, if you are planning to enlarge an image then the original picture should be stored in an uncompressed format such as TIFF or raw-data. Both of these formats do in fact have compression options and raw images are often compressed 'losslessly' by cameras but even this is far better than choosing to use JPEG compression.

Various high-quality image enlargement programs have existed at different times, ranging from the excellent VF-Zoom (the technology behind which has since been incorporated in other software) through to Genuine Fractals, knowledge of which was once tightly guarded by the *cognoscenti*. One of the very best of the current offerings is FixerLabs' SizeFixer, which has been used to enlarge many of the images in this book that were taken on modest pixel-count cameras.

The fact that image enlargement is feasible and bears almost no unwanted side-effects beyond the additional, albeit slight, workload involved in using the software, means that it is possible to think afresh about which digital camera you might want to buy. In particular, it would almost certainly be better to buy a model with six million high-quality pixels that will withstand image enlargement when the need arises than to buy an eight million pixel camera that always produces images that are no more than average in quality. You might even find that a three or four million pixel digital compact is a wiser choice than a six million pixel model. The best way to proceed will be simply to take some test pictures on a camera that you are thinking of buying then to see what happens when they are enlarged.

To process an image using SizeFixer it is only necessary to start the software, open an image and select the desired scaling factor (up to 400%). SizeFixer, which runs under both Windows and Mac-OS in two slightly different versions, does everything else automatically. In addition, not only does SizeFixer use and retain any Exif data provided but also it preserves any embedded colour tags. Clearly SizeFixer is a very sophisticated tool that can be used by enthusiast and professional photographers alike but as such it is also rather costly. In fact, you could probably buy a fairly well-specified digital compact camera for the same price as you would pay for SizeFixer. Nevertheless, by considering the bigger picture (quite literally) and thinking about the optimum pixel count in your ideal camera you might well find that it is possible to spend less money on the camera and divert some of those funds towards SizeFixer. To find out more about the software, or to download a trial version, go to www.fixerlabs.com.

This picture has been reproduced here at a considerably larger size than ought to be possible. It was taken using a two million pixel Epson PhotoPC-850Z and has been enlarged without any significant loss of quality using SizeFixer.

Image browsers

The chances are that if you are looking for image files on your computer you will probably use Windows Explorer to move from one folder to another, viewing the files therein as either lists, icons or thumbnails. This system works well if you have only a fairly small number of picture files that are all saved in JPEG format but as your collection grows or you start to engage in image editing, therefore mixing different file types, Windows Explorer starts to become more limited. Fortunately there is an excellent and totally free alternative in the form of XnView.

As well as being a very quick image browser, XnView also contains some useful features such as the ability to rotate JPEGs losslessly: the alternative technique, which involves opening the image for rotation then saving it again, means applying a second tier of JPEG compression that can degrade the picture very slightly. In addition XnView has some useful tools for converting images from one format to another and for

XnView is a free program that provides a much richer image-browsing experience than is offered by general-purpose browsers such as Explorer. In this screen-grab XnView's ability to enlarge selected images within the browser is demonstrated. There is also full access to EXIF and IPTC data.

Extensis Portfolio combines a versatile image browser with sophisticated database and searching options that make it exceptionally easy to find any picture that has been suitably catalogued. As seen here, the program automatically recognizes all of an image's metadata.

compiling sets of images, whether this is in contact-sheet form, as a web-page or on a CD.

The program's conversion engine is based on Dave Coffin's dcraw program and is effective on most types of raw files. This is an important benefit bearing in mind the comment made in the previous chapter about raw-conversion software in general. For more information, or to download your own copy of XnView, go to www.xnview.com. An alternative program, which is not free but which has excellent thumbnailing features and is compatible with Digimarc's watermarking system (see below) is ThumbsPlus, details about which can be obtained from www.ttp.co.uk.

Box 13.1 File extensions

Every file name, whether it belongs to a text document, music track or software program, contains two parts; the individual identifier, which is what most people think of as the name, and a separate file extension that denotes the file type. These two parts are separated by a decimal point (full stop) and by default comprise eight characters for the individual part of the name and three characters for the extension. It is possible, depending on how your computer has been set up, that the extension may not be visible and all you see when you list the files in a folder is each one's individual identifier. In the case of digital camera files this could be something like IMG00067, sandwiched in between IMG00066 and IMG00068. If you right-click on any file and select Properties you will see the file name listed in full with the decimal point followed by the file type. It is also possible, though not normal for as-shot camera files, that the name will be longer than eight characters: this makes absolutely no difference to what follows in the discussion about file types.

Although there are two universal file types for digital images there are also two different, and not entirely compatible, conventions for writing the extensions in each case. The JPEG file type can be denoted either as *.jpg (where * is replaced by any individual identifier) or *.jpeg. Similarly, the TIFF file type can be denoted as either *.tif or *.tiff. As was mentioned Chapter 3 on camera menus, the more correct format is the three-letter version but that has not stopped some programs from saving files using the four-letter version, which other image-handling programs cannot recognize. This is not only inconvenient but it can also be scary if you have saved a file from SizeFixer, for example, but cannot find it when you go to the appropriate directory to open the enlarged image using Adobe Photoshop.

Fortunately there is a simple solution, which is to rename the file. However, if done incorrectly this can cause a file no longer to be recognized, so extreme caution must be exercised. The method is to right-click on a file that needs to be renamed then to select Rename from the drop-down menu. The entire file name becomes highlighted and you should left-click just to the right of the end of the extension (but within the box surrounding the file name). Now you can use the backspace key to delete the existing extension and type the new format for the same file type. For example, if you delete tiff you will type tif, making sure that the decimal point remains intact. Then press Enter, at which point Windows will tell you that you are doing something that can cause problems. Double-check that you have typed the correct letters then click OK.

Now go back to the program that originally could not find your file and go through the File>Open routine again; navigate to the appropriate folder and you should now see the file that was previously invisible.

Although this is a potentially dangerous operation there is absolutely no reason why it should cause difficulties; indeed there is every reason to expect it to solve problems, provided that you work carefully and only ever use the alternative file extensions listed above.

Filing software

By far the most important thing as far as any filing software is concerned is the ability to index pictures with keywords so that they can be found at a later date and with a minimum of fuss. The two leading contenders in this field are iView MediaPro and Extensis Portfolio. Both programs work

Corrupt files are less common today than they used to be but are still encountered from time to time. While looking through CDs in search of pictures for this book I found two pictures, this being one, that were no longer usable. This risk must always be acknowledged and multiple copies stored, on separate media, of any images that are of above-average importance.

Adobe Photo Downloader is a useful program that, as its name suggests, manages downloads from digital cameras and memory cards.

There are times when the lenses available make it impossible to capture all of a scene at once. In this case stitching software, such as RealViz Stitcher used here, can be used to create a convincing composite image. The original components should always be filed together with the final version.

on the basis of storing a catalogue of thumbnail images to which can be appended different types of information. This information can comprise the picture's metadata and path name, for example, as well as manually-entered keywords. The path-name is a particular feature of Portfolio and is useful because it means that if you adopt a logical naming convention you should be able to index and find almost any picture with very little additional effort. For example, there is no point in manually naming files with the date when the pictures were taken because this information is automatically embedded. Similarly, the name of the camera used should also be embedded because it will be in each and every image's metadata. Therefore the most sensible thing to do is to name files by the subjects that they depict.

This type of naming can become very tedious so a better solution is to name the folder in which all of the files are contained and to nest folders to generate multiple keywords automatically. For example, pictures taken on holiday in Paris might be contained in a folder called Paris inside another one called Holidays. If you wanted to you could sub-divide the pictures into people, placed in a folder called Robert_Sue_Ian_James for example, and pictures of tourist sights in a folder called Sightseeing. This is fine for folders but if you start to use manually entered keywords it makes sense to standardize them so that you will be able to remember them in the future and avoid having some images indexed as 'monochrome' while others are 'black-and-white'

This image was stitched from four separate components that were photographed from directly underneath the dome of Malta's Mosta Cathedral, which is the third-largest unsupported dome in the world after those in the Vatican and St Paul's.

or even 'b&w', for example. To combat such confusions the software can keep a list of pre-defined keywords that can be applied to selected images. Importantly, the images can be indexed in more detail at a later date by referring only to the thumbnails: there is no need to dig out the master CDs when improving your database. A really nice touch in MediaPro is the flag that indicates whether a given image is immediately available or stored on an off-line medium.

Essential to any image cataloguing program is the ability to create thumbnails from a wide range of file formats, including raw formats. Most formats are widely recognized, especially Kodak, Nikon and Canon files as well as Adobe's raw format *.dng. The size of the catalogue will be tiny compared with the sizes of the original files that it represents: each image is typically around 10 kB whereas 5000 thumbnails can be stored in about 50 MB, which is probably not much more space than would be occupied by no more than four uncompressed pictures. Bearing in mind that a whole mass of indexing information can be included in the catalogue, it is easy to appreciate quite how powerful a system of this sort can become.

An advantage in favour of Extensis Portfolio is the software's ability not only to extract thumbnails from more different types of raw files than iView MediaPro can currently handle, but also to convert raw images into a standard form, such as JPEG or TIFF, at up to half the file's maximum size. Presumably this half-size limitation has been imposed so as to avoid undermining the camera manufacturers' own software but even so it is a very useful feature. More details about Portfolio and MediaPro can be obtained online from www.extensis.com and www.iview-multimedia.com.

Image enhancements

Despite the fact that the software supplied with your camera will have contained image correction features there may still be room to apply additional enhancements that are provided by third-party software. An excellent example of software of this type is DxO OpticsPro, which addresses image distortion and vignetting problems caused by the lens used. These effects could be viewed as being outside the camera manufacturer's domain, though Epson does include lens-correction features in the PhotoRaw software supplied with its R-D1 cameras. The advantage of OpticsPro is that it is more widely applicable and, thanks to a very sensible change in the software's pricing, once you have bought the software you are free to add further lens and camera modules of the same type if they become useful to you in the future. Beware, however, that DxO's software uses the picture's metadata to determine the appropriate corrections that are needed, so if a picture is processed in a manner that loses its metadata OpticsPro will be stymied. Therefore, and as is the case for all image correction and enhancement software, including SizeFixer, it is always best to undertake these sorts of changes before attempting more radical image manipulations. For more details about DxO's software go to www.dxo.com.

Kodak has put a library of different 'looks' in its software so that images can be adjusted with minimal fuss to create specific effects. Shown here are three of the available colour renderings; Portrait Reduced-Colour, Portrait (Normal) and Product High-Colour. Also shown are three of the monochrome options; Normal, Wratten 25 (red filter effect, giving higher contrast) and Warm Sepia.

Two more programs that offer enhancement features are Bibble Pro and CaptureOne, both of which are professional tools that appear to prioritise feedback and workflow respectively. Bibble Pro allows very fine adjustments to be made to an image and clearly flags any likely problems but can sometimes be a bit slow to carry out the specified adjustments. CaptureOne has sophisticated colour-handling features and benefits from a progress bar, which Bibble Pro lacks, but I have found that it sometimes crops images unexpectedly. A third member of this group, RawShooter, was formerly available in a choice of professional (paid-for) and enthusiast (free) versions

DxO Optics Pro is an excellent image-enhancement program that lets the user decide how much effect the software should have on the image. Shown here are the original image (*top*), modest adjustment (*middle*) and strong adjustment.

Bibble Pro issues a warning if it detects areas of the picture where the component colours are out of harmony as this indicates a possible colour cast.

PhaseOne's Capture One software features a split-screen function that makes it especially easy to assess the effects of changes made to images.

but following Adobe's acquisition of Pixmantec the free version is no longer supported and will be discontinued. The paid-for version continues at present but Adobe's stated aim is to incorporate Pixmantec's technology in its own products so RawsShooter's future may be limited in the long term. To find out about the latest offerings from these companies visit www.bibblelabs.com, www.phaseone.com and www.pixmantec.com respectively.

Watermarking

In the days when photographs were only ever handled as paper prints it was easy, if you were a professional photographer trying to protect your livelihood, to write a copyright message on the reverse of a print – or even to stamp it over the front of the image if you feared a serious risk of copying. Today things are different and people assume, often quite wrongly, that possession of a digital file also means possession of the right to print it and do whatever else with it may seem appropriate. Such files can be obtained simply by downloading pictures from the Internet since the general perception is that anything placed on the World Wide Web is available for free use

There is an invisible watermark embedded in the first picture in this chapter but sometimes it is more useful to have a visible deterrent against people copying your photographs. Picture Shark is a free (with optional subscription) program that makes visible copyrighting very easy for both individual and multiple images.

Information can also be hidden in pictures for reasons of secrecy as well as copyright. This picture contains a message that has been embedded using PGE (Pretty Good Envelope). If you scan this page and analyse the picture using PGE, which can be downloaded free of charge, you may be able to recover the message.

by everybody else. To a degree this is true in practice, if not in the eyes of the law, but that does not mean that the creator of the image should not be recognized. In the free-software world, for example, one of the conditions applied to the distribution and use of such programs is that the author's identification must always remain intact.

Digital images can be labelled very simply using the creator field in the picture's metadata: in some cases it is even possible to upload this information to a camera so that every picture will be appropriately identified the moment it is captured. The problem with this technique, however, is that the information is very easy to change. Two different approaches are therefore used; one involves applying a visible 'stamp' to the image whereas the other involves embedding an invisible watermark that can never be removed but will alert all users to the fact that it exists.

Given that a visible stamp degrades at least part of the image there is no point in using this technique if your images will only ever be accessed by people whom you trust. Similarly, given that an invisible watermark is intended to be a warning flag there is no point in applying one if you have no means of enforcing your copyright. If you have a website that contains a collection of personal images then it would be wise to put a discrete copyright notice along one edge of every picture, so as not to ruin the overall effect of the image, but you must accept that this could easily be cropped off by an unscrupulous downloader. That said, why should anybody want to steal your picture of the Eiffel Tower when there are millions of others (some doubtless much better) around? If, on the other hand, you have a picture of the two most talked-about celebrities kissing, fighting or

whatever else would make the front cover of a celebrity magazine, then you should be more sensible than to post it on your personal blog page for anyone to steal.

In short, although copyright-protection technologies exist it is doubtful whether they will be useful to you unless you are a commercial photographer or picture library. If, on the other hand, you do wish to stamp your images this can easily be done using any image editing program that supports layers. Simply create a message or logo that will be applied to the picture and save this as an image file in its own right, choosing a size that will be appropriate to the pixel dimensions of the images you will be stamping. Next, open the image file and paste the message/logo over the image in a new layer, drag the new layer into the best position, select an appropriate level of transparency/opacity and then flatten the composite image. The stamp is then embedded as part of the image and can only be removed by either cropping or retouching. If you would prefer to use a program with automated batch-stamping facilities then you might like to investigate PictureShark, which is free but can also be registered at a very low cost in order to guarantee unrestricted access to future updates. To find out more visit www.picture-shark.com.

The industry leader for invisible watermarking is Digimarc, a reader for which is incorporated within Adobe Photoshop, so if a professional user opens a watermarked file the software immediately signals this fact. Ideally the invisible watermark should be able to withstand a lot of changes being made to the file so that the copyright flag is always displayed: Digimarc's technology is pretty good in this respect but if in doubt the recommendation must be to watermark at the highest level possible. Digimarc's technology can be evaluated free of charge but a paid-for licence is needed to take advantage of the image linking function. This feature is an essential part of Digimarc's commercial service: it allows the user of a picture to visit an online register and discover the name and contact details of the picture's copyright owner in order to get in touch and agree a suitable fee for use of the image. At the highest level, Digimarc operates an online image tracking service that detects uses of watermarked images and provides a report to the copyright owners directly, so avoiding the need to rely on the honesty of individual users. For more details go online to www.digimarc.com.

A less robust form of invisible watermarking, known as fragile watermarking, can be used as a way of checking that a certain image file has not been manipulated in any way. Just as placing too faint a watermark will mean that fairly routine image manipulation could render an image unprotected, so using the same technique could allow the veracity of an image to be confirmed if the faint watermark is still intact. This is a highly specialized area that will probably be of primary concern to law enforcement agencies but it does lead the way to one final aspect of watermarking that has a certain James Bond aspect to it.

Given that a watermark is essentially invisible it would in theory be possible to place a piece of information in the watermark then to send the

picture to somebody else by e-mail without any third parties being aware that a secret message is being conveyed. The espionage possibilities may seem intriguing but less dramatically this trick might be used for something as ordinary as arranging a surprise party without another member of your family knowing. To start exploring these possibilities download the free program PGE (Pretty Good Envelope) from the link at www.jjtc.com/Security/stegtools.htm. This could open-up a whole new world of digital imaging and you may never look at pictures the same way again!

Smooth-toned areas and diagonal straight lines are demanding subjects for digital photography: the former shows image noise and the latter reveals artefacts. Neither problem is apparent in this image, which was taken using a Nikon D1X.

Digital Quality

This chapter is the first of three that are aimed at readers who want more details about the technical side of digital imaging technology. They represent a light skate over some very complex issues and the information they contain is not essential to the rest of this book. They can safely be left unread if you are interested only in *what* digital cameras can do rather than *how* they do those things. This chapter will concern itself chiefly with digital sensors themselves, although it will also touch on digital camera lenses and colour, which are covered in detail in the two chapters that follow.

According to Albert Theuwissen's very technical book *Solid-State Imaging with Charge-Coupled Devices* (Kluwer Academic Publishers, 1995), the foundations of electronic imaging components were laid in 1969. In that year, while Neil Armstrong and Buzz Aldrin were taking mankind's first steps on the lunar surface, two workers (Sangster and Teer) at the Philips Research Labs in Holland published a paper about a completely new type

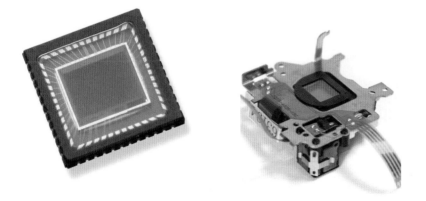

These two pictures show a sensor in isolation and on a motorized platform that was introduced by Minolta in its A1 camera as a way to reduce blurring caused by camera shake. Unlike in a film camera, where the film both detects and stores the image, an electronic sensor only detects the image. In addition, despite being found in digital cameras they are in fact analogue devices.

Box 14.1 The photo-electric effect

The various effects that light has on different materials have been of interest to scientists for hundreds of years but one particular effect was the centre of attention in the early part of the twentieth century. Researchers had previously discovered that if metals were heated they gave off electrons: this effect was exploited in electronic valves used inside radios, television sets and even the earliest computers. Less easy to explain was the fact that when light is shone onto a clean, polished metal surface electrons can again be emitted. It followed, people thought, that if the intensity of the light were increased then the number of electrons emitted should also increase: this was found to be true but some metals did not emit any electrons no matter how bright the light became. That would not have been a problem were it not for the fact that a different light source could sometimes cause electrons to be emitted even though the first light could not. Clearly there was another effect at work other than simply the brightness of the light.

The answer was supplied by Albert Einstein and it was for this work, not his Theory of Relativity, that Einstein won the 1921 Nobel Prize for Physics. Einstein showed that the factor that determined whether or not any electrons were released from a metal was the frequency (colour) of the light. He suggested that it took a certain amount of energy to release one electron and used previous work by Max Planck, who won the Nobel Prize for Physics in 1918 for his quantum theory of light, to show that a light particle's (photon's) energy, provided it is sufficient, both releases an electron and speeds it away from the metal. Shining a brighter light onto the metal only increases the number of electrons released: it does not have any affect on their energy. Although ultra-violet light is required to achieve the release of electrons from metals it is possible to engineer semi-conductor materials in which electrons can be released by the action of visible light, thus paving the way to electronic imaging sensors.

This interaction is important in photography, both film-based and electronic, because it is the action of a photon, in releasing an electron, that causes film grains to become developable and pixels to accumulate charge. In an ideal world one photon would release one electron but in fact there can be both inertia (a minimum number of photons needed to give any measurable effect) and non-linearity. In digital imaging a lot of work has been done to improve the photon efficiency of sensors without increasing the noise that comes from randomly liberated electrons, which would otherwise

accumulate in exactly the same way as image-forming electrons. Sadly, and despite the fact that pixels that are more efficient should give better image quality, the most widely recognized measure of a sensor's sophistication is often still just the number of pixels that it contains.

of component that they dubbed the Bucket-Brigade Device. It worked by transferring packets of charge from one transistor to another and was developed as part of work being undertaken on analogue signals (see below), but was quickly spotted as the basis of a solid-state imaging sensor. A year later two researchers (Boyle and Smith) at the Bell Laboratories in America improved the charge-transfer concept and named their component the Charge-Coupled Device (CCD).

Progressing from the basic idea of accumulating and moving the charge created by the action of light on a semi-conductor junction (see Box 14.1) to a useful photographic imaging device involved considerable miniaturization to yield sensors containing many thousands (and later millions) of individual detectors. It also required a systematic method of extracting and storing the data in such a way that it could be reassembled later to provide a meaningful representation of the original scene-brightness distribution. That representation, when expressed as shades of light and dark (luminosity) and hues of different colours (chroma), is what our human eyes translate as a picture.

Ironically, digital cameras' sensors are not digital devices and the first so-called 'digital cameras' were in fact still-video cameras that were effectively capturing single frames from a video. This was true for a good decade, right though from Sony's original Mavica, which was unveiled in August 1981, to Canon's successful ION cameras of the early 1990s. Later cameras continued to use similar sensor technologies but changed the way in which the data were encoded to accommodate the shift from a television-based (analogue) society to one in which digital personal computers played a pivotal role. The terms 'analogue' and 'digital' are much-used but their differences are not always fully appreciated: clarifying these terms is therefore the first aim of this chapter.

Analogue versus digital

An analogue system is one in which something varies in a continuous manner whereas digital representations use a series of discrete states. This is comparable to the difference between a ramp and a set of stairs: in the former case the change from one level to another is smooth whereas the latter involves a finite series of vertical height changes. If you opted to take the

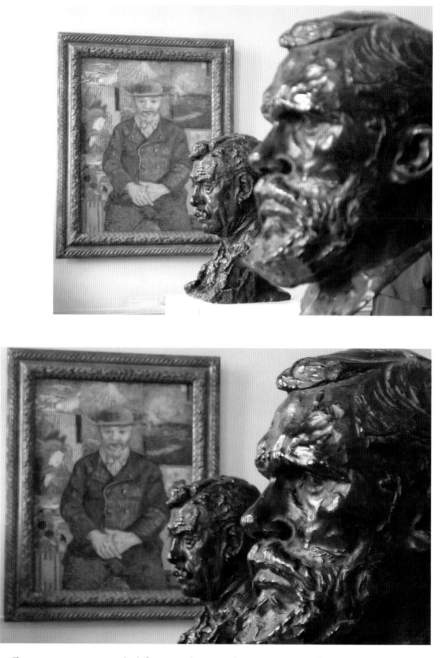

There are two common standards for sensor shapes, resulting in two common formats for digital pictures. One format employs a 4:3 aspect ratio that has it roots in electronic (video) imaging; the other employs a 3:2 aspect ratio that echoes the proportions of 35 mm film. Some hybrid cameras offer a choice of aspect ratios that is delivered by cropping the image area in-camera.

stairs it would be a simple matter to give your instantaneous location at any time just by saying which step you had reached. Things are less straightforward on a ramp because the best you could hope to do would be to report how far you had travelled along the ramp, which would not be the same thing as the vertical height you had climbed.

Continuing this analogy, it follows that although a digital system is more precise than an analogue system it is also more limiting because there are no 'half steps' if they should be needed. One area in which 'half steps' can be important is when dealing with colour. Suppose, for example, that you wanted to choose some paint to decorate a room and had a chart listing all the colours available from a particular paint manufacturer: despite a vast range of choice you might decide there was nothing exactly right and might therefore ask to have a mixture of two adjacent shades. You might even say that the colour you want is closer to one adjacent shade than to the other and request that the mixture comprises two-thirds one colour and one-third the other. The documented shades of a colour from the lightest to the darkest tone could be considered to be a digital representation, but by opting for something in-between you are using an analogue approach because you are asking for something that is not previously defined.

In getting a bespoke paint colour you are losing standardization: a previously defined colour is a standard but your own mixture is personal. Some time later you may not be able to remember the precise mixture that you used to make your customized colour whereas if you forgot which standard paint you used you could simply refer to the colour card to identify the perfect match. As a result, it should be evident that digital is not automatically better than analogue but it does have certain advantages when standardization is required.

The standardization that applies inside digital equipment refers to the number of discrete steps that data are allowed to occupy. So if we think about greyscale tones going from pure white to solid black then digitization defines the number of intermediate shades of grey that is permitted. It also defines the fact that these shades will all be equally spaced.

Electronic sensors are colour-blind by default. One of the early ways of recording coloured images was by using a filter wheel mounted on the front of the camera: this was rotated so that separate pictures could be taken to record the red, green and blue information in a scene. The three components were then combined using software installed on a computer that was tethered to the camera.

Bits and bytes

Computers work using streams of 0s and 1s that carry their instructions. The same system is also used to represent data, including the individual pieces of information that comprise digital pictures. One binary digit (which can take the value of either 0 or 1) is called a 'bit', this name having been formed from the beginning of 'binary' and the end of 'digit'. Individual binary digits can only indicate which of two states apply to a piece of data, such as whether a switch is off or on, so to convey more information the bits are linked together in blocks of eight. This packet of eight bits is called a byte and it is from this that we get the terms kilobyte (kB) and megabyte (MB). (Note that the symbol for quantities that are measured in bytes is a capital 'B': this means that it is simply not correct to write, as some people do, kilobytes as 'kb' because this actually means kilobits.)

As an aside, we can observe that although a kilometre is 1000 metres, a kilobyte is actually 1024 bytes, owing to the fact that computers work in powers of two and 1024 is the product obtained by multiplying two by itself ten times. Similarly, a megabyte is 1024 × 1024, which equates to 1.05 million rather than just one million. There have been moves to remove this anomaly, and the SI definition does indeed use one thousand and one million as the multipliers for digital quantities, but there is still some confusion as to whether a megabyte refers to a million bytes or 50,000 more than a million. Similarly, it is not correct to use the term 'megapixel' (meaning one million pixels) because a pixel is not a unit of measurement: this is the same reason why we do not say 'megadollars' when talking about millions of dollars. Nevertheless, despite its inelegance and incorrect structure, the term 'megapixels' is in serious danger of becoming accepted into the English language.

Returning to bits and bytes, and the apparent limitation of one bit only being able to represent two different states, it is interesting to see how many states can be indicated by combining multiple bits. The easiest way to do this is using 0s and 1s but without getting too involved with the intricacies of binary notation that you might have studied at school. If we have three bits then we have three digits that can each be either 0 or 1. This gives eight possible unique arrangements as follows: 000, 001, 010, 011, 100, 101, 110 and 111. In other words, by using just three pieces of data (bits) we can define eight different things, such as eight shades of grey. If we have a look-up table (LUT) that is somewhat like the paint chart previously mentioned, then we can identify a shade of grey by number and the computer can display the appropriate tone.

More generally, to find the total number of unique states that can be defined by a collection of bits, it is only necessary to multiply two by itself the same number of times as there are bits. This means that three bits can define eight (2 × 2 × 2) different states and that our eight-bit byte can define 256 (2 × 2 × 2 × 2 × 2 × 2 × 2 × 2) different things. In the shades-of-grey example quoted above it therefore follows that the standard eight-bit byte

can define 254 shades of grey plus pure black and pure white, making 256 tones in all.

This same method for defining data is also used for defining colours except instead of being limited to just 256 colours in all, which would be a very small number compared to the range of hues that the human eye can discern, the same division is applied separately to the red, green and blue components of each and every colour. This in turn means it is possible to define a total of $256 \times 256 \times 256$ different colours, which works out to be a massive 16.77 million unique colours. Huge though this range is, however, it is normal for modern camera sensors to yield data that cover an even greater number of discrete levels. The 'bit depth' of digital camera sensors may be 10-bit, 12-bit or 14-bit but their data are normally reduced to eight bits in order to be contained in JPEG or TIFF files, although they may alternatively get coded as 16-bit because this can be conveniently done by using exactly two bytes at a time.

This is what a sensor looks like close-up. The pictures show the microlens array seen obliquely from above and a cross-section through one photo-site. Each photo-site responds only to the brightness of the light that it receives.

It is possible to overlay a grid of coloured filters on a sensor so that each photo-site receives light of a particular colour (red, green or blue). The Bayer Colour Filter Array (CFA) was invented by Kodak and is used, in one form or another, in most digital cameras today.

This Fujifilm diagram shows how the various parts of a sensor fit together. The colour filter array sits between the photo-sites and the microlenses above them.

Pixels

The word 'pixel', like the word bit, is derived from two words; in this case it is the beginnings of the words in the phrase 'picture element' with a rounding of the two syllables. As such a pixel is the smallest individual part of a picture. The same term is also used to describe the separate image-gathering sites that adorn a sensor's surface: these sites are not true picture elements but the name has stuck and is so widely used that it is unlikely ever to be changed. Nevertheless, when discussing the technical quality of sensors, it is common to refer to photo-sites or photo-diodes, the latter being the part of each site that converts photons in the incident light into charge (accumulated electrons).

Pixel count

In general, the greater the number of pixels that a camera has, the better its image quality is likely to be. Of course there is more than one way to measure image quality and it may be that increasing the pixel count improves one aspect, such as resolution, but degrades another, such as sensitivity. Even so, the effect on the resolution of a fixed-size sensor obtained by increasing the number of pixels is small because the increase in pixel count is spread across the entire area of the sensor whereas resolution is a linear figure. As a result of this, doubling the number of pixels on a sensor does not double the maximum theoretical resolution but rather boosts it by only 1.4 ×. If the aim is to double the resolution then the number of pixels must be quadrupled. This is significant because the difference in the number of pixels between the most sparsely populated digital compact camera sensor and the norm for the upper end is indeed approaching a factor of about four (from about three million pixels to around ten million pixels). In short, theory suggests that the best digital compacts can resolve only about twice as much detail as the cheapest models. More will be said about resolution in the next chapter.

One reason not to choose a camera with the maximum number of pixels is the fact that high pixel-count cameras are often slower to use

owing to the time taken to process the increased amount of image data obtained when a picture is taken. There is therefore a case for saying that the optimum number of pixels to choose is the fewest that will meet your requirements. In most cases, a maximum of about six million pixels should be sufficient. Interestingly, this figure represents only a 50% increase over the optimum suggested in the previous version of this book, which was published in 2003. That is a relatively small gain in digital terms and indicates the extent to which pixel quality has suffered while digital camera manufacturers have concentrated on achieving ever-higher pixel counts. It is also significant that the arrival of six-million pixel sensors was the stage at which professional photographers started to get really excited about the quality that could be obtained from digital SLRs.

Sensor area

The next most important pixel-related factor to consider is the overall size of the sensor combined with the number of pixels provided. It follows that a large sensor containing a relatively small number of pixels should have a large area for each individual pixel. Similarly, if the same pixels are shrunk down they can be placed on a smaller sensor that allows the overall camera design to be miniaturized as well. All other things being equal, larger pixels tend to bring better image quality and higher sensitivity. If a small-pixel camera has an effective basic sensitivity of ISO80–100 then a large pixel camera might be ISO200–400. The same is also true at the upper end of a camera's sensitivity scale: a small-pixel camera might have a maximum rating of ISO400 whereas a large-pixel camera might extend to ISO3200 and therefore be capable of taking pictures under lower levels of lighting. Even at mid-range sensitivities the ability of a sensor to record very bright and very dark details relies on a wide dynamic range and is often associated with larger pixels.

On the other hand, if pixels are imagined to be like grains in a photographic film then larger pixels ought to mean inferior image quality owing to the fact that the structure of the image-containing medium (be this grain or pixels) will be more obvious. That would be true if the image-capture area were constant, but not otherwise. Although it is true to say that an ISO400 film gives more grainy pictures than an ISO100 film when both are exposed using the same camera, if a larger format ISO400 film were used in a bigger camera then the final result could well be no more grainy than the ISO100 picture taken in the smaller camera. So it is with digital also.

It follows that, theoretically, the very best digital camera is likely to be based on a large sensor containing a large number of large pixels. Several things count against this as the ultimate guide to finding the best digital camera in practice but by far the most important one is cost: the price of a sensor rises very steeply as its area increases owing to the inevitable occurrence of imperfections. So the larger the sensor becomes the more chance there is of imperfections that will render its results inferior, hence the more expensive it is to manufacture a completely perfect device because a high proportion of

sensors made will be imperfect and have to be discarded. Manufacturers try to reduce the final cost of all sensors by placing finite, non-zero limits on the number of imperfections that will be accepted in the production process. Provided that this limit is small and clever software processing is undertaken in the camera to minimize the effect of 'dead' pixels you might never be aware of the tactic that has been used to keep down the price of a camera that would, in a perfect world, have been much more expensive.

Overall, the best quality in a compact camera is likely to come from a medium size (not ultra-compact) model featuring a medium number of pixels (something in the four-to-six million range) with a low minimum sensitivity (around ISO100) and a modest maximum sensitivity (no more than ISO800). Of course there are also non-sensor factors to take into account, some of which are covered in the next two chapters.

The future?

One question that often comes up is the maximum number of pixels that digital cameras are likely to have, or indeed need, in the future. It is interesting to look back and see that in March 2001 the magazine *Electronics*

These three pictures illustrate the fact that there is more than one way of translating an electronic sensor's data into a visual image. The two apparently identical pictures of the Tarxien Temple ruins in Malta were separately obtained by converting raw data from the sensor in-camera and using external software. The two images were then subtracted from each other and the resulting difference image was boosted to maximum saturation and contrast. If the two renditions had been identical then the difference image would have been a uniform mid-grey: the fact that it contains a pattern proves that one translation method included more image information than the other.

and Beyond identified ten million pixels as the next major target. In June 2006 a semi-conductor manufacturer, Dalsa, announced that it had broken the hundred million pixel barrier and that it is now starting to manufacture thirty million pixel sensors for commercial digital cameras. The hundred million pixel sensor measures approximately 10 cm square and comprises a grid of 10560 × 10560 pixels, each one 9 microns (μm) in size. This pixel size is considerably larger than the technology is now capable of delivering, thus lending support to the idea that larger pixels generally offer better image quality.

Sensor types

Dalsa's record-breaking sensor will be used in a US Navy telescope to make very accurate measurements of the positions and motions of celestial objects and has a square format because this makes best use of the image projected by any lens. This was the same thinking behind Rollei's and Hasselblad's adoption of square-format negatives in the days of film. Having a fixed size and shape for film formats is essential because films are manufactured by one set of companies whereas cameras are, for the most part, manufactured by another set of companies and it is in both parties' interests for films and cameras to be completely compatible. This is less true for digital cameras because the imaging device (the sensor) is built into the camera and cannot be changed: it is therefore of little importance whether the sensor is the same as that in another camera provided that the images recorded can be made compatible with universal standards at some stage. In other words, provided that a camera can produce JPEG or TIFF images, either directly or via dedicated conversion software, the sensor matters only in the bearing that it has on image

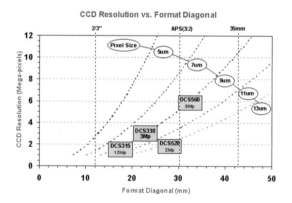

It has always been the case, as this graph based on early digital cameras illustrates, that in order to provide either more pixels or smaller sensors the pixel size has to be reduced. This can result in lower image quality. The table printed elsewhere in this chapter shows that even now, five years after the graph was compiled, the same trend exists and optimum image quality for digital photography still requires a pixel size of around seven-to-nine microns. (From *Digital Camera Techniques*, Focal Press, 2003, based on original data from Eastman Kodak.)

quality. As a result there are no fixed rules that govern sensor sizes and shapes other than those that camera manufacturers have adopted voluntarily.

Sensor sizes

The reason for adopting common sensor sizes harks back to the camera lens and particularly the need to define the area over which the lens must project its image when a picture is being taken. Agreed sensor formats are therefore only really important for cameras that have interchangeable lenses. That said, a sensor's shape also determines the proportions of the pictures that it produces and there is a good case for saying that this should match common print proportions. Given that many prints are made at enprint (4 × 6 or 5 × 7 inch) or A4 (210 × 297 mm) sizes, and that all of these formats have approximately 2:3 proportions, it follows that a good sensor format would have the same 2:3 proportions. Unsurprisingly, the common arrangement for a six million pixel sensor is indeed 2000 × 3000 pixels.

The standard sensor sizes that have evolved are APS-C (28.7 × 19.1 mm), Nikon DX (23.7 × 15.7 mm) and Four-Thirds (18 × 13.5 mm), though there is a case for saying that the image circle, defined by the diagonal length of the sensor, is the most important measurement since it determines the lens characteristics needed to accommodate a given sensor size. In addition, some manufacturers have pursued the idea of using sensors that are the same size as a 35 mm film negative (36 × 24 mm): this format is sometimes referred to a 'full-frame'. The first full-frame digital camera was the Contax N Digital, which had six million pixels and was launched early in 2002. Later that same year, Kodak pipped Canon to the post by just one day to announce the world's second full-frame digital camera and also took the record for the highest number of pixels (fourteen million): Canon's camera seemed inferior with only eleven million pixels but turned out to be more reliable and long-lived.

More costly digital backs initially used full-frame sensors but now feature larger sensors that are either double-full-frame (36 × 48 mm) or square arrays of various sizes. Compact cameras, on the other hand, tend to feature much smaller sensors that are derived from video sizes. In the video world the basic standard is a one-inch imaging tube, which has a 16 mm diagonal working area with 4:3 (classical television and computer screen) proportions. Thus the active area of a one-inch sensor measures 12.8 × 9.6 mm, a half-inch sensor measures 6.4 × 4.8 mm and a two-thirds sensor measures 8.5 × 6.4 mm. In theory a four-thirds sensor should measure approximately 17.1 × 12.8 mm but this does not quite match the proclaimed size for the Four-Thirds system mentioned previously. Further complications arise from size descriptors such as 1/1.7 inch and 1/2.7 inch, both of which are employed by Fujifilm. These work out to be 0.85 inch and 0.37 inch respectively and therefore suggest sensor sizes of 10.8 × 8.2 mm and 4.7 × 3.5 mm. These are tiny sizes compared with Fujifilm's largest

sensor, which measures 23 × 15.5 mm and is fitted inside the current flagship FinePix S5 Pro. The fact that the largest sensor is almost exactly the same size as Nikon's DX format is probably not a coincidence given that the Fujifilm camera is based on a Nikon body and takes Nikon-fit lenses.

Electronic technologies

As well as different sizes of sensors, different cameras also employ different electronic technologies. In particular there has been much debate in the past about the relative merits of Charge Coupled Device (CCD) and Complementary Metal-Oxide Semiconductor (CMOS) sensors. As was noted at the start of this chapter, CCD sensors came first: they were also, for a long time, the outright winners when it came to image quality but lost out on power consumption and therefore not only battery drain but also the amount of heat that they generated in use. Heat can cause electronic noise, and noise degrades image quality, so some high-end professional cameras that used CCD sensors had to be fitted with active cooling systems to prevent their chips from getting too hot. The situation today is very different and, to a large degree, CMOS sensors seem to be winning.

CMOS sensors have noise of their own but this is fixed-pattern noise rather than the low-signal noise that can sometimes be seen in pictures taken at night. Fixed-pattern noise arises from the fact that conventional CMOS sensors have a separate amplifier on each pixel site. These amplifiers will not normally be fully matched across the entire chip and it is the residual mismatch that causes fixed-pattern noise: in a CCD, all the pixels feed through a common amplifier stage so the same problem does not arise. That said, fixed pattern noise is no longer the problem that it once was and the inherent CMOS advantages of low power and greater circuit integration mean that even high-end digital SLRs now use such sensors. As a result Nikon, for example, switched from CCD technology in its D1X to CMOS technology in its D2X when it boosted its sensors from six to twelve million pixels. Similarly, Kodak was once dismissive of the suitability of CMOS sensors to professional imaging applications but now manufacturers top-quality sensors of this type alongside its CCD lines.

Fujifilm Super-CCD

Although the CCD-versus-CMOS battle has been all but won by CMOS sensors, there are several completely different approaches to sensor design that are worth covering in the last two sections of this chapter, starting with Fujifilm's impressive Super-CCD. Initially this was distinguished from other sensors by its octagonal geometry but the latest incarnation now features twin photo-diodes within each pixel. The characteristic octagonal geometry provides a way of reducing the amount of each pixel's area that is given over to microscopic wiring and channels that separate its signals from those

Although most sensors have just one photo-site for each pixel, Fujifilm Super-CCD Type SR sensor has dual photo-sites that result in improved highlight and shadow detail.

belonging to adjacent pixels. This reduction leaves more area for active light gathering and results, in theory, in greater sensitivity and less noise than would be achieved using the same pitch (overall size) of square pixels.

In addition, the Super-CCD has its colour-coded rows turned through 45 degrees (something made possible by its octagonal geometry) and therefore the columns of pixels are staggered compared to their standard position. This reduces the effective pixel separation, as projected on vertical and horizontal axes, and is used by Fujifilm as a means to increase the amount of image data using a special type of interpolation. Much debate has surrounded the validity of this technique but there are two simple observations that can be made. The first is that all data is either detected or invented; there is no halfway house. If a sensor contains six million pixels then that is how many data points it can detect. It may be that a different distribution of those points allows better guesses to be made about the nature of the gaps in between but there is no escaping the fact that these are guesses (though increasingly sophisticated ones). The second point is that all Bayer-pattern sensors require data interpolation in order to obtain red, green and blue values for every point, where originally only one of the three actually existed.

This means that it is unfair to criticize any particular manufacturer for employing interpolation when all do so of a sort. The difference is that whereas most use only colour interpolation, manufacturers who seek to increase the total number of pixels are also interpolating spatially. It is significant to note that when spatially interpolated files are analysed it becomes obvious that their image resolution is less than would be predicted from the image's proclaimed pixel-count. In fact, until somebody devises a very much cleverer system of interpolation, a lower-than-anticipated resolution can be a useful way to spot that this procedure has been employed.

Despite sharing the same Super-CCD name not all of Fujifilm's sensors are identical: specifically, SR-type sensors have larger photo-sites that comprise twin photo-diodes whereas HR-type sensors have smaller photo-sites that comprise a single photo-diode. The latter type is therefore the more

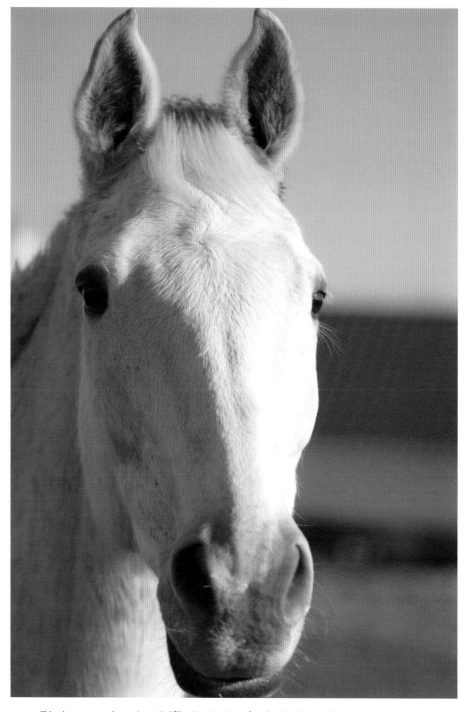

This picture was taken using a Fujifilm FinePix S3 Pro fitted with a Super-CCD Type SR sensor that has held excellent detail on the sunlit side of the horse's white face.

conventional arrangement and has the advantage of allowing Fujifilm to pack the maximum number of pixels into a given size of sensor. This is a tactic that has been forced upon digital camera manufacturers, especially in the compact market, because the pixel count is the first thing that most potential buyers ask about, even though the number of pixels on a sensor is far from being the whole story as far as overall picture quality is concerned.

Fujifilm's SR-type Super-CCD sensors, which are found only in the company's top-of-the-range digital cameras, use twin photo-diodes to improve the dynamic range and therefore provide more shadow and highlight detail than would otherwise be possible. The fact that twin photo-diodes are needed stems from the comment made earlier about digital levels being equally spaced. This distribution is problematic because our eyes have a variable accommodation and can perceive detail even in areas that are very bright indeed whereas there is a definite maximum brightness that any digital sensor can record, this being the point at which the pixel reaches saturation. Although sensor designers worked on improving this and succeeded in increasing the 'well depth' at each pixel, so allowing the sensor to discriminate between brightness levels that would previously have exceeded its saturation point, Fujifilm chose to take a very different approach.

The fact is that a high bit-depth (indicating deep pixel-wells) does not always improve image quality. This is because all pixels have a certain amount of noise that becomes most obvious when the image signal is also low: this applies regardless of the type of sensor (CCD or CMOS) and is the main reason why images taken under low levels of lighting tend to look comparatively poor. As the total well size increases levels of light that could previously have quarter-filled the well might now be down at one-tenth full and therefore closer to the dreaded noise level. Fujifilm overcame this problem in its fourth-generation Super-CCD SR sensors by having two photo-diodes with different areas within each photo-site. The larger photo-diode records most of the brightness information whereas the smaller photo-diode is activated only at higher brightness levels when the larger photo-diode starts to become saturated. Looking at histograms of images containing low-contrast (a short subject-brightness range) and high contrast (a wide subject-brightness range) it appears that the smaller photo-diode modulates the larger photo-diode's data rather than simply adding to it. Whether this is actually what happens, or is merely a consequence of other image processing, is immaterial: the simple fact is that Fujifilm's Super-CCD SR sensors offer a definite advantage when photographing high-contrast subjects.

Kodak sensors

Although Kodak no longer sells professional digital SLRs, it manufactures a wide range of sensors that are used in an equally wide variety of cameras,

Table 14.1 Summary of Kodak's range of sensors

Sensor type	Device identification	Total pixels (MP)	Sensor dimensions (pixels)	Pixel size (μm)	Sensor diagonal (mm)	Frame rate (fps)
CMOS	KAC-9618	0.3	648 × 488	7.5	5.3	30
CMOS	KAC-9619	0.3	648 × 488	7.5	5.3	30
CMOS	KAC-9628	0.3	648 × 488	7.5	5.3	30
CMOS	KAC-00400	0.4	768 × 488	6.7	5.3	60
CMOS	KAC-01301	1.3	1284 × 1028	2.7	4.0	15
CMOS	KAC-3100	3.1	2048 × 1536	2.7	5.9	10
CMOS	KAC-5000	5.0	2592 × 1944	2.7	8.9	6
Interline CCD	KAI-0330	0.3	648 × 484	9.0	7.3	60/120
Interline CCD	KAI-0340	0.3	640 × 480	7.4	5.9	110/210
Interline CCD	KAI-0373	0.4	768 × 484	11.6 × 13.6	11.1	30
Interline CCD	KAI-1003	1.0	1024 × 1024	12.8	18.5	15/30
Interline CCD	KAI-1010	1.0	1008 × 1018	9.0	12.9	15/30
Interline CCD	KAI-1011	1.0	1008 × 1018	9.0	12.9	15/30
Interline CCD	KAI-1020	1.0	1000 × 1000	7.4	10.5	30/50
Interline CCD	KAI-2001	1.9	1600 × 1200	7.4	14.8	15/30
Interline CCD	KAI-2020	1.9	1600 × 1200	7.4	14.8	15/30
Interline CCD	KAI-2093	2.1	1920 × 1080	7.4	16.3	15/30
Interline CCD	KAI-4011	4.2	2048 × 2048	7.4	21.4	8/15
Interline CCD	KAI-4021	4.2	2048 × 2048	7.4	21.4	8/15
Interline CCD	KAI-11002	10.7	4008 × 2672	9.0	43.4	2/5
Full-frame CCD	KAF-0261	0.3	512 × 512	20.0	14.5	15
Full-frame CCD	KAF-0401	0.4	768 × 512	9.0	8.3	20
Full-frame CCD	KAF-0402	0.4	768 × 512	9.0	8.3	20
Full-frame CCD	KAF-1001	1.0	1024 × 1024	24.0	34.8	3
Full-frame CCD	KAF-1301	1.3	1280 × 1024	16.0	26.2	2.5
Full-frame CCD	KAF-1602	1.6	1536 × 1024	9.0	16.6	2.2
Full-frame CCD	KAF-1603	1.6	1536 × 1024	9.0	16.6	2.2
Full-frame CCD	KAF-3200	3.3	2184 × 1510	6.8	18.0	2.5
Full-frame CCD	KAF-4202	4.2	2048 × 2048	9.0	26.1	0.5
Full-frame CCD	KAF-4301	4.3	2048 × 2048	24.0	70.7	0.2
Full-frame CCD	KAF-4320	4.3	2048 × 2048	24.0	70.7	2.0
Full-frame CCD	KAF-6302	6.3	3088 × 2056	9.0	33.4	0.6
Full-frame CCD	KAF-6303	6.3	3088 × 2056	9.0	33.4	0.6
Full-frame CCD	KAF-8300	8.3	3326 × 2504	5.5	22.5	2.9
Full-frame CCD	KAF-09000	9.3	3056 × 3056	12.0	51.9	0.4
Full-frame CCD	KAF-10010	10.0	3876 × 2584	6.8	31.7	2.4
Full-frame CCD	KAF-16801	16.8	4096 × 4096	9.0	52.1	0.4
Full-frame CCD	KAF-16802	16.6	4080 × 4080	9.0	51.9	0.5
Full-frame CCD	KAF-16803	16.8	4096 × 4096	9.0	52.1	0.2
Full-frame CCD	KAF-18000	18.0	4904 × 3678	9.0	55.1	1.6
Full-frame CCD	KAF-22000	22.0	4080 × 5440	9.0	61.2	0.4
Full-frame CCD	KAF-31600	31.6	6496 × 4872	6.8	55.2	1.0
Full-frame CCD	KAF-39000	39.0	7216 × 5412	6.8	61.3	0.9

including some of the top professional models. Table 14.1 contains the sensors that were current as this book went to press (2007).

Colour variations

Although most of this book's technical discussion about colour is to be found in a later chapter, it is important to note that not all sensors use the conventional, Kodak-invented, RGB Bayer mosaic. Some manufacturers have added fourth colours to the mosaic and others have changed the three colours from additive to subtractive primaries (see Chapter 9). The second of these options was employed by Kodak itself in the CMY-filtered sensor that was employed in digital SLRs bearing an 'X' designation, such as the Kodak DCS 620X.

The advantage of using a colour filter array (CFA) comprising cyan, magenta and yellow components is that these dyes have higher transmission factors than the additive primary colours. This in turn gives greater sensitivity from the same sensor, or less noise at higher speed ratings. Kodak said there was a small compromise in colour rendering but I never managed to find any problems – which is more than can be said for the colour renderings of some other sensors! Even so, Kodak's CMY-filtered sensor appears to have fallen from favour, perhaps on account of the economics of large-scale production clashing with the notion of bespoke mosaic variations.

The second alternative approach is Foveon's X3 CMOS sensor, which has been adopted by Sigma for its Sigma Digital (SD) range of digital SLRs. Foveon's X3 is different in that it exploits silicon's progressive absorption of different wavelengths as light passes through the semiconductor itself. This means that red, green and blue pixels can be stacked one above the other and the semiconductor can be made to perform the filtering process without any need for surface-mounted filter arrays. Therefore, instead of being limited only to red, green or blue, each and every imaging point can resolve full colour, which in turn removes the otherwise inevitable need for colour data interpolation.

A completely different approach to recording colour information is used by Foveon in its X3 sensor, which exploits the progressive absorption of different wavelengths of light with increasing depth under the surface of the sensor.

In an ideal world the image processing that is used to convert sensor data into image data should never introduce any information that was not present in the original image. This picture, showing the rear of a Lancia Stratos replica, has suffered from a small amount of false-colour noise, as the greatly enlarged section taken from the edge of the lamp cluster shows. This is not a serious problem in this case, especially bearing in mind that the picture was taken ten years ago on a very early digital camera (the Ricoh RDC-2L) and has been alleviated in recent years thanks to more sophisticated processing algorithms and higher pixel counts.

Interestingly, whereas Bayer-based CCD and CMOS sensors have higher luminance resolution than they do colour, in the Foveon CMOS X3 chip the two resolutions are the same. Using a reverse-scaling approach, Foveon's initial 3.4 million (2300 × 1500) pixel implementation of the X3 was described as being equivalent to a conventional ten million pixel sensor. Despite the fact that ten million pixel digital SLRs simply did not exist when the Sigma SD9 was launched the sensor manufacturer's claim for pixel superiority never really caught on. Fortunately, this did not stop SD9 and its successors becoming popular with certain photographers – including myself.

There is also a variety of ways in which colour data is taken from a sensor, each offering its own special advantages. In a conventional CCD the

signals are removed in pairs of lines that comprise either green-and-red or green-and-blue signals, but Fujifilm's Super-CCD generates lines that contain all three colour signals, in each and every line. This is useful for displaying real-time video and it is probably no coincidence that Fujifilm's FinePix S3 Pro was the first professional digital SLR to provide a live video feedback on the camera's LCD review screen that could be enlarged to confirm critical focusing. Yet another approach has been adopted by Nikon in its LBCAST sensor, which outputs all of the green-pixel data on one line and alternates between red and blue data on the other. As well as speeding-up image processing this also ensures that the green data all passes through the same amplifier circuitry thereby avoiding fixed-pattern noise despite employing the same X-Y addressing that is used by CMOS sensors. This in turn avoids the need to perform a fixed-pattern noise compensation routine when cameras using the LBCAST are first switched on, yet still retains the faster data-extraction rate associated with X-Y addressing. Unsurprisingly, given this emphasis on exceptional performance, the LBCAST sensor was introduced in Nikon's high-speed, high-sensitivity D2H professional digital SLR.

Lens choice affects both picture composition and overall image quality. This picture was taken using a 105 mm Micro Nikkor macro lens (though not using macro mode). The DX-size sensor resulted in an angle-of-view equivalent to a 150 mm lens on a full-frame 35 mm camera.

CHAPTER 15

Optical Quality

It is not possible to consider the quality of a digital camera's sensor in isolation because the lens in particular also has a huge effect on the overall image. This is quite different from the situation that exists in film photography, where the film and lens can be evaluated independently. Conventional testing is not entirely appropriate in the digital arena and a great deal of new work has been done by Anders Uschold, leading to the formulation of his DCTau method of camera-and-lens testing. More details about this are available online at www.uschold.com.

Two of the most basic digital difficulties arise from the fact that electronic imaging sensors have various sizes (see Chapter 14) but always a regular array of pixels that contrasts with scene information that is essentially random. The latter point becomes a problem when the scene data loses its

Sigma's apochromatic 50–150 mm F2.8 EX DC HSM zoom is typical of the latest generation of top-quality lenses that have been specially tailored to meet the demands made by modern high-resolution digital SLRs.

As well as a wide variety of commonly-used lenses, manufacturers also offer more exotic lenses to accommodate particular needs. Shown here is the Olympus Zuiko Digital ED 300 mm F2.8 lens for Four-Thirds cameras, such as the Olympus E-1 that is shown alongside. Owing to the small size of the Four-Thirds sensor this lens takes pictures that would need a 600 mm lens when shooting on full-frame 35 mm film.

This picture was taken using a digital compact camera that has a less-than-perfect lens. In particular, the horizon very clearly bows slightly upwards in the centre of the picture: this outward bowing is known as barrel distortion.

randomness and exhibits a regular pattern in an area that may then interact with the regular pattern on the sensor to create a new pattern that never existed. This is called the Moiré effect and is clearly a huge problem as it means that the sensor's image cannot be trusted since it is no longer solely dependent on the scene that was in front of the camera.

The varying sizes of sensors is important because lenses have to be designed to cover the image sensor while also providing high resolutions in order to match the tiny pixel sizes now starting to appear in some digital cameras. Under normal circumstances a high-resolution lens would be more expensive but the fact that the sensor size is reduced, and therefore the lens only has to cover a smaller area than before, offsets the requirement for increased resolution. In short, digital-camera lenses have higher resolutions than were previously the norm for film-camera lenses because they need higher resolutions on account of their smaller pixel and sensor sizes: digital lenses are not automatically better than film lenses, they are just different.

Some manufacturers, including Nikon and Sigma, have therefore developed extensive ranges of lenses specifically for digital cameras. These should really be your first choice if a digitally optimized lens is available of the type that you want.

These two pictures show the same subject photographed from the same place using a full-frame digital camera (Canon EOS 1Ds-II) and an APS-C digital camera (Canon EOS 350D). The lens used in both cases was Sigma's 30 mm F1.4 EX DC, which is optimized for use with APS-C sensors and as such has caused vignetting in the full-frame picture. This effect is one reason why it is very important that the lens is matched to the sensor size.

Resolution terminology

The word 'resolution' keeps cropping up and should now be defined before going any further. Resolution refers to the amount of fine detail that can be seen in a picture and can be equated with the closeness of small, adjacent objects that can be discerned as individual items. It is common, for example, to look down from an aircraft as it climbs aloft and observe that the people below look like ants, but when the aircraft reaches its cruising altitude people are no longer visible on the ground: this is because objects the size of a person are beyond the resolution of the human eye when viewed from a distance of thousands of metres. This example also stresses the fact that the size of an object and the distance from which it is viewed are both important when talking about resolution, which is actually an angular, rather than linear, measurement. (The resolution of the human eye is discussed in more detail in Box 15.1.)

There is also another side to resolution that is especially significant in digital imaging, which is its effect on the ability to record straight lines as being truly straight. Lenses can cause lines to bow outwards (barrel distortion) or inwards (pincushion distortion) but this is not the effect being referred to here, which is similar to the dottiness seen when a line is photographed on film and viewed at such high magnification that the grain becomes apparent. In digital sensors the 'grain' is the pixel pattern, which unlike grain has a regular structure. As a result, diagonal lines may become stepped, causing what used to be known as 'jaggies'. This is a problem because, once again, it causes an image to be recorded with a different geometry from that of the original object.

Modern in-camera image processing reduces the obviousness of jaggies but does so by reducing the contrast at the edges of any lines and at the same

The maximum resolution of any electronic sensor is directly related to the number of pixels that it contains. This fact has been illustrated here by photographing the same etching using four different digital SLRs then examining the resulting images at 100% magnification. The screen-grab comparison reveals that the Kodak DCS 14n (*top left*) recorded the most detail followed, some way behind, by the Fujifilm FinePix S2 Pro (*bottom left*). The two Nikon cameras used have a very similar colour rendering but the D1X (*top right*) has recorded more detail than the D1H (*bottom right*). This ranking in terms of image detail is identical to the cameras' ranking in terms of pixel counts. The full image is also shown. The picture was framed so that its width filled the width of the viewfinder inside each camera.

time introduces a certain softness to the image that may not suit some subjects, such as architecture. The hard edges that define many buildings, especially modern designs, are known as high-frequency information because the changes from one surface to another, and the transition from the corners of a building to the sky beyond, are all abrupt. It is therefore important that they are recorded equally abruptly by the imaging sensor but the maximum abruptness possible is determined by the size of a single pixel and nothing that is smaller or finer-detailed than this can be recorded.

In addition, some cameras are fitted with low-pass filters to prevent Moiré fringes, which were explained at the start of this chapter, but these filters also soften the edges of single hard lines. All of this explains why some prints benefit from additional unsharp masking to restore image sharpness later on. Importantly, this only makes the print look visually more pleasing: it cannot reinstate information that has been discarded, or was never recorded by the sensor.

Maximum resolution

Although the lens has an unavoidable effect on the image there is a theoretical way to calculate the sensor's maximum resolution, which can only ever be reduced by the effect of the lens and any image processing applied either in-camera or subsequently. In theory the smallest object that can be captured by a digital sensor might be imagined to be one that is the same size as a pixel when it is projected onto the imaging plane inside the camera. In fact this is only true in exceptional circumstances (see below) but it will be accepted here because it provides an absolute maximum figure. If there is an identical object adjacent to the first one, then there also needs to be at least a one-pixel gap between the images of the two objects in order for them to be resolved separately. This means that to form an image of an object it will always be necessary to use at least two pixels (one for the object and one to separate it from the next object).

The quickest way to work out the closeness of separate details that can be resolved by any camera's sensor is therefore simply to halve the number of pixels per millimetre on the chip's surface. Unfortunately, camera manufacturers do not often quote pixel densities for their sensors and this figure is also not given in the metadata attached to image files, though really it should appear where currently you are likely to spot values such as 72 ppi or 96 ppi. (This topic was touched on in Chapter 10, devoted to printing techniques.) Fortunately, if the pixel count and sensor size are both known then a pixel density can be calculated by dividing the number of pixels in the horizontal direction by the horizontal length (in millimetres) of the sensor: this figure should be the same as that obtained by dividing the number of pixels in the vertical direction by the vertical dimension (in millimetres) and will be the pixel density in pixels per millimetre. This figure can then be halved to give the sensor's maximum resolution measured in line-pairs per millimetre (lp/mm).

Any subject that contains fine detail can be used for subjective resolution testing and may also, as is the case here, reveal chromatic aberrations. The trampoline bed image was captured using a Fujifilm FinePix S20 Pro that has, as the screen grab reveals, a significant colour problem with its (fixed) lens. The image opposite was captured using a Fujifilm FinePix S3 Pro fitted with a Nikkor 28 mm F2 manual-focus lens: as the insert shows there is much less chromatic aberration present and also considerably better retention of detail in the white line. This is a fairly typical different between hybrid cameras such as the S20 and interchangeable-lens digital SLRs.

Alternatively, if the pixel size is known then the resolution can be calculated directly. Pixel sizes are measured in microns (μm), which are millionths of a metre, so to get the pixel density in pixels per millimetre simply divide one-thousand by the pixel size (in microns). In all cases remember that the sensor's resolution in line-pairs per millimetre is a value that is half the pixel-density figure. It turns out that many digital cameras have pixel sizes in the range from three microns to nine microns, giving resolutions from about 55 lp/mm to roughly 170 lp/mm on the sensor surface. The amount of detail that can be resolved in the object being photographed is then related to the image size in combination with the sensor's resolution. If the object were photographed at life-size then in theory the maximum amount of detail that could be seen on its surface would be the same as the sensor's resolution, though in practice the true figure will be less.

Resolution testing

As has already been implied, resolution is normally measured according to the sensor's ability to record a pattern of parallel black and white bars of various separations. In this pattern each black bar represents an object and each white bar provides the space in between two adjacent objects (black bars). One way to vary the apparent separation of the bars is to vary the pattern's distance from the camera. As the distance increases the pattern appears to become finer and more closely spaced until, like the people observed from an aircraft, eventually there will come a distance at which the black and

white lines merge into greyness and are no longer visible in their own right. It is possible to quantify the effect of increasing distance by noting that the printed line-pairs per millimetre (lp/mm) density of the pattern on the test chart is increased by a factor that is approximately equal to the camera-to-chart distance divided by the focal length of the lens used. This guide can be used to create a home-made test chart, using a computer-based image editing program, comprising pairs of lines of, for example, two-millimetre, one-millimetre and half-millimetre thickness and separation at a variety of different angles on a sheet of high-quality inkjet printing paper. If you were to photograph this chart using, for example, a 50 mm lens at a distance of 5 metres (one hundred times the focal-length of the lens) then the three patterns would equate to approximately 50 lp/mm, 100 lp/mm and 200 lp/mm on the sensor.

If you want to do this test using a digital compact camera with a non-interchangeable lens, then move the camera's zoom setting to its longest focal-length and then calculate the appropriate distance for the test chart by multiplying the longest focal-length quoted for the lens by one hundred. If, for example, your camera were fitted with a 5.8–17.4 mm zoom lens

Richard Stringer's series of test charts is well suited to testing digital cameras as the targets include not only orthogonal sets of line-pairs but also circularly-symmetrical patterns that can reveal directional resolution effects. For more information visit www.stringercam.com.

Box 15.1 Resolution of the human eye

While talking about the resolution of camera lenses it is useful to consider the resolution of the human eye, which can be estimated by thinking about the diameter of the pupil or by considering the density of receptors on the retina. In both cases the figures obtained are expressed as an angular measurement in radians, rather than using linear line-pairs per millimetre. It is possible to convert from radians to line-pairs per millimetre at any stated viewing distance, as explained below.

The first approach treats the eye like any other lens system and calculates its resolution limit using the Rayleigh criterion, which says that the minimum angular separation between two just-resolvable objects is given by the wavelength of light divided by the aperture of the lens. Although this is a simplified and fairly arbitrary limit it does provide a useful starting point: if the wavelength of light is taken to be 550 nm and the diameter of the pupil of the eye is around 2–5 mm then the minimum angular separation of two just-resolvable objects will be in the range 0.00027 radians to 0.00011 radians respectively.

A list of important visual values, headed Useful Numbers from Vision Science, can be found at http://white.stanford.edu/~brian/numbers/numbers.html, where the maximum resolution of the human eye is given as 50–60 cycles per degree under bright lighting illumination and 20–30 cycles per degree at lower light levels. This suggests a minimum angular separation of one arc minute, or about 0.00029 radians. The same resource also gives a maximum cone density on the retina of 160 000 per square millimetre and a minimum cone spacing of 0.5 arc minutes, or about 0.00015 radians.

These figures all cover approximately the same range but are likely to be rather better than would be measured by an everyday test such as could be performed using a grid or line target that is viewed from a distance. The reason for this is not only the brightness of the illumination, mentioned above, but also the contrast of the target used. This last fact is commonly acknowledged in lens testing, when considerably better results are obtained for high contrast (black on white) targets than for low contrast (black on grey) targets. A fairly arbitrary estimate of the eye's true resolution under normal conditions might be 0.0004 radians. In photographic terms, if we think about an A4 print that is viewed at arm's length, or roughly 50 cm, then any feature on the print that is less than 0.02 cm (one-fifth of a millimetre) across will probably be invisible.

It would, of course, have been possible to work backwards from the print having observed the limit of objects that the eye can discern in practice. This was done in the days of film photography

when a maximum allowed circle-of-confusion was used to calculate depth-of-field limits. The often-quoted limit was 0.2 mm on an 8 × 10 inch transparency for critical viewing at the closest point of distinct vision, which is approximately 250 mm for a person with good vision. The A4-based calculation given previously assumed a viewing distance that is twice as far but used the same limiting object size and as such is twice as demanding. That said, digital photography is indeed a more demanding medium because images can be enlarged to almost any degree on a computer screen and therefore 0.02 cm at 50 cm range (0.0004 radians) is probably a good maximum working figure.

then you would multiply 17.4 by one hundred to get 1740 mm, or 1.74 metres. With a bit of luck the thickest line pattern will be recorded very clearly but the others may be blurred. This would mean that your camera and lens could resolve at least 50 lp/mm but not as much as 100 lp/mm.

By moving the chart forwards and backwards over a relatively short range of distances and performing new scaling calculations you should be able to find the maximum actual (rather than theoretical) resolution of the particular lens and camera combination being used. You might also want to investigate the effect of changing the lens aperture and look to see how much the resolution is affected by camera shake if you hand-hold the camera and set longer exposure times.

For ease of use, rather than having a simple three-value test pattern and changing its distance from the camera to find the point at which the lines can no longer be seen, then having to do a new set of calculations, it is more usual to have a chart that contains a greater variety of sets of lines that have different thicknesses and separations. As before, the density of the line-pair patterns projected onto the sensor is related to the fineness of the printed patterns, the distance that the chart is away from the camera and the focal-length of the lens used. Using this technique a single picture can be taken of the test chart at a known distance and then analysed to determine the finest pattern that is still clearly composed of white and black bars. The density of this pattern is taken to be the camera system's resolution.

An important limitation of this entire approach resides in the directional nature of the test pattern used. In the days of film, when the light-sensitive centres (film grains) were randomly arranged this did not really matter: all that was important was the radial and tangential performance of a lens at various distances from the centre of the image field. If there were any variations in these figures going around a circle at a fixed radius from the centre of the field then this indicated an optical fault in the lens. The same is not true for digital sensors because the image sensor now comprises a regular grid of photo-sites that is arranged linearly, not circularly. Using technical

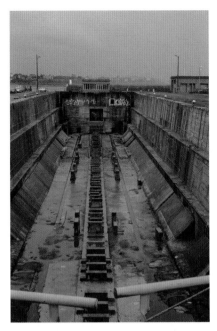

The grating at the far end of this dry-dock picture, about one-third of the way down from the top of the picture, shows a colour interference pattern that has been caused by an interaction between the camera's sensor and the regular pattern on the grating. This is shown more clearly in the enlarged section of the image. The same effect can also be investigated using a test chart: the section shown here is the centre area from a Richard Stringer chart.

Since natural subjects do not generally contain high-frequency information it might be assumed that they do not need to be photographed using high-resolution sensors but in fact high resolution is required in this case to give smooth tonal and colour gradations.

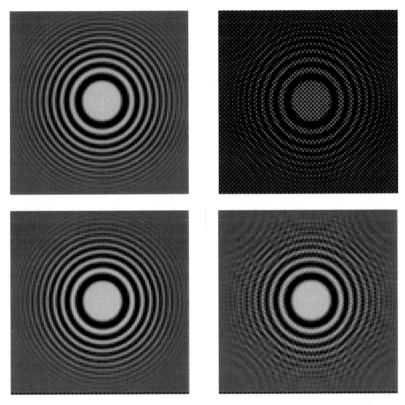

Although the Nyquist criterion states a limit beyond which information cannot be recorded accurately, it is possible, by careful image processing, to remove the colour patterns that occur beyond that limit, thereby allowing the limit to be exceeded. The basic principle is illustrated here by a series of pictures taken from Nikon's website which show (clockwise from top left) an original image, the same image seen through an RGB Bayer colour filter array, the type of image degradation obtained when low-level processing is used and the near-original result obtained using Nikon's high-level image processing algorithms. To find out more visit Nikon's technology pages at www.nikon.co.jp/main/eng/portfolio/about/technology/nikon_technology/image_processing_e/index.htm.

testing it is therefore possible to spot some variation in resolution at different angles across the image field for any given combination of sensor and lens.

Nyquist limitations

The maximum resolution that any electronic sensor can record occurs when the white and black bars of a test chart fall directly over the sensor's photo-sites. So if a certain target projects, say, 35 lp/mm (line pairs per millimetre) then it follows that seventy detectors are needed per millimetre to record that pattern. This works out to a spacing between detectors of about fourteen microns. Given that a more typical detector spacing (pixel size) in current digital cameras is between three and nine microns it follows that a 35 lp/mm pattern should be easily visible. But suppose now that the camera

were moved just a shade to one side so that the pattern's bars and its white gaps fell half way across two adjacent detectors: what will the fourteen-micron sensor see now? The answer is that each and every pixel would be subjected to an equal mixture of black and white areas, so they would all record an overall grey blur: no bars would be visible at all. To get around this problem it is necessary to have a greater density of detectors than there is of line-pairs. It turns out that the minimum density of detectors required to resolve a resolution target unambiguously is double the information density of the resolution pattern. In other words, the pixels would have to be half the expected size to be able to detect the pattern regardless of precisely how it is aligned with the pixels on the sensor. This doubling of the detector frequency compared with the signal frequency is known as the Nyquist criterion.

Although this is the theory I have found, after a lot of testing of digital cameras, that the Nyquist criterion is an over-pessimistic estimate of what can be achieved to a reasonable level of certainty when the resolution limit is determined by subjective assessment. I suggest that the visual (rather than absolute) resolution of a digital camera is not half the maximum lp/mm figure but rather a larger factor that is in the region of 70%. Interestingly, Nikon has released some information that shows how it uses a higher-frequency optical low-pass filter (OLPF) than would be suggested by the Nyquist criterion and then applies sophisticated image processing to remove false colours and achieve a higher spatial resolution than would otherwise be possible. (More details about this and other Nikon innovations can be found online under Nikon Technologies at www.nikon.co.jp/main/eng/portfolio/about/technology/index.htm.)

Typically I have found that a band of 100 pixels, which might resolve 50 line-pairs under ideal conditions, but no more than 25 unambiguously according to the Nyquist condition, can provide the viewer with enough information to detect about 35 line-pairs. This is true regardless of the pixel size but to get a resolution figure in line-pairs per millimetre it is necessary to take this additional factor into account. According to the Nyquist criterion the maximum resolutions that can be obtained using sensors with pixel sizes of seven, five and three microns are 36 lp/mm, 50 lp/mm and 83 lp/mm respectively but in practice figures around 50 lp/mm, 70 lp/mm and 120 lp/mm could be possible depending on the influence of other factors. Interestingly, even higher figures are sometimes quoted for lenses that are incorporated in digital compacts but, as has just been explained, that does not mean these high resolutions will be obtained in the final picture so much as that this specification is demanded by the sensor in order to achieve a lower final figure.

Finally, bear in mind that higher spatial resolutions are not necessarily a good thing – primarily because the density of pixels should always be considered alongside the sensor size. As was pointed out in the previous chapter, if there is a fixed number of pixels it is generally better to have bigger pixels on a larger sensor than smaller pixels on a smaller sensor. The former

Box 15.2 Ten possible causes of poor focusing

1. Dirty or damaged sensor (the image may entirely smeared in extreme cases)
2. Camera used in shutter-priority (not focus-priority) mode – see Chapter 4 on exposure and focusing for more details about this
3. AF sensor area not aligned with critical plane of subject (the eyes in a portrait, for example)
4. Camera's focusing algorithms fail to identify the correct (intended) focusing point
5. Mismatch between the plane of the sensor surface and the plane of sharp focus of the lens
6. Dirty or poor-quality accessories fitted in front of the lens
7. Manual focusing faulty owing to the user's eyesight and/or incorrect dioptre adjustment
8. Low light level or low contrast make AF operation erratic or impossible
9. The subject is closer than the lens's minimum object distance
10. Problems caused by lens-design factors such as chromatic aberrations and small-aperture diffraction

will automatically give a lower resolution on the image plane (sensor) but not necessarily a lower resolution on the object plane (the thing being photographed). Furthermore, even if the same amount of spatial image detail is recorded by both systems the larger-pixel sensor will probably win overall on account of superior dynamic range and/or sensitivity.

Accurate focusing

It may not be entirely coincidental that as the prices of digital SLRs have fallen the amount of discussion about focusing problems has increased. If a lens does not focus accurately then its pictures may look slightly soft or, in extreme cases, distinctly unsharp. This problem can be caused by a number of factors but it is always tempting to blame the lens, especially if other lenses on the same camera do not cause any problems. It is often less convenient to test the same lens on multiple camera bodies but this can be very revealing indeed, as I discovered when I did this very experiment for a report that was published in the *British Journal of Photography* (15 February 2006).

Most of the discussions about unsharp pictures, which seem to affect some types of equipment more than others to judge by comments published in magazines and on the Internet, revolve around the idea that a lens may for some reason be focusing slightly in front of or behind the intended plane. This is believable given that it is standard manufacturing

By using the same lens to photograph the same subject on six different cameras, and then examining the sharpness of the images produced, it is possible to conclude that the camera body used has a significant effect on the resulting image. It is tempting to assume that any unsharpness seen in an image can only be due to a lens fault but this is clearly not true. The screen grab shows the same small area of the main image as recorded by the following cameras (clockwise from top left): Nikon D70s, Nikon D100, Sigma SD10, Canon EOS 350D, Canon EOS-1Ds-II and Canon EOS 1D-II. In this test the Sigma SD10 was easily the best camera followed by the Canon EOS 1Ds-II and the Nikon D70s.

practice to place a finite, non-zero tolerance on the level of deviation that a product can exhibit yet still pass quality control. As the quality control specifications get tighter the number of allowable defects decreases and the product's price rises. Similarly, one way to achieve a lower price is to have a higher percentage of products passing quality control, which may mean a more relaxed tolerance before products are rejected. Critical applications require virtually perfect products and often have budgets that are commensurate with such high levels of demand, whereas in price-sensitive markets there is an inevitable amount of product imperfection in order to maintain high volumes (and therefore lower prices).

Perhaps contrary to expectations, greater accuracy is required when focusing a short focal-length lens than one with a longer focal length. This is because the amount of movement required to change the plane of focus is proportional to the lens focal-length, so any focusing error should be more apparent with wide-angle lenses than it is with longer focal-lengths. Against this, however, is the fact that a wide-angle lens exhibits greater depth-of-field (which varies inversely with the image-to-object size ratio and increases as the lens focal-length gets less). Therefore, the best way to expose inaccurate focusing is by using a short focal-length lens with a large maximum aperture (small aperture number) on a variety of different camera bodies.

Focusing accuracy depends not only on the quality of the lens but also on the resolution of the AF sensor and the processing algorithms used inside the camera together with any discrepancy that may exist between the position of the AF sensor and the plane of the imaging sensor. The last of these factors is a particular potential problem for digital cameras where the relatively simple parallel-and-machined-to-thickness method that was used when the film plane was mechanically defined during camera-body manufacture has been replaced by a sensor location that depends on fitting circuit-boards into an existing camera shell. In theory any discrepancy between the positions of the AF sensor and a digital imaging sensor could be detected during quality control and corrected using shims or micro-fine screws but this would require manual (expensive) intervention that might be prohibitive for acutely cost-sensitive products. It therefore seems likely that some tolerance of focusing inaccuracy must be inevitable.

When I investigated focusing accuracy I used three Canon bodies, two Nikon bodies and a Sigma SD10. All were tested using the same lens, which was Sigma's 30 mm F1.4 EX DC in Nikon, Canon and Sigma fittings. This lens, which was chosen because it has the requisite short focal-length and wide maximum aperture, is manufactured in mounts to fit all three camera brands and is optimized for small-format use: as such it should produce the best results on cameras that are fitted with APS-C or DX format sensors. It is not suitable for use on full-frame cameras and therefore produced heavy vignetting when tested on the Canon EOS-1Ds: nevertheless, the lens still focused accurately on that camera despite this obvious limitation but performed best of all on the Sigma SD10.

The most interesting finding, and the one of particular relevance here, was that different results were obtained between the three Canon cameras and also between the two Nikons. Given that the very same lens was used for all the models of the same brand it must surely be the case that the observed differences arise from the cameras themselves, or at worst the camera's interaction with the lens. In short, if a digital image is found to be unsharp then on the basis of my own tests I can clearly state that there is absolutely no justification for assuming that the lens alone is to blame.

Lens choice

All of which leads to the inevitable question: how do you select the best lens? As was stated at the beginning of this chapter, if there is a lens that is specifically designed to cover the size of the sensor fitted to your camera then this should be your starting point. Having identified a possible contender you should then proceed by carrying out a simple test. Take your digital SLR to your local camera dealer and shoot some test images

Professional photographers are often obliged to use exotic lenses owing to the pictures that they need to take or the positions from which they have to work. The white lens barrel seen here is characteristic of Canon lenses and is said to help keep the lens cool when working in fierce sunlight. The fact that the lens has a Nikon press-pass wrapped around it is due to the photographer having been working at a Nikon-sponsored event. There is enormous rivalry between these two leading digital SLR manufacturers: ironically, given the Canon/Nikon dominance of the professional market, this picture was taken using a Fujifilm FinePix S1 Pro.

of a flat target, such as a road sign, then go back home and inspect the images at high magnification on a computer screen. If they are fully sharp then you should feel confident about returning to buy the lens that you tested, but make sure it is exactly the same lens (the same serial number) as there may be some variation between lenses that could invalidate your testing. Similarly, there is no point in testing one lens at a local camera dealer's shop then buying the same type of lens cheaper on the Internet, because you will not have tested the actual lens that you are buying.

As for the best lens specification to choose, the accompanying list of lens terminology should help you. Finally, as might be deduced from my multi-camera test, there may be a case for saying that the best results are obtained by using lenses and cameras that come from the same manufacturer.

Box 15.3 Lens terminology

AF Automatic motorized mechanisms linked to in-camera feed-back systems that bring the lens to a point of sharp focus on a specific image plane. Almost all digital camera lenses, except those for models such as Epson's R-D1s, include a motorized automatic focusing (auto-focus) mode.

AF-S Nikon's designation to indicate lenses that feature the company's improved high-speed focusing mechanism. See also USM/HSM.

APERTURE The diameter of the lens iris through which light passes to reach the sensor. The maximum aperture of a lens is often quoted in its specification with the focal length (see below). The format may either involve a capital F, such as F4, or a lower-case f with a division sign, such as f/4: only the number itself is significant.

APOCHROMATIC The distance at which a simple lens focuses incoming light is dependent on the wavelength of the light. Photographic lenses are, by default, designed to focus both blue and green light in the same place but do not bring red light to exactly the same point: these lenses are said to be achromatic. The lack of red focus does not matter if the lens has a short focal-length (except when engaging in infra-red imaging) but for longer lenses the lack of red focus can cause noticeable softness. More expensive long focal-length lenses therefore focus green, blue and red light at the same point: these are known as apo-chromatic lenses (or 'apo' for short).

DC/DG Sigma's way of discriminating between lenses that are suitable only for digital sensors up to APS-C size (DC) and those that are suitable for full-frame sensors or film use (DG).

DI/DI-II Tamron's way of discriminating between lenses that are suitable only for digital sensors up to APS-C size (DI-II) and those that are suitable for full-frame sensors or film use (DI).

DX Nikon's designation for lenses that are matched to its DX-format sensor. Nikkor lenses without DX in their name are suitable for all formats up to full-frame, including both film and digital photography.

EF/EF-S Canon's way of discriminating between lenses that are suitable only for digital sensors up to APS-C size (EF-S) and those that are suitable for full-frame sensors or film use (EF).

ED/LD/SLD/UD Descriptors used by different manufacturers to indicate the use of low-dispersion glass in the lens to reduce chromatic aberrations and improve image quality. This is a very desirable feature for top-quality digital lenses.

FOCAL-LENGTH Determines the field of view. Provided that the image-capture area is constant, a lens with a small focal-length will have a wider field of view than another lens with a larger focal-length. Specifically, if the focal-length doubles then the width and height of the field of view will both halve. When the image-capture area changes the focal-length must also change to maintain a constant field of view.

IF Indicates that a lens uses internal focusing, which means that its overall dimensions do not change and the balance of the lens is virtually constant: in long focal-length lenses that do not have internal focusing the centre-of-mass of the lens moves forwards (away from the camera) quite appreciably when the lens is focused on nearer objects, thereby making handling more difficult.

IS/VR Technologies introduced into lenses to compensate for the effect of random movements (camera shake): Canon uses the term Image Stabilization (IS) whereas Nikon uses Vibration Reduction (VR). Although these systems reduce the amount of blurring evident in an image they are not a replacement for use of a sturdy tripod if possible.

MACRO Strictly speaking this means a lens that can focus down to twice the focal-length of the lens so that the image size is the same as the object size in order to take life-size pictures. The term is sometimes used less precisely to indicate a lens that has an extended close-up focusing ability.

PERSPECTIVE This is the visual appearance of a picture, especially the extent to which foreground and background regions are either well-separated or squashed together. Although the focal-length (see above) determines the field of view for any given image-capture area, the perspective is determined by the position from

which the picture is taken – specifically, the distance from the camera to each separate part of the photographed scene. It is possible to maintain a constant field of view with a varying perspective by changing the focal-length of the lens while at the same time moving the camera either forwards or backwards in compensation. This technique was used to great effect in the film *Jaws*.

SPECIFICATION The combined focal-length, maximum aperture and other characteristics that uniquely define a particular lens, such as Sigma 30 mm F1.4 EX DC or Canon EF-S 17-55 mm f/2.8 IS USM. Note that there is no consistent format for the aperture (see above). If a lens is updated but is essentially unchanged, then it may have II (for Mk-II) added to its name.

PROFESSIONAL Some lens manufacturers designate specific lenses as 'professional': this often indicates a wider maximum aperture and tougher build quality. Canon lenses that have an L and Sigma lenses that have EX in their specifications are rated by their manufactures as professional. Nikon does not have a specific label for its professional-grade lenses but in general any Nikkor lens with IF and/or AF-S in its name is likely to be of this standard.

USM/HSM Terms used by Canon (USM) and Sigma (HSM) to indicate the use of improved (faster and quieter) focusing mechanisms. See also AF-S.

Colour is often taken for granted in contemporary digital imaging except when it goes wrong. The lead picture here was taken using a Kodak DCS 14n Pro and recorded using Kodak's ProPhoto RGB colour space: this profile is recognized by Adobe Photoshop and used to render the image with the best possible colour quality. The smaller version (opposite) is the same image as it would appear if opened using an imaging program that did not recognize colour profiles: such programs assume that all images use the sRGB colour space and if this is not the case, as here, then the picture's colours will be misinterpreted.

CHAPTER 16

Colour Quality

Combining some of the information in the previous two chapters it is possible to state that all digital cameras output image files that, either directly or indirectly, conform with universal standards regarding the format of their data yet obtain this data using sensors that may be very different from each other. Ensuring a consistent pixel arrangement and bit-depth is fairly straight-forward but guaranteeing consistent colour is much harder, especially since colour is both a technical and a subjective topic about which different manufacturers have different ideas when it comes to optimum image quality.

As was mentioned briefly in Chapter 14 on digital quality, there are various approaches that manufacturers have taken to extract colour data from imaging sensors that are really only sensitive to the brightness of the illumination that they detect. Most commonly this is done using a colour filter array (CFA) comprising millions of red, green and blue regions that each cover one pixel. The colours are generally arranged on a square grid that contains twice as many green pixels as there are red and blue pixels: this arrangement is called the Bayer pattern. Although this is not a universal system it is sufficiently standard to form the basis for the first part

Box 16.1 Colour separations

The idea that it is possible to create white light by mixing red, green and blue light is well-known, even if the accompanying observation that yellow can be obtained by mixing red and green (which was illustrated in Chapter 9) is less intuitive. The idea of separating colours into their red, green and blue components by photographic means was first demonstrated by James Clerk Maxwell at the Royal Institution on 17 May 1861. Maxwell used black-and-white film to take three pictures of a coloured ribbon where each picture was taken through a different coloured filter (solution). By combining the three resulting images he was able to show, albeit imperfectly owing to uneven exposures, that a colour image could be deconstructed and recreated via its separate monochrome (red, green and blue) elements.

There has been some debate in the years since this demonstration about whether or not it can really have been as convincing as the recorded report suggests. The biggest problem would have been the fact that the films available at that time responded only to blue and ultra-violet light whereas there needed to be some red and green sensitivity in order to record those components of the coloured object. This problem, which depends on the frequency (energy) of the incident light, is similar to the difference that exists between the metal-based photoelectric effect and the visible-light response of semiconductor-based pixels as discussed in the chapter devoted to digital quality (Chapter 14).

More recent work has been done in this area by Dr Andrew Stevens, who extended Maxwell's experiments by using both modern and vintage black-and-white negatives to see whether the inherent spectral sensitivities of those emulsions could be used to recreate coloured images even if the photographer did not deliberately set out to record coloured information through the use of filters, for example. Stevens' work, which achieved demonstrable success, was reported in various articles published in the *British Journal of Photography* under my editorship during 2001 and 2002.

of this chapter, after which discussion switches to more general aspects of colour quality, including colour profiling techniques.

Recording colour

The fact that an imaging system is colour-blind need not prevent it from recording colour information. This fact was demonstrated in the earliest days of film photography by James Clerk Maxwell (see Box 16.1). Some of

The common knowledge that all colours can be created by combining red, green and blue light (which is shown by the accompanying mixing diagram even though it is actually not quite true – as is explained later in this chapter) led to the notion that every colour can be broken down into its red, green and blue components. There are several different ways in which digital cameras have used this idea: Minolta's RD-3000, shown here, contained three separate colour sensors to detect red, green and blue image data but it is now much more common for digital cameras to use a single sensor with a multicolour filter array.

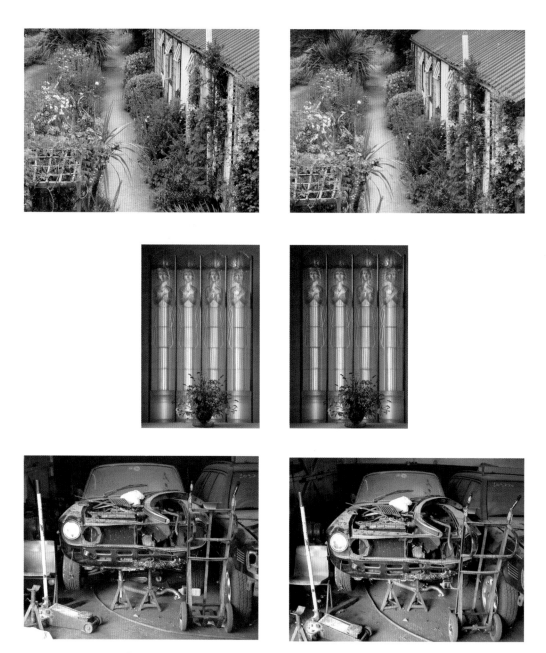

These three pairs of pictures illustrate three different effects that can cause variations in the colours recorded in digital photographs. The two path pictures were taken on different cameras, both of which yielded sRGB pictures but using different sensors with different inherent colour gamuts. The two pictures of a glass sculpture, lit internally with fluorescent tubes, were taken using different white-balance settings: the slightly green image was taken using the Daylight setting whereas the slightly blue image was taken using the Fluorescent setting. The two garage pictures were taken using different lighting: the slightly warmer picture was taken using only available light from a nearby doorway whereas the slightly bluer picture was taken with fill-in flash.

the first digital cameras adopted a similar approach to Clerk Maxwell's in that they were fitted with a monochrome sensor and employed an externally-mounted motorized filter-wheel that rotated automatically, in the case of the Leaf DCB, to capture separate red, green and blue components consecutively over a period of about twenty seconds. A later variation on this idea used three separate monochrome sensors within the camera and divided the light that entered through the lens so that the red, green and blue filtered sensors could all record the image at the same time. This method, which derives from high-end professional video cameras, was employed in the Minolta RD-3000 but never caught on in the stills market generally.

The current solution to the dual demands of trying to record multiple colour components in a single exposure is the aforementioned Bayer pattern with its arrangement of red, green and blue filter elements distributed in a regular array over the front of the individual detectors on a single sensor chip. The pattern has a four-element unit cell that is created from pairs of rows that alternate green with red sensors on one row and green with blue sensors on the other, the positions of the green cells being off-set between the two rows. Thanks to sophisticated signal processing the filter pattern is usually invisible in digital photographs though it can sometimes be revealed by using strongly coloured filters over the camera lens.

The clever bit is how to convert the adjacent colour components to what appear to be coincident full-colour image points given that an individual sensor does not record the exact true colour of any point within the image: the best that a sensor can ever do is to determine the amount of red, green or blue in a particular location. That said, matters are eased slightly by the fact that the filter dyes used are sufficiently broad-band to provide a small amount of spectral overlap between the three components (but not so much as to cause desaturation). In addition, the same data are also analysed to provide resolution information so that the scene contains as much fine detail as possible. Collectively, this is all done by extracting luminance data and colour (chroma) data separately then combining this information in such a way as to provide a picture that is both visually pleasing and technically correct.

The difference between technical correctness and subjective appeal can be observed by noticing the colour settings to which different people adjust their television pictures. Some people clearly like brighter colours (higher saturation) whereas other seem to prefer a warmer hue (colour balance) overall. The fact that colour scientists and software engineers who work on digital cameras and their associated technologies are able to satisfy such a wide range of demands is very impressive indeed.

Colour values

Having noted previously that the standard format for digital image files employs eight bits (one byte) of information for each of the red, green and blue channels, and that this equates to a grand total of 16.77 million

The subtle orange hues of this rose have been lost by the digital camera that was used to take the picture. This problem can arise either from the sensor's inability to discriminate the colours (as in this case) or from insufficient capacity in the colour space used to define the image.

uniquely definable colours, it is now time to admit that this is an idealized situation. In particular, owing to different sensor technologies and filter characteristics the hue of pure red, for example, that causes one sensor to reach red saturation may not be exactly the same colour as the hue of red that causes another sensor to reach saturation. This means that what one camera defines as 255 units of red (maximum red) might in another camera be only 250 units of red. This in turn means that the second camera would be able to go on discerning different hues of red after the point at which every red starts to look the same to the first camera.

As it happens, red is a very good colour to choose because there are some digital cameras that have a noticeably poor ability to render these hues accurately, especially at high saturation levels. This problem, if it appears, is directly connected to the camera's hardware and cannot be solved except by buying a new sensor – which means buying a new camera. This is an important respect in which digital photography differs from film: in the film world if a manufacturer brings out a product that is better than everything that existed previously then it is easy for all users to switch-over. This can still

happen in the case of digital photography except that now it is necessary not just to buy different (comparatively inexpensive) film but rather an entire (and much more costly) camera.

An obvious way around the problem would be to allow cameras to use more than eight bits when defining their colour levels. Many cameras do in fact do this but, because of the way that computers work, this doubles the resulting file size as anything over eight bits per colour has to be recorded as sixteen bits per colour (using two eight-bit bytes) even if the camera only supplies ten, twelve or fourteen bits of data. Worse still, some image editing programs cannot read sixteen-bit files, which are also known as 48-bit colour since this is the total data content of the three sixteen-bit components. This might seem to suggest that there is no point in having the extra data but the camera manufacturer's own software can use all the information recorded and this is why such software should be employed whenever possible when making adjustments to the image data.

How many colours?

The fact that eight-bit colour representations provide up to 16.77 million ($256 \times 256 \times 256$) colour definitions really ought to be enough for anyone and there should be no need to use bigger data ranges. Sure enough, despite the fact that some cameras employ sixteen-bit colour the number of different colours in a digital picture never gets anywhere near the theoretical maximum. This is not surprising given the fact that higher bit-depths are provided to increase the brightness range, rather than the colour gamut, that a sensor can record but it does make a mockery of people talking about 16.77 million colours, let alone the 281 billion (thousand billion if you are an American) colours that sixteen-bit colour can in theory define.

Having analysed a lot of pictures I have found that the number of different colours contained in digital images rarely reaches one million and is more often around the half-million mark. The possible explanations for this, aside of the difficulty of finding a wide-ranging test subject, include coarse colour analysis in the interest of speedy camera operation and the inevitable fact that because digital colour is predefined in a regimented way some of the colours will not be used in any particular picture. The second point harks back to an earlier observation about the need to have constant intervals between adjacent digital levels, such as evenly spaced tones of grey going from solid black to pure white.

There is also a complication arising from noise, which generates random signals that do not define true colour: in attempting to discard this corrupted data there is the danger of also losing genuine colour information. Ignoring only the least-significant data bit (the first 1 or 0 of the eight-bit byte that defines each colour) reduces the number of definable colours by a factor of eight from 16.77 million to about 2.1 million. Whether or not noise-reduction algorithms really do have this effect is uncertain: what is

certain is that noise must definitely be a factor, either in losing colours if processed out, or in generating false random colours if left in.

Colour balance

The most obvious way in which colour is manipulated in a digital camera is via the white-balance function. If you were to take pictures on colour film both indoors and outdoors, sometimes with flash and sometimes without, you would find that the resulting prints exhibited a range of different colour casts. This is due to a mismatch between the spectral sensitivity of the film and the spectral emission characteristics of the light source. In particular, pictures taken indoors by artificial light tend to look orange under tungsten lighting and green under fluorescent lighting. We do not register these colours with our eyes in real life because the human brain has a sophisticated procedure for correcting the effects of different light sources, which film cannot do. In the days of film photography it was therefore common to fit filters over the camera lens that were opposite in colour to the cast that would otherwise be seen: orange colour casts were cancelled out by using blue filters and green colour casts were cancelled out by magenta/red filters.

If a digital camera is set to daylight white-balance and pictures are taken indoors then the same effects appear as are seen on film, except that now there is an electronic way to correct this problem without resorting to filters. The white-balance function can either be used manually, by setting tungsten or fluorescent respectively, or by using the camera's automatic adjustment. The latter works by analysing the image and identifying the lightest regions: these areas ought to be white or a neutral shade of grey and any deviation from this can be interpreted as an overall colour cast that can be compensated by applying the same amount of the complementary colour. An alternative approach is that based on analysing and balancing the overall proportions of red, green and blue light (to give what is known as 'grey world' correction) tends to be less successful because it is easily fooled by scenes that contain an uneven distribution of colours.

Automatic white-balance is not a foolproof correction feature but it does work well most of the time. Setting the white balance manually to daylight (for outdoor photography) will give results that may be more reminiscent of film and minimizes the risk of problems caused by subjects that contain predominantly one colour. The best option of all, however, is to save your pictures in raw format as this allows careful and repeated adjustment of the white-balance later. Provided that the monitor screen on which you are assessing the images is correctly calibrated (see discussion of profiling below) then you should be able to view perfect results from every picture, save for any limitations imposed by the spectral sensitivity of your camera's sensor.

There are several different tricks that can be used to balance the colours in a digital image. One method is to make the brightest highlights neutral on the grounds that bright highlights are normally colourless. Another method assumes that the colours in an image average out to a neutral mid-grey, which is not always true. A long-recognized exception to the 'grey world' approach is pictures of sunsets, but even less obvious subjects can suffer when this method is used. In the case of these roses, the more saturated flowers and greyer leaves are natural whereas the pale flowers and brighter greener leaves were obtained when the 'grey world' system was used.

Defining colour

Earlier on it was stated that different cameras (sensors) record the same colours in different ways. You can check this for yourself by using two cameras to photograph the same subject and then opening both images in an image editing program so as to use a dropper tool to check the colour values that are distributed across the image. It is then easy to confirm that the same part of the subject does not always have exactly the same colour values. And it is at this point that you may well throw your hands up in horror! If the colours do not agree then how do you know which one (if any) is right? The answer is that you don't. The only way to calibrate a digital camera is to take a picture of a precisely defined test chart and examine how its colours are recorded. This information is then compared with the data expected for the known colours and a conversion table is created that can be used to adjust all the other pictures taken under exactly the same lighting conditions. This procedure is known as colour profiling and is one of the most powerful weapons at a digital photographer's disposal.

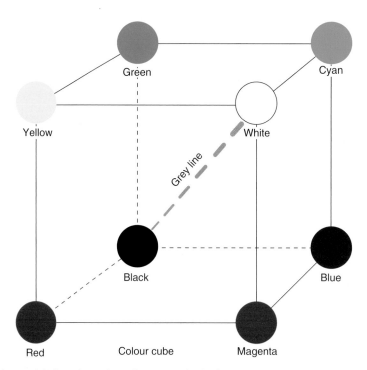

A simple way of thinking about colour is by using a cube that has at its corners pure black, pure white, the three additive primaries (red, green and blue) and the three subtractive primaries (cyan, magenta and yellow). The diagonal line that connects the black and white corners is the locus of all the shades of neutral grey.

In order for colour profiling to work it is first necessary to have some standards that define the appearances of different colours. This is where technical accuracy begins to deviate from practical experience, even though it is also the point at which digital imaging needs to start getting more technical in order to become better defined. The biggest problem is how to define and represent colour, which is really nothing more than a human physiological reaction to a certain stimulus that we call visible light. From a technical standpoint the idea of mixing red, green and blue light to get white light is as stupid as saying that all the different television signals that are being broadcast should mix together to make one combined signal, which clearly they do not. The fact that a rainbow is able to split white light back into its component colours only frustrates matters since our eyes are incapable of doing this for themselves. Effectively, our eyes are television sets that have no tuning dial and on which you can only watch one big mixture of every single program that is being broadcast at that time.

Nevertheless, define colour we must and the obvious way to do this is by using a model based on a cube where every corner is the meeting point for three edges that head off in completely different directions. If we were to call one edge the red direction, another the green direction and the third the blue direction then we could define every colour as a point somewhere inside the cube. The corner from which all the colours started could be solid black and the diagonally opposite corner would then be pure white. The diagonal line running through the centre of the cube connecting these two points would define all the shades of neutral grey and every other colour would have its own unique co-ordinates inside the cube. This model is exactly the one that is used when we define colours using red, green and blue values from 0 to 255: the point R=0, G=0 and B=0 is the location corresponding to solid black and the cube has sides that are 256 units long (extending from 0 to 255) so that the diagonally opposite corner is R=255, G=255 and B=255 and corresponds to pure white.

Although this is a lovely mathematical model it can be a bit confusing because the brightness axis runs diagonally through the centre of the cube whereas the colour axes are along the outside edges. That would not be so bad were it not for the fact that our eyes recognize the brightnesses of colours almost as much, and in some cases more, than they notice the hue. An alternative representation that accommodates this can be thought of by turning the cube so that it is balanced on the corner from which the red, green and blue axes originate: this gives black at the bottom and white at the top with all the various shades running vertically in between. The middle region contains all six of the remaining corners of the cube (excluding the one it is balanced upon and the one directly above it) and defines both the additive and the subtractive primary colours. By pulling these corners onto a single plane (they are off-set on a tilted cube) the centre plane can be made to contain every mid-tone colour possible.

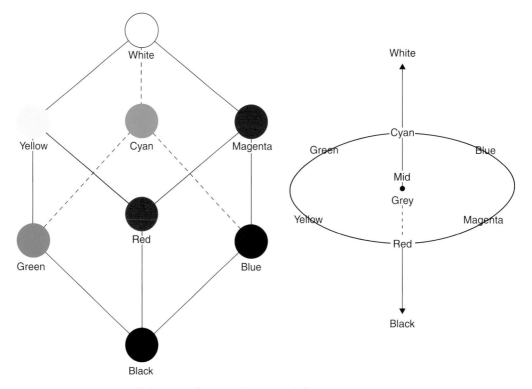

It is more logical to turn the colour cube so that it balances on its black corner, which is the lowest point, with its white corner at the top. The other six corners are staggered around the middle region, which is better represented on a single circular plane where the additive and subtractive colours alternate at sixty-degree intervals. The middle plane is familiar to artists as the colour wheel and to digital photographers as the hue circle of the HSL, HSV and HSB colour models.

Furthermore, each position around the perimeter of this plane, if it could be quantified, would define the location of every fully saturated colour that is neither paler by the addition of more white (in which case it would be above the central plane) nor darkened by the addition of more black (in which case it would be below the central plane).

There are two methods used for quantifying these centre-plane positions. One method involves treating the plane as a disk and measuring the distance of a point from the centre of the plane, which says how much colour it contains relative to neutral grey (the saturation) and also measuring how far around the plane the point is (which is called the hue angle). Red is given a hue angle of zero degrees and the subtractive and additive primaries follow thereafter, alternating at 60 degree intervals in the order yellow, green, cyan, blue, magenta then back to red again. This is the hue, saturation and lightness model (HSL) using which the strongest green, for example, would have values 120 (degrees), 100 (per cent saturation), 50 (percentage grey, being neither lightened nor darkened).

The second method involves imagining a cross drawn on the centre plane where one axis varies from red to green and the other varies from blue to yellow. Both axes have positive and negative numbers, with zeros where they cross coinciding with a neutral mid-grey. This system is called LAB colour. The red–green axis is called a*: it has positive values up to 127 for red hues and negative values down to −128 for green hues. The yellow–blue axis is called b*: it has positive values up to 127 for yellow hues and negative values down to −128 for blue hues. Once again the lightness values go from 0 (solid black) to 100 (pure white) and the strongest colours have a lightness value of 50 because they are neither lightened nor darkened. More information about these various models and the practical applications of colour theory can be found in various specialist books including Ken Pender's *Digital Colour in Graphic Design* (Focal Press, 1998) and Edward Giorgianni's and Thomas Madden's *Digital Colour Management Encoding Solutions* (Addison Wesley, 1997).

Colour calibration

If all of this sounds like very hard work then rest assured that it is not necessary to understand the intricacies of digital colour in order to get perfect colour results from digital images. In fact these three models (RGB, HSL and LAB) are all too technical for practical use and it is far more common to see reference to the CIE xyY Chromaticity Diagram, which looks rather like a falling-over triangle with a rounded top apex. This is a plot of the way that colours appear visually to a fictitious human eye and contains only the plane of maximum saturation. It is based on a failing of the model that has been used all the way up to this point, which is the theory that it is possible to create any colour simply by mixing different amounts of red, green and blue light. This is not true. Specifically, if you were to set up a test whereby you shone single colours of light of a specific frequency onto a screen and asked an observer to adjust the brightness of red, green and blue lights that were mixed together to give a single apparent colour you would find that some colours could not be matched using the mixing system alone. In fact the only way to achieve a match is by adding one of the primary colours to the test colour, which is equivalent to adding negative colour to the mixture. Unsurprisingly, when all the mathematics are done to characterize human colour vision it turns out that the figures involve some negative numbers.

Scientists generally have an aversion to negative numbers, which is why Lord Kelvin redefined the temperature scale going from absolute zero with all positive values. In colorimetry the answer is to invent some imaginary primary colours that could all be added with positive values to define every visual colour, as well as some that cannot be seen. The tilted triangle uses exactly this trick. It has imaginary primaries for red, green and blue on the corners of a right-angle triangle, with imaginary blue in

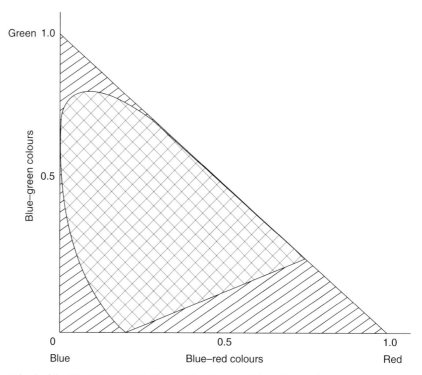

A sketch of the CIE xyY Chromaticity Diagram. The 45-degree, right-angle triangle has at its apexes the imaginary additive primaries that would be needed to make all visible colours simply by mixing different amounts of red, green and blue light. The smaller, rounded triangle represents all the different colours that the human eye can discern. The colour ranges provided by different digital devices are even smaller triangular regions within the range of the eye's colour sensitivity.

These two screen grabs show some of the information about colour that is provided within Nikon Capture software. The colour-space diagram is a more detailed version of the CIE x–y Chromaticity Diagram sketch above. The list of available colour spaces is accompanied by a sample image (which can be changed) that indicates the extent to which wider colour spaces can bring better colour discrimination.

the right-angle corner (bottom left), imaginary green at the top and imaginary red in the bottom right corner. A set of real primaries is then chosen inside this triangle to define the range of colours that can be obtained by conventional colour mixing: it is within this smaller triangle that all of the colours that electronic devices are calibrated to display now sit. In an ideal world those electronic colours would fill the triangle but in practice they do not, though by changing the way that colour is defined the area of possible colours can be increased or decreased as appropriate.

Colour spaces

Having gone to all the trouble of trying to define the widest possible range of colours that can be created by mixing red, green and blue light, why would anybody then want to shrink the range of colours allowed? The answer is that different electronic devices have different colour-display characteristics and in an ideal world the range of colours presented to a device from a digital picture should match the range of colours that the device is capable of displaying. To do that, it is necessary to characterize all of the display devices that will be used and also to map all of the digital image's colours in a standardized way that can be related to the particular device's display capabilities. This in turn harks back to the problem of one camera having described a particular colour as pure red (R = 255) and another camera having described the same colour differently (R = 250). Although both systems cannot be correct they can both be related to a specific range of colours using different conversion factors so that the two sets of co-ordinates point to exactly the same final colour.

This final colour goes via the absolute colours (defined by the CIE LAB model) but point to a displayable colour contained within a subset of the CIE Chromaticity Diagram. The two subsets most commonly used, more correctly called colour spaces, are sRGB and Adobe RGB. Of the two, sRGB is the smaller colour space but it is useful because its range of colours is well matched to the display characteristics of many screens. It is also the default colour space to which all image editing and printing programs are calibrated unless they specifically offer another alternative. Adobe RGB, which should really be referred to in full as Adobe RGB (1998), is a bigger colour space and is more suitable as a co-ordinate system if the image will subsequently be converted into CMYK for offset magazine printing – but not for desktop inkjet printing as these devices' drivers work in RGB and, as just noted, default to sRGB. This does not mean that Adobe RGB is a red herring but rather that it may not be helpful in all cases and could sometimes be counter-productive.

In addition to these two options, professional digital SLRs frequently offer manufacturer-specific colour spaces such as Kodak ProPhoto RGB. These have the advantage of making best use of the sensor's colour-recording characteristics but they also risk a lack of compatibility with software that cannot support non-sRGB colour spaces. Therefore it is

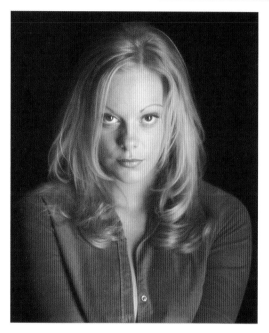

The biggest advantage in favour of Adobe Photoshop over other common image manipulation programs is its recognition of colour profiles. When a picture is opened the software warns the user if the image's colour description is different from that assumed by the software: various options are then available to deal with this situation. If you take pictures using the Adobe RGB colour space and then edit your pictures using a program that works only in sRGB it is inevitable that the colours in your pictures will never be correct. The paler-skin portrait here is an Adobe RGB picture that has been properly interpreted: the more saturated version illustrates how the same image would look when opened in an sRGB program.

important that the manufacturer's software supplied with the camera includes an option to convert images to the sRGB colour space. There are no such problems with Adobe Photoshop, however, and for this reason it is the software of choice for most professional photographers who need to be able to maintain close control over their pictures' colour renderings under a wide variety of conditions.

Profiling

Regardless of the colour space used by a device it is also possible to define its colour rendering with reference to the absolute colour ranges mentioned earlier. This is the art of colour profiling and is a calibration exercise that is specific to one set of conditions, which means that profiling may have to be done several times with the same equipment in order to cover different situations. That caveat does not apply for scanners, which are self-contained and almost impossible to vary, but it becomes increasingly more important for monitors, printers and cameras (in that order).

Profiling a scanner is entirely straight-forward and many high-end scanners come with the necessary test image and software: if not, there are some easy-to-use packages such as the various SilverFast products that are available from third parties. Monitor profiling is almost as easy except for the fact that it is necessary to make manual adjustments to the colour balance and the brightness/contrast in advance. The colour balance setting is expressed as a value in kelvin and may be set very high, perhaps 9300 K, by default: this gives a blue-white picture that is very bright but not natural. A value between 5000 K and 6000 K will give better colours overall. Brightness and contrast are adjusted using a pattern of grey tones and need to be set so that whites are as bright as possible and blacks are as dark as possible with a definite step visible between those end values and the immediately adjacent tones. As well as manual adjustment of these settings it is possible to purchase the Kodak Professional Colour Management Check-Up Kit, which is a low-cost but very useful diagnostic tool (see Chapter 10 on printing problems).

Having done these preliminary settings it is then possible to use profiling software to characterize the full range of colours that your monitor can display. Crucially, however, you must not alter any of the manual settings after running the profiling program as this would nullify its effect. You should also repeat the calibration process on a regular basis: some programs issue notifications to advise or remind you when profiling is next due.

Printers are more tricky because it is so easy to change from one type of paper to another and even this simple variation can be enough to render a colour profile ineffective. Fortunately, as was noted in Chapter 11 when discussing fine art printing, it is possible to get your printer profiled free of charge if you use Fotospeed printing papers. Alternatively, you can combine your printer and scanner to perform a simple in-house calibrating process. Dedicated hardware to perform printer profiling uses either a spectrophotometer or a colorimeter, which vary in their level of sophistication and colour discrimination and have prices that roughly mirror those of digital cameras. The cheapest systems are about the same price as a good digital compact camera whereas more sophisticated models start at about the same price as a professional digital SLR.

Finally there are cameras to consider. As was pointed out in the section concerning colour balance, digital cameras can adjust their colour

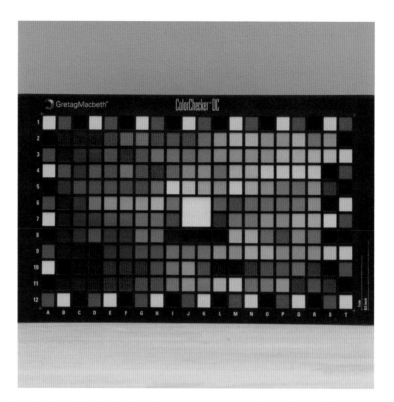

Every form of colour calibration involves using a test target that contains a selection of known colours. This is either photographed, scanned or printed and analysed to determine how the device's interpretation of the colours compares with the known values that are expected for each area of the original target. A profile is then built, translating the device's colour renderings to a reference colour space that other devices can use to in order to determine their own renderings of the colours that have been recorded. The target shown here is the Macbeth ColorChecker DC, which is used for profiling professional digital camera systems.

renderings according to the prevailing illumination. This means that profiling, which is carried out by photographing a chart containing known colours then running a program that compares the camera's values for these colours with the expected values, is only valid for the lighting used to illuminate the test chart. As soon as the lighting is changed the profile will become invalid. Not only that, but work reported by Kodak imaging scientist Don Williams at a technical conference held as part of *Photokina 2002* revealed that digital cameras shift their colour renderings when their sensitivity level (ISO setting) is changed even when the lighting remains constant. This being the case, when colour accuracy is really important the digital camera must be profiled and once this has been done every setting must be kept the same during the picture-taking session so that the very best results are obtained.

Pantone's ColorVision Spyder is a device, with accompanying software, that can be used to calibrate both LCD and CRT monitors, which should be checked on a regular basis to ensure their colour accuracy.

Using profiles is entirely straightforward because everything will be handled by your image editing program or the drivers for specific items of equipment. Only if you have had a profile made remotely, such as when using Fotospeed's service, will you need to install the profile in the appropriate folder on your computer yourself: in all other cases everything will happen automatically. To find out more about colour profiling and some of the products available visit the Colour Confidence website at www.colourconfidence.com.

Taken using the Olympus E-10 fixed-lens digital SLR. Close-up inspection reveals that the JPEG compression used has put an artificial texture into the sky areas but this may not be evident on the printed page.

A Backward Glance

This book finishes with a look backwards, for it is by observing our past that we get some inkling of what to expect in the future. It does not go right back to the days when film was dominant because those times are no longer relevant. Instead, the account that follows is a largely personal perspective on the advance of digital cameras to date and is mostly based on some of the digital compacts that I own. It does not cover the history of digital SLRs because that would fill an entire book if considered in detail; nevertheless, I will attempt to summarize the history of digital SLRs in brief before looking in more detail at compact cameras.

Digital SLRs

From 1991, when Kodak unveiled the world's first professional digital SLR, later to be named the DCS 100, until June 1999, when Nikon announced its D1, the digital SLR market was dominated by Kodak. Kodak's original camera, which at £17,000 cost roughly the same as a small luxury car at the

The Kodak Digital Camera System, announced in 1991, was the first digital SLR but required the camera body to be attached to an over-the-shoulder storage pack. Subsequent cameras, such as the Kodak DCS 420, had their storage packs bolted under the camera body. Gradually the packs got smaller until they became incorporated within the camera body itself.

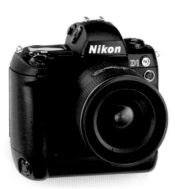

Kodak's supremacy in the digital SLR market was challenged by Nikon with the announcement of its keenly-priced D1 in 1999.

Contax was the first company to offer a full-frame digital SLR in the form of its N Digital, which was launched in 2002.

time, was based on the Nikon F3 and featured a 1.3 million pixel sensor. Prices remained strong for several years, during which time Kodak manufactured digital SLRs using both Nikon and Canon 35 mm camera bodies as well as a Nikon APS body. Although prices fell significantly during this time, digital SLRs still remained beyond the grasp of all but the most affluent photographers until Nikon entered the fray. The D1 took an age to arrive following its announcement but its aggressive pricing had an immediate effect on photographers' expectations and paved the way for Fujifilm's FinePix S1 Pro, which arrived in the summer of 2000, and the Canon EOS D30, which followed in that autumn.

Nikon has now revealed that the D1's sensor comprised more than ten million pixels despite the fact that its specifications quoted fewer than three million pixels. Quoted in the company's online magazine *Behind The Scene* (http://nikonimaging.com/global/technology/scene/12/index.htm), Nikon General Manager, 1st Development Department, Mr Kiyoshige Shibazaki, explained that the technical reason for an actual pixel count four times the figure indicated publicly, resided in the need to achieve high sensitivity and a good signal-to-noise ratio. The D1's colour rendering came in for some criticism on account of the NTSC colour space used but even this had a positive effect in that it raised the profile of digital colour management. Within a year Nikon went on to announce two new digital SLRs; the D1X with a

high-resolution sensor comprising approximately six million pixels and the high-speed D1H with just under three million pixels on its sensor but a 5 fps capture rate for forty consecutive frames. The NTSC colour space was gone and both cameras now allowed users to choose between sRGB and Adobe RGB. Canon seemed to be lagging behind but responded with its EOS-1D in December 2001.

The next big step forward came early in 2002 when Contax announced the world's first full-frame digital SLR, the Contax N Digital: later that year Kodak and Canon launched higher-resolution full-frame models of their own at the Photokina World Imaging Fair. Nikon stood firm in its decision to work with its smaller DX-format sensor but no doubt watched carefully as the Nikon-bodied Kodak camera took on the might of Canon. At the same Photokina trade fair, Pentax announced that it would enter the market, Olympus unveiled the Four-Thirds system and Sigma launched its SD9 based on the innovative Foveon X3 sensor. Since then the big push has been to bring prices down to the extent that digital SLRs from Nikon, Canon and Pentax can now all be had for little more than the cost of a top-of-the-range digital compact camera. Sadly, Kodak withdrew from the professional digital SLR market when its full-frame, fourteen million pixel DCS Pro 14n, which subsequently appeared in Canon guise as well as its initial Nikon form, reached the end of its life-cycle. Contax has also withdrawn, not only from the digital SLR market but also from cameras entirely in order to focus its expertise in the camera-phone market, and Minolta's name has disappeared although its products live on under the Sony brand.

At the present time Canon is the only manufacturer that offers a full-frame digital SLR and opinions are now divided about whether or not full-frame capture is really necessary.

In the beginning

Sony is often credited with inventing the digital still camera, having unveiled its first Mavica in August 1981. But in truth the very name of that product gave the game away, for Mavica is a concatenation of the first

Vintage press release picture showing Akio Morita, Sony Chairman and CEO, holding the newly launched Mavica still-video camera in August 1981.

two letters of the words 'magnetic video camera'. As such, and like many of the products that followed soon after it, the original Mavica should more correctly be described as an analogue (still video) electronic camera.

The first truly digital camera was Fujifilm's Fujix DS-1P, which was revealed at *Photokina* in 1988 and converted video images into digitized red, green and blue values before storing them on a solid-state memory card. To say that this product was ahead of its time would be an understatement given that static-RAM memory cards had capacities that were normally measured in kilobytes (or even kilobits) in those days. Even in 1990 the cost of a mere 1 MB SRAM card was more than the price of a complete digital SLR today. Not only that but the various early memory cards differed from each other both physically (in their numbers of pins) and electronically (in their file protocols).

At the beginning of 1990 Geoffrey Crawley, at that time technical editor of the *British Journal of Photography*, reviewed the UK's first analogue still video consumer product, the Canon ION (RC-251). 'It is not intended as a professional unit,' he admitted, 'but its arrival signifies a turning point when the general public will be made aware of the new imaging technology and be invited to use it at the snap-shooter level. The ION deserves attention therefore as the herald of more advanced units to come, no doubt from several makers, and a widening of imagery possibilities of which the pro must become aware.' The more advanced units that Crawley anticipated arrived en masse at *Photokina* in 1996. Such was the flurry of activity at the German trade show that by the end of the year there were more than thirty companies offering sixty different models of digital cameras, led by Kodak. From then on things moved very quickly and in multiple directions. Some companies flourished but others, as previously noted, perished. This is a dreadful shame not only for the inevitable loss of jobs but also because some fantastic products are now without successors and could easily sink without trace.

Ten digital cameras

What follows here is a brief survey of personally selected highlights from the decade between 1996 and 2005. The camera choices have been made on the simple basis that they are all in my collection so I am able to get them out and take side-by-side pictures for comparison purposes: they are also some of my own very favourite cameras in terms of aesthetic design and technical innovations.

Ricoh RDC-2L

One of the products that appeared at the landmark *Photokina* of 1996 was Ricoh's RDC-2. Rejecting the bland-box design used for earlier digital cameras and their still video ancestors, the RDC-2 was enclosed inside a stylish champagne-silver shell. It also had an optional LCD screen that, when installed, promoted the camera from RDC-2 designation to RDC-2L. It is

(*left*) Ricoh RDC-2L with its optional LCD screen fitted and folded flat. (*right*) Example picture taken using the Ricoh RDC-2L.

true that the first digital camera with an LCD screen was the Casio QV-10 of March 1995, but the Casio's 250,000 pixel resolution made it an otherwise unremarkable camera. A year earlier, in 1994, Apple had launched its Quicktake 100 with a resolution of 640 × 480 pixels and in the same year that Casio's camera appeared Kodak (which co-developed the Quicktake with Apple) unveiled its DC40 with a resolution of 756 × 504 pixels. These earlier launches made the Casio seem rather modest by comparison save for its LCD screen, but Casio was the first company to make digital cameras affordable for the general public rather than business users, to whom Apple's and Kodak's models mostly appealed.

Ricoh redefined sub-£1000 digital camera specifications by adding a playback speaker (built into the optional DM-2 LCD panel) and a PCMCIA slot for removable memory cards. The RDC-2 also had a respectable 768 × 576 pixel CCD and enjoyed the benefit of a dual focal-length lens that could be switched between 35 mm-equivalents of 35 mm and 55 mm via a short-throw lever on the top of the camera. Retrospectively things are not so rosy because the file format used by the RDC-2 (*.j6i) is a JPEG derivative that is not supported by current image editing programs. As a result it takes a little effort to extract the RDC-2L's pictures today. Once extracted the pictures stand out for their lack of dynamic range and burnt-out highlights. Similarly, the camera's 440,000 pixels are insufficient to record much scene detail, or even to fill a modern computer screen.

Although the RDC-2's pictures fall far short of modern standards the camera was highly desirable in its day. Its design lived on in later years in Ricoh's Internet-enabled RDC-i700 and the very impressive RDC-7.

Fujifilm Fujix DS-300

The summer of 1997 was notable for two products, the most important of which for professional photographers was Fujifilm's Fujix DS-300. This

(*left*) Fujifilm Fujix DS-300 in its raw form with neither the optional LCD finder, which mounts via the camera's hotshoe, nor the SCSI unit, which attaches underneath the body. (*right*) Example picture taken using the Fujifilm Fujix DS-300.

rangefinder-style camera followed a successful collaboration between Fujifilm and Nikon on the SLR-bodied E2/DS-505 and other members of the same family. Unique to the Fujifilm/Nikon project was a special lens group within the camera body that condensed the field of view of conventional full-frame lenses onto the smaller-than-full-frame CCD sensor. Sadly, there was a price to be paid in that the lens group imposed a maximum aperture of f/6.7 (though this was expanded to f/4.8 in the Nikon E3/E3s that arrived at the same time as the DS-300).

It is worth noting that, like the Fujix DS-300, the Fujifilm/Nikon cameras all employed a nominally 1.3 million pixel CCD. The prices and sensitivities, however, tell a very different story. In 1994 the first Fujifilm/Nikon cameras carried price tags of £8000 and £12,000 for the standard and high-speed models respectively, with a maximum sensitivity equivalent to ISO1600. In 1996 the improved Nikon E2N/E2Ns sold for £7000/£9000 with a maximum sensitivity of ISO3200. When the E3/E3s arrived in 1997 (with a new sensor) the entry price had fallen to £5000 but still remained beyond the reach of most photographers.

It was no surprise, therefore, that the £2000 Fujix DS-300 was welcomed with open arms. There was a choice of two sensitivities (ISO100 or ISO400) and an integral 3× zoom lens equivalent to 35–105 mm on full-frame 35 mm film. Although the camera had a PCMCIA card slot Fuji also offered an adaptor that allowed the use of SmartMedia cards (which were originally known as Solid State Floppy Disk Cards, or SSFDC for short). As was the case with the Ricoh RDC-2L, the DS-300's software was supplied on 3.5-inch floppy disks for both Windows and Macintosh operating systems.

Optional accessories for the DS-300 included the LV-D3 LCD viewfinder, which allowed image-playback, and the Extension Unit EU-D3A with more RAM (for prolonged high-speed capture) and an integral SCSI socket.

The DS-300's images, like those from the RDC-2L, are prone to burnt-out highlights but the Fujix's scenes are rich in sharp detail by comparison. The sensor captures a significantly wider view than is seen through the optical viewfinder, which can be a serious issue when there are only 1.3 million pixels to play with. Provided that it is used under favourable conditions the Fujix DS-300 is capable of taking some very acceptable digital images, but when its pictures are put alongside those from more modern digital cameras its colour rendering can seem rather poor.

Sony MVC-FD7

In June 1997, a long 16 years after the original Mavica, Sony announced its first fully digital still cameras. Interestingly, the company's online list of manufacturing achievements starts with the MVC-FD7 reviewed here, not with the analogue Mavicas that came before it.

The MVC-FD7 was launched alongside the cheaper (£450) and less sophisticated MVC-FD5: the two shared the same rather modest 640 × 480 pixel CCD and a conventional 3.5-inch floppy drive for image storage. So ubiquitous was the 3.5-inch disk at this time that it was regarded as the easiest way of transferring pictures from camera to computer. Even manufacturers that favoured other media offered adaptors that enabled those cards to be accessed via a disk-drive adaptor: Olympus sold a carrier for SmartMedia cards and Sony was later to launch a floppy-disk adaptor for its MemoryStick medium.

Physically the MVC-FD7 harked back to designs of old at a time when other manufacturers were looking towards the future, but the change of name from Mavica to Digital Mavica was a more subtle indicator of what was to come from Sony. Although its first cameras were only VGA resolution (see Box 17.1) and 1998's MVC-FD91 and MVC-FD81 were only XGA resolution, Sony has since gone on to reach the forefront of compact-camera pixel counts. Nevertheless, despite the fact that it has fewer

Sony MVC-FD7, the first digital Mavica.

Box 17.1 **Screen formats**

Early digital cameras echoed computer screen resolutions in their pixel counts. This table
designation and colour depth. Digital cameras subsequently outgrew screen resolutions

Designation	Date	Resolution
MDA		720×350
CGA	1981	640×200
EGA		640×350
TV (NTSC)		720×487
TV (PAL)		720×576
VGA[2]	1987	640×480
8514/A[3]	1987	1024×768
SVGA		800×600
XGA	1990	1024×768
PhotoCD[4]		768×512
SXGA		1280×1024
UXGA		1600×1200

[1] The figure quoted is the product of the horizontal and vertical resolutions.
[2] VGA in text mode has a maximum resolution of 720×400.
[3] 8514/A was a video standard contemporaneous with the VGA computer standard.
[4] PhotoCD figures refer to Base image resolution.

Digital camera	Date	Price	Pixel count	Sensor size**	Pitch	Colour
Ricoh RDC-2	1996	£950	768×576	3.2×2.4 mm	4μm	Non-EXIF
Sony MVC-FD7	1997	£550	640×480	3.2×2.4 mm	5μm	Non-EXIF
Fujifilm Fujix DS-300	1997	£1,950	1280×1000	8.8×6.6 mm	7μm	Not given
Nikon Coolpix 900	1998	£750	1280×960	4.8×3.6 mm	4μm	'Uncalibrated'
Epson PhotoPC-850Z	1999	£600	1600×1200	6.4×4.8 mm	4μm	sRGB
Pentax EI-2000	2000	£900	1600×1280	8.8×6.6 mm	5μm	sRGB
Olympus Camedia E-10	2000	£1,400	2240×1680	8.8×6.6 mm	4μm	sRGB
Minolta Dimage X	2002	£400	1600×1200	4.8×3.6 mm	3μm	sRGB
Contax SL300RT*	2003	£400	2048×1536	4.8×3.6 mm	2μm	sRGB
Kodak EasyShare P880	2005	£450	3264×2448	7.1×5.3 mm	2μm	sRGB

* The lens figures given are equivalent focal lengths compared to a full-frame 35 mm camera.
** Sensor sizes are derived from the standard whereby a one-inch sensor equates to a 16 mm diagonal and all sensors have a
video tubes for motion picture recording.

records the progression of computer screen resolutions together with each resolution's
and are therefore no longer referred to in the same way.

Aspect ratio	Pixels[1]	Simultaneous colours
n/a	n/a	Monochrome (text only)
n/a	n/a	Two colours (graphics only)
9:5	224,000	16
3:2	350,640	–
4:3	414,720	–
4:3	307,200	16
4:3	786,432	256 (or 64 greys)
4:3	480,000	Up to 16.7 m (limited by VRAM)
4:3	786,432	65,536
3:2	393,216	16.77 million
5:4	1.31 million	16.77 million
4:3	1.92 million	16.77 million

Lens*	ISO	File formats	Storage	Notes
35/55	Unknown	J6I	PCMCIA	Optional LCD with integral speaker
40–400	Fixed 100	JPEG	Floppy	Sony's first Digital Mavica
35–105	100/400	JPEG/TIFF-YC	PCMCIA/SM	Optional LCD viewfinder and SCSI Extension Unit
38–115	Fixed 64	JPEG	CF	Wide-angle and telephoto accessory lenses
35–105	100–400	JPEG	CF	Daylight illumination mode for LCD screen
34–107	25–400	JPEG/TIFF	CF	Compact fixed-lens digital SLR
35–140	80–320	JPEG/TIFF/RAW	CF/SM	Sophisticated fixed-lens digital SLR
37–111	100–200	JPEG/TIFF	MMC/SD	Prism within lens to produce more compact design
35–115	100–800	JPEG	MMC/SD	R-Tune technology (analogue front end processing)
24–140	50–400	JPEG/TIFF/RAW	SD	Digital SLR features in a smaller format (fixed lens)

4:3 aspect ratio. A half-inch sensor therefore has an 8 mm diagonal, and so on. This curious standard relates back to the days of

pixels a side-by-side comparison reveals that the MVC-FD7 takes pictures that are richer in detail than the Ricoh's: this is substantially due to the Sony's superior focusing. In addition, the Sony has a 10× optical zoom lens that easily out-classes the dual focal lengths offered by the RDC-2L in terms of all-round versatility. The Sony's colour is on the bright side, which can be quite appealing, but it is also somewhat variable in overall balance and is prone to burnt-out highlights. As floppy disks disappear into the mists of time Sony's camera could become unusable in the future simply because its storage medium is no longer supported. This is an important point that could also apply to other cameras in the future.

Nikon Coolpix 900

At the start of 1998 Nikon's Coolpix 900 arrived on the scene as the first member of a new family of high-end Nikon digital compacts. It had a 1.2 million pixel CCD, 3× optical zoom lens and a CompactFlash card slot. More importantly, the Coolpix 900, with its versatile swivel-lens design, produced really good quality images yet sold for under £800.

The year before, in 1997, Nikon had put its innovative Coolpix 100 and Coolpix 300 PIA on the market. The former was a very modest digital camera attached to a 1 MB PCMCIA memory card, which allowed the device to be slotted directly into laptop computers. Its 512 × 480 pixel images were sufficient for such applications and the novelty of the design helped to justify an otherwise excessive (for the resolution) price on the high side of £500. The Coolpix 300 PIA shared the same 6.2 mm f/4 lens but was even more radical in that it featured a 2.5-inch touch-sensitive screen that provided access to note-writing and audio-recording facilities. In essence the Coolpix 300 PIA, which produced 640 × 480 pixel images, was a combined camera and basic personal data assistant, much as the Ricoh RDC-i700 of 2000 used a similar touch-sensitive screen to provide Internet facilities in conjunction with a mobile data card.

Nikon Coolpix 900 with its lens section twisted at right-angles to the main body.

Compared with its contemporaries the Coolpix 900 had vastly superior exposure metering, especially when having to balance the on-board flash unit's output with low-level ambient lighting. It also gave a very natural colour rendition and was pleasingly free from the coloured fringes that marred the edges of pictures produced by some of its competitors. When placed side-by-side with the other cameras mentioned here the Coolpix 900's colours look slightly muted, perhaps on account of the 'uncalibrated' colour space used, but are very pleasing nevertheless.

Epson PhotoPC-850Z

Jumping on 17 months we come to the Epson PhotoPC-850Z, which was unveiled in July 1999. Its predecessor, the PhotoPC-750Z, was the first digital camera that I carried and used to take pictures on a regular basis. Such was the success that I enjoyed with the earlier camera that I was already well-disposed towards the PhotoPC-850Z even before it arrived. As it turned out the new camera introduced two notable features; a screw-in lens hood (and therefore a filter thread for other accessories as well – a feature that was shared by the Nikon Coolpix 900) and a daylight mode for its LCD. The latter worked via a small lever that opened a flap to allow sunlight to enter behind the screen, so providing brighter-than-normal back-illumination. Epson's camera also benefited from three sensitivity settings (ISO100, ISO200 and ISO400) and a HyPict mode that used in-camera interpolation to boost the maximum image size from 1600×1200 pixels off the sensor to 1984×1488 pixels in the final picture. The colour space was defined as sRGB and its rendering had a similar subtlety to that exhibited by the Coolpix 900.

In the hydrangea shoot-out (p. 329) the Epson's pictures have the edge over the Nikon's by virtue of holding better highlight detail but their

(*left*) Epson PhotoPC-850Z. (*right*) Example picture taken using the Epson PhotoPC-850Z.

subtlety of colour verges on appearing washed-out. That said, under more favourable conditions the PhotoPC-850Z's pictures can be very good indeed and there was a time when this was my standard camera on which to take product pictures to accompany articles written for photographic magazines. In particular, the Epson has a very good macro mode that can be used with the wide-angle lens setting to capture some striking perspectives.

Pentax EI-2000

Echoing the Fujifilm/Nikon collaboration some years earlier, Pentax's EI-2000 was a joint project with Hewlett–Packard: as such, the same camera was also sold as the HP PhotoSmart C912. In many ways the EI-2000 is the best of the ten cameras discussed here. Like the Olympus E-10 (see below) it benefits from a genuine optical SLR design but it surpasses the Olympus in offering sensitivities from ISO25 to ISO400. The lower settings are made possible in part by the camera's five micron photo-sites, which are larger-than-average for a digital compact camera's pixels.

Pentax's design was reminiscent of a small 35 mm film-based SLR and even featured a twist-action zoom ring on the lens barrel rather than the more common thumb-rocker on the back of the camera (a feature that it shares with the Kodak EasyShare P880). The icons on its mode dial were similarly familiar and although other cameras had provided a filter thread previously the Pentax's 49 mm size was more in line with conventional camera accessories. On the down side, the EI-2000 is the only camera in my collection to have suffered a failed battery. Despite being older cameras, the Fujix's and the Sony's Li-Ion packs both continue to function to this day but the Pentax's pack no longer holds its charge. Fortunately, the EI-2000 also accepts Ni-MH AA cells, which the Fujix and the Sony do not.

(*left*) Pentax EI-2000 fixed-lens digital SLR. (*right*) Example picture taken using the Pentax EI-2000.

In terms of both colour fidelity and highlight taming, the sRGB-based Pentax EI-2000 was the very clear winner of the hydrangea shoot-out test. In the gateway shoot-out test, however, the Pentax's pictures were noticeably blue, dropping it into third place in this instance behind the Kodak EasyShare P880 and the Minolta Dimage X.

Olympus E-10

Towards the end of 2000 Olympus launched its massively important Camedia E-10. This was the model that paved the way for the E-20 (with five million pixels rather than four million) followed by the interchangeable-lens E-1, which launched the Four-Thirds system. Like the Fujifilm Fujix DS-300, the Olympus E-10 was immediately embraced by professional photographers but this time editorial rather than social snappers.

With its high capacity lithium-polymer battery unit attached to its baseplate the E-10 looks, feels and handles like a professional camera: it even has a second shutter release to make life easier when working in portrait orientation. The E-10 has in-built dioptre adjustment on a genuine optical TTL viewfinder and the rear-mounted LCD panel can be pulled out to the horizontal position for waist-level operation, as it can on the Pentax EI-2000.

Olympus's camera has dual memory card slots for both SmartMedia (as used in other Olympus models of the time) and CompactFlash (as favoured by professional photographers). The four-times zoom lens was a significant improvement over the capabilities of most contemporary fixed-lens digital cameras except Sony's. Although it still handles superbly the E-10's images are fairly unremarkable and the camera suffers in terms of file formats: it seems to take forever to save uncompressed files and its JPEG images always look just a little bit too poor to be an agreeable alternative. More positively, when time permits there is a raw option that can be used to improve image

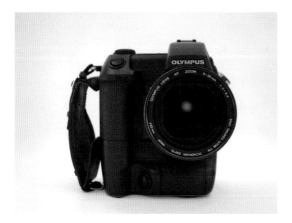

Olympus E-10 fixed-lens digital SLR with battery pack and extended grip fitted.

quality enormously using Olympus's own software, this being a feature that was previously confined largely to high-end digital systems.

Minolta Dimage X

April 2002 saw the arrival of Minolta's Dimage X with its innovative 'folded' lens that featured a prism behind the front element. Not only did this result in an exceptionally compact design but also it placed the focusing movement inside the camera. Another factor that contributed to the Dimage X's tiny proportions was its use of the then-new Multi-Media Cards (MMC) and Secure Digital (SD) cards. There was, however, a drawback to this choice: I well remember spending an entire afternoon walking the streets of Milan, very soon after the camera was first launched, trying to find a spare card after having filled up the two that I had brought with me from England.

The Dimage X offered users a curious mixture of control and automation. The sensitivity range was limited (ISO100–200) and operated entirely at the camera's whim yet there was instant access to exposure compensation via the forward/back arrows adjacent to the 'wide/tele' zoom rocker. Overall, the camera produces excellent pictures more often than not but its two million pixels were already on the low side for a £400 digital compact in 2002. A more serious fault was the significant mismatch between what is seen through the optical viewfinder and what is recorded by the sensor. Worse still, the fact that the LCD screen is positively tiny means it is not a practical alternative when composing pictures. But against that, the camera remains fabulously small, even by today's standards, and is reassuringly robust thanks to its metal housing and a metal shutter that covers the lens during storage and transportation. Equally importantly, it is capable of recording some very pleasing images and produced the most natural pictures in the gateway shoot-out test (see p. 330).

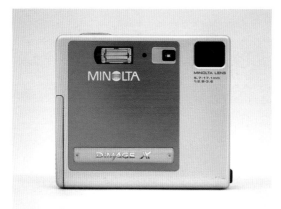

Minolta Dimage X with its lens cover (top right corner) open ready for picture taking.

Contax SL300R-T*

At the end of November 2003 Contax announced what turned out to be its last ground-breaking camera, the SL300R-T*. This camera combined a wide sensitivity range (ISO100–800) with add-on lens accessories and a new approach to signal processing. Specifically, the SL300R-T* performs some of its processing in the analogue domain before converting the sensor's data to digital values. The result is said to be better colour and fewer artefacts, resulting in smaller file sizes than would otherwise be possible using JPEG compression. Kyocera, the manufacturer of Contax cameras, achieved this advance thanks to its investment in another company, NuCore, which developed the image optimization technology used, called R-Tune.

The Contax SL300R-T* was an improved version of Kyocera's Finecam SL300R with the addition of a Carl Zeiss Vario-Tessar T* lens. It followed the ultra-compact ambitions of the Minolta Dimage X but added a swivelling lens section that harked back to the Nikon Coolpix 900. There was even a smart leather carrying pouch, which was sorely lacking from the Dimage X kit. As well as high quality still images the SL300R-T* could also capture continuous video clips that were limited only by the capacity of the high-speed SD card installed. In this respect Contax's camera was a clear sign of the way in which traditional film camera manufacturers sought to address the ongoing convergence between still and moving picture digital recording.

Despite being only a year younger, the SL300R-T* performed very much better than the Dimage X in the hydrangea shoot-out test, leaping ahead of the Olympus E-10 to sit in the runner-up slot behind Pentax's EI-2000 in terms of overall colour and highlight detail.

(left) Contax SL300R-T* with its lens section twisted forwards. (right) Example picture taken using the Contax SL300R-T* illustrating the camera's ability to record both brightly lit and shadowed areas with equal detail in each.

Kodak EasyShare P880

When Kodak announced that there would be no replacement for the DCS 14n digital SLR at the end of its life-cycle, and that it would also be withdrawing from the professional market entirely, the company promised that this would not mark an end to its leadership in digital cameras generally. In due course two flagship hybrid cameras were announced at the start of August 2005; the Kodak EasyShare P880 was to have an eight million pixel sensor and an almost 6× zoom lens whereas the Kodak EasyShare P850 would bear a five million pixel sensor with a 12× zoom lens. The cameras duly arrived and, despite looking fairly unremarkable, proved to be exceptionally well specified. The short focal-length end of the P880's lens goes as wide as a 24 mm lens on a full-frame camera and the long focal-length end of the P850's lens, which benefits from optical image stabilization to help guarantee sharp pictures, is equivalent to a 432 mm lens. There is an accessory tele-converter to extend the long-focus end of the P880's zoom range and a wide-angle converter to extend the short-focus end of the P850's lens. Both cameras have a raw file option and include the ability to convert from raw to JPEG inside the camera without the use of any external software.

One of the most obvious external differences between the P880 and the other cameras mentioned in this chapter is the size and clarity of its review screen: less obvious is the powerful pop-up flashgun with both ambient-light and flash exposure compensation. The viewfinder is electronic but has a much shorter interruption time when the camera is focusing, making panning easier (but still not trouble-free). There is also a very capable 640 × 480 pixel, 30fps video mode from which it is possible to extract individual frames thanks to the type of compression used.

Although it is no match for the professional digital SLRs with which Kodak dominated the early professional camera market, the P880 is a capable hybrid camera that can record good images in a variety of different situations. Thanks to cameras like this technologies that were once the preserve of affluent professional photographers are now available to a wider range of users. Not only that but cameras such as this also bring new features, such as video recording, that are not possible with the types of sensors currently used in professional digital SLRs.

Kodak EasyShare P880 digital SLR: unlike the other digital SLRs included here the P880 is fitted with an electronic viewfinder (EVF).

These six pictures show the results obtained when the same scene was photographed using the Ricoh RDC-2L (*top left*), Nikon Coolpix 900 (*top right*), Epson PhotoPC-850Z (*middle left*), Pentax EI-2000 (*middle right*), Minolta Dimage X (*bottom left*) and Contax SL300R-T* (*bottom right*). The Pentax EI-2000 produced the best result in this case, followed by the Contax SL300R-T*, Olympus E-10 (not shown) and Minolta Dimage X.

These six pictures show the results obtained when the same scene was photographed using the Fujifilm Fujix DS-300 (*top left*), Sony MVC-FD7 (*top right*), Pentax EI-2000 (*middle left*), Olympus E-10 (*middle right*), Minolta Dimage X (*bottom left*) and Kodak EasyShare P880 (*bottom right*). The most natural appearance was that recorded by the Minolta Dimage X with the Kodak EasyShare P880 in second place with slightly over-saturated colours. The Kodak has a choice of colour strengths and this picture was taken using the default option. The Pentax EI-2000 and the Olympus E-10 have both recorded the scene with a slight blue cast whereas the Fujix DS-300 has recorded a green cast and the Sony MVC-FD7 has recorded a slight red cast.

Summary

The ten cameras discussed in this chapter illustrate the progress that has been seen in digital camera design and performance since the landmark *Photokina* of 1996. They also illustrate some of the changes that have taken place; shifts in memory media, brands that no longer exist and the convergence of stills/video and professional/enthusiast technologies. But perhaps the most interesting observation is the fact that some of the earlier cameras have proved superior to more recent models in side-by-side testing. This is important because it highlights the fact that if a camera meets your immediate demands then you should buy it now because there is no guarantee that the next 'improved' model will be truly better than the one that you are already holding.

Although there has been undeniable overall progress in the quality of digital cameras' images and specifications it is clear that there have been some notable offerings that have leapt ahead of the norm, probably on account of manufacturers' desires to try something new and succeed in finding a better way of solving existing problems. Sadly, I suspect that if all ten of the cameras discussed here were current models and were laid out side-by-side on a shop counter then most potential buyers would be more interested in the cameras' pixel-counts than anything else. As has been stressed elsewhere in this book, and as this chapter clearly proves, there is very much more to digital photography than the number of pixels that a camera possesses.

In my earlier book *Digital Camera Techniques* (Focal Press, 2003), the smaller version of this portrait was published full-page as an example of the best image quality that was obtained in a comparison of digital SLR pictures and film photographs. It was taken using a Kodak DCS760. Today, however, accessible scanning technology has improved to the extent that the film image, which was captured using 35 mm Kodak Ultra 200UC and scanned by Photovision Services using a Fujifilm Frontier 570 minilab, now surpasses the best digital file. For that reason the film version is now printed full-page. (Photovision can be contacted on +44 (0) 1732 740280.)

CHAPTER 18

Epilogue

The fact that photography will inevitably be digital in the future (owing to commercial influences) means that the crucial question, of whether digital imaging offers better or worse image quality than film-based photography, is of little more than academic interest. On many occasions I have compared images from digital cameras with those of the same subject taken at the same time using film cameras, and the most consistent conclusion I have been able to draw is that the determined superiority of one medium over the other depends on the method used to inspect the images. In order to be able to compare film and digital images it is necessary to bring them both into the same domain: one way is to print both types of images and compare them on paper in the analogue (visual) domain; the other way is to digitize film images so that they can be compared with digital images electronically. The first approach is best suited to subjective assessment whereas the second allows more objective methods to be used. The problem with the second approach is that the hardware used to digitize the images will almost certainly have a bearing on the outcome of the comparison, so in a sense it is difficult to evaluate film images in isolation. Equally, the film used to capture the images will have an effect as well, so

This vintage negative was scanned at 1200 dpi using an Epson film scanner. Dust can be a real problem when scanning films (though less so when scanning prints) so when buying a scanner always look for one with good automated dust-removal software.

there will always be some variation in the findings of different tests of this type.

If we level the playing field by insisting that any comparison between digital camera images and film-based images must be carried out using hardware with a similar overall value then it is likely that the fairest comparison will be one that pitches photographs taken on negative films, scanned using a desktop scanner, against a selection of digital images taken on entry-level digital SLRs. Although it is not appropriate to discuss the following statement at length in this book, the fact is that when scans are made using good quality, modestly priced scanners there is almost nothing to separate images digitized from the original negatives and the same images digitized from enlarged prints – other than the greater amount of time needed to optimize the film scans by removing dust and correcting colour casts. The example comparisons shown here therefore comprise a mixture of film and print scans that are compared with digital camera images.

Image quality

The accompanying stadium pictures were captured digitally using a six million pixel Nikon D70s and using an all-manual Olympus OM4-Ti film camera. The stand was photographed in late-afternoon light, which added a visibly orange glow to the scene and turned the grass slightly more yellow than it would have looked in the middle of the day. The D70s picture was taken at the long-focus end of its matching 18–70 mm Nikkor DX zoom whereas the OM4-Ti was fitted with a 100 mm Zuiko prime lens. Fujicolor Superia X-tra 400 was used in the Olympus, with both cameras set to ISO400 and f/8 aperture. The D70s picture of the stadium looks good on screen but the silver halide print looks even better overall. Making an inkjet print of the digital camera's image does not help: the silver halide print still has a nicer all-round appearance. In the digital domain, however, the D70s wins hands-down: the scanned film image clearly lacks sharpness when compared with the digital file.

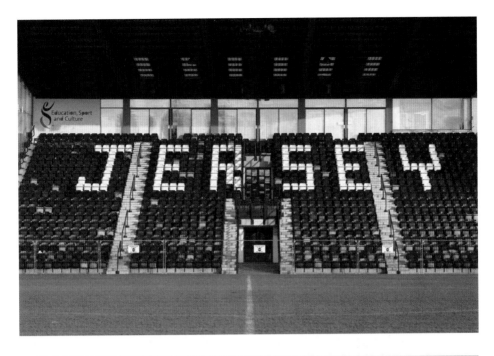

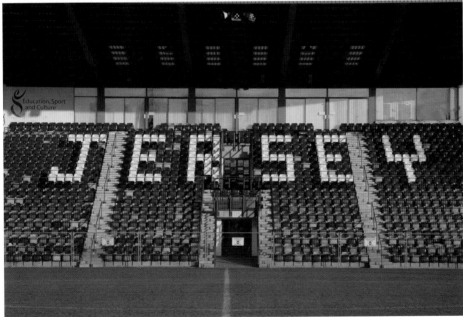

These two pictures were taken to compare the quality obtained from a film print with that available from an entry-level digital SLR. The film image (*top*) captures the colours of the scene very much better but the digital image, which was taken using a Nikon D70s, contains more detail as the close-up composite image (*overleaf*) clearly shows.

The section on the right is from the digital picture and clearly shows better clarity.

Although this test, and many others, suggests that film's appeal is mostly subjective and that digital capture produces demonstrably better technical image quality, there remains the possibility that the film images were let down by the scanners used. The way to check this, without having to invest in scanning equipment that is disproportionately expensive when compared with the cost of a digital camera, is to make use of the independent scanning services that are offered by High Street and professional photographic printing labs. Both Fujifilm's and Kodak's film-processing services include an option to have images scanned and copied to a CD at minimal cost. The problem is that these low-cost scans are often only medium quality, even when described as 'high resolution': better scans can be obtained but only at greater cost and therefore on an image-by-image basis rather than as a whole film at a time. The lead picture for this chapter was scanned in that way, using a Fujifilm Frontier 570 minilab machine, and is easily superior to the comparison digital file in both technical and subjective terms. This finding lends weight to the idea that film still has the potential to out-do digital images but only when every last trace of quality is extracted from it. On a day-to-day basis, using equipment of a similar value, digital images

The wider view here has been scanned from a Fujicolor Superia 200 negative using a Fujifilm Frontier 570 minilab printer; the tighter composition was captured digitally at the outset using a Kodak DCS620x.

offer superior technical quality even though film images may look better as prints.

Interestingly, the technical superiority of digital images is not a new finding. In the final year of the last millennium I did a test comparing images captured using a two million pixel Kodak DCS620x professional digital SLR with negatives taken using an Olympus iS-200 hybrid SLR loaded with Fujicolor Superior 200 colour film. The statue-and-fountain picture, above, is one of the subjects used for that test. The fact that the Kodak's sensor was smaller than full-frame, as indeed remains the case for

Close inspection reveals that the water in the digital picture has been recorded as multicolour droplets. It is rare to see this problem in modern digital images (this comparison having been undertaken back in the year 2000).

most digital cameras today, has resulted in a clear difference in framing. Cropping the film image and using Paint Shop Pro's automatic brightness and contrast adjustment tools results in an appearance that is much closer to the digital camera's rendering of the same scene. Surprisingly, given that the sensor in the Kodak DCS620x comprised just 1728 × 1152 pixels, it is very clear that there is more detail and better sharpness in the digital file than there is in the film image, which was scanned at 3200 dpi to give an 18 MB file after cropping. On the other hand, the digital version has multi-coloured droplets of water whereas there were no such artefacts when film capture was used. Neither technology is the clear winner here but this archive test does prove that digital has for some while been able to compete with film in some respects, even when digital capture was represented by a mere two million pixel sensor.

Final thoughts

Bob Carlos Clarke once said to me that the difference between painting and film-based photography is that the former is a very deliberate activity whereas the latter can involve an element of chance. The only way that painting could benefit from random events, he suggested, would be for a passing cat to knock a tin of paint onto the canvas in a fortuitously effective way. Film-based photography, on the other hand, comprises many processes and it often happens that a perfect chemically toned print can never be repeated in quite the same way a second time: that is both the beauty and the danger of silver halide photography.

This film effect, where parts of an image become reversed and dark lines appear at the boundaries between normal and reversed areas (such as to the left of the model's jaw line) was discovered by Armand Sabattier in 1862. It is impossible to predict precisely how a scene will turn out and as such this attractive technique is an excellent example of the uncertainty that is unique to film-based photography. There can be no equivalent serendipity in digital imaging save for the intervention of Bob Carlos Clarke's clumsy cat.

A print of this image that was made using PermaJet's Portrait Classic paper and Monochrome Pro black-and-white inks looks every bit as good as the darkroom reference print from which it was scanned.

Things are different in the digital domain. Everything is controllable and everything is repeatable. With sufficient practice you should be able do anything that is possible within the confines of the system being used. In a way this ought to help digital photographers to become more like artists in their pursuit of deliberately composed creations, but the ubiquitous Undo button means this is just an illusion. Of course it was always possible for artists to paint over their canvases to change the image for whatever reason but that is not the same thing as magically changing the canvas so that work done before is completely erased. The whole point is that we can detect the changes that artists made and have therefore been able to learn more about the ways in which some painters worked. There is no equivalent of this in digital photography and we have also lost Carlos Clarke's element of spontaneity to boot.

The matter of whither digital photography is headed is one that could provide endless hours of debate but as a teacher who is now around young people a great deal of the time I can see that immediate access and portability are lynch-pins in their uses of photography. Pupils whom I teach think nothing of taking pictures on their cellphone-cameras and of posting these images on personal websites. They are not particularly critical of image quality provided that the picture is clear. This being the case there is simply no need for ten million pixels, nor even six million pixels, if this is representative of the way in which the majority of pictures will be regarded in the future. This does not mean that people will not want to progress to more sophisticated digital SLRs (indeed I was delighted to have a discussion with one pupil about the relative merits of these cameras just a couple of weeks before finishing this book) but it does suggest that the new growth area in digital photography may be quite different from what could ever have been imagined for the film-based medium. In the future there will be less need to look backwards because the history of photography will become less relevant to the current reality of digital imaging.

I have made my own digital prints from top-quality negative scans and seen that they look every bit as good as darkroom prints: I therefore know

Taken just a few weeks before this book went to press, this self-portrait was shot using a Kodak EasyShare P880 at its wide-angle setting then cropped to provide a better composition post-capture. This cavalier discarding of pixels would never have been possible in the early days of digital photography but is yet another way in which digital images have become as versatile as pictures recorded on film.

there can be no reason to be sad that the medium has moved on but that still does not stop me from believing, even against the evidence, that a darkroom print is superior. Nevertheless, for the first time in my life, and despite fifteen years' experience of digital cameras, I have just been on holiday taking only a digital camera (no film cameras) with me. I am delighted to report that the pictures turned out very well indeed. I hope that having got to the end of this book and digested its contents you will be making the same assessments of your own digital photographs. Thank you for reading and good luck with your photography in the future.

Index